WHAT OTHERS ARE SA

M000266457

"If you've been reluctant to tackle Mexico on your own, Kathy gives you all the tools you need, including maps of major cities, itineraries, shopping and camping tips, and a step-by-step guide to the official paperwork involved. The most exciting book I've seen in years."
—Janet Groene - Author, Travel Writer, and Columnist-FMCA Magazine

"For anyone who is planning to travel by motorhome south of the border for the first time, *Mexico By RV* is an excellent resource. Unlike most travel books, it's chock-full of useful information that is written by an RVer specifically for RVers."
— Sherry McBride, Associate Editor, Motorhome Magazine

"Mexico by RV contains all the information an RV traveler would need on crossing the border, inspections, money matters, driving the Mexican roadways, health services, grocery shopping, dining out and entertainment. It also has a list of miscellaneous items and tips, national and religious holidays, and general information on embassies and Mexican tourism offices. Throughout the book, Kathy mentions the Spanish name for different things making easier for travelers to ask for or understand something "
— Kathy Loretta, Miami Herald Cancun Edition

"If you are anticipating traveling and vacationing in Mexico with an RV, begin your planning with a thorough reading of Kathy Olivas' *Mexico By RV.*"
—James Cox, Editor in Chief, Midwest Book Review

"This is a must book for the novice traveler to Mexico. As a combination encyclopedia-dictionary-how-to reference book, it provides the traveler with details that make travel easier and more meaningful. It is obvious that Kathy is an old pro at travel in Mexico; better yet, she knows how to impart her knowledge simply and effectively."
—Gaylord Maxwell, Founder of "Life on Wheels",
 Author of *Introduction to Full-Time RVing*

"This easy-to-read, well organized guide is essential to RVers thinking of going to Mexico. A must-have for south-of-the border adventuring."
—Marcella Gauthier, Escapees Magazine

"*Mexico By RV* is a superb travel book and enthusiastically recommended for all Mexico-bound travelers in general and those with an RV in particular!"
—Midwest Book Review, Library Bookwatch Newsletter

"Thank you for developing such a great tool for RVers. This book is a wonderful resource for those with hesitation of traveling in Mexico with their RV."
—Carol Taylor Clay, Country Coach, Inc.

"No more mystery and fear about traveling in Mexico! This book covers all the essential elements to make your RV journey easy, fun and safe. Don't go south of the border without it!"
—Nel Filliger, Founder of Fantasy RV Tours

"From how to handle money and give the right answers when crossing the border to where to go and how to get there, this book tells it all."
—Coast to Coast Magazine

MEXICO BY R.V.

A Step-By-Step Guide
to R.V.'ing in Mexico

Third Edition

Kathy Olivas

Sunseeker Publications

SUNSEEKER
PUBLICATIONS

Published by
SunSeeker Publications
1970 N. Leslie Street, Suite 2003
Pahrump, Nevada 89060-3678 U.S.A.
http://www.sunseekerpub.com

Maps and cover design by Jack Olivas

First Edition 2001
Second Edition 2004
Third Edition 2007

Printed in the United States of America

Publisher's - Cataloging-in-Publication

Olivas, Kathy.
 Mexico by R.V. : a step-by step guide to R.V.'ing in
Mexico -- 1st ed.
 p. cm.
 Includes bibliographical references and index.
 LCCN: 2001126059
 ISBN 10: 0-9711936-3-0
 ISBN 13: 978-0-9711936-3-5

 1. Automobile travel--Mexico--Guidebooks.
2. Recreational vehicles--Mexico--Guidebooks. 3. Mexico--
Guidebooks. I. Title.

GV1025.M4045 2001 917.204'837
 QB101-200806

THIS BOOK IS DEDICATED

To my parents, Loveta & Bill, whose enduring
love and guidance have made me a better person.
To my son, Emmett, who I will always remember with love.
To my daughter, Janelle, of whom I am eternally proud.
And to my partner, companion, best friend, and husband, Jack.

CONTENTS

TABLE OF CONTENTS

ACKNOWLEDGEMENTS

During our travels in Mexico, my husband and I were asked many questions from the people we were leading on RV Caravan tours. We also had many of our own. Those repeated queries spawned the idea that a book was needed to document the information for future travelers. Much of the material covered is a direct result of finding answers to the multitude of questions and attending the needs of our tour customers and other travel companions.

It would be impossible to thank individually all those people who asked the questions that provided the idea and material for writing and publishing this book. I would, however, like to thank all of the caravan tour customers and friends who traveled with us for their input.

I'd like to express my gratitude to all those citizens of Mexico I have met over the past years who made me feel so welcome in their country. Many of them contributed information contained in this guide. This book was written largely to encourage and assist others to partake in the wealth of knowledge that comes from understanding and the sharing of culture and friendship.

Thanks to my friend, Primi, in Puerto Vallarta. He patiently answered my constant inquiries about the language, customs, and food. He continues to be a resource along with many other Mexican citizens who have befriended and helped us in our journeys.

And I owe Fantasy RV Tours a special thanks for the travel opportunities and educational experiences that my husband and I enjoyed while leading tours for them as wagonmasters.

My husband, Jack, contributed so much. His support, encouragement, content contributions, and graphic design skills were invaluable in creating the final product. He constantly encouraged and supported me throughout as well as enduring many inconveniences in the quest for information. I could not have completed this book without him.

WARNING, DISCLOSURE, AND DISCLAIMER

This book was written and designed strictly to provide information that might be helpful to those seeking to travel or tour Mexico in a recreational vehicle. The author has engaged in thorough research to ensure the accuracy of all materials as of the time of publication. You may need to do personal research at the time of your travel to determine that border regulations, travel restrictions, fuel or permit prices, viability of campgrounds, and road conditions have not changed.

The author and publisher do not assume, and hereby disclaim, any liability or responsibility to any party or entity for any loss or damage caused, or alleged to have been caused, directly or indirectly, by errors, omissions, or any other cause.

Many of the topics covered in this book are subject to change due to the passage of time as well as economic and social progress, and political climate. We welcome any updated information that might be suitable for inclusion in future reprints and editions of this book.

SunSeeker Publications
1970 N. Leslie Street, Suite 2003
Pahrump, Nevada 89060-3678

INTRODUCTION

For the traveler who wants to explore Mexico in a recreational vehicle (RV), it could take years of travel to experience the whole country. If you're simply seeking a temperate climate or warm beach on which to spend an inexpensive winter in your RV, you won't be disappointed either.

There were already books and numerous websites that detail the camping facilities and the travel destinations in Mexico. Some favorites are listed in the Appendix. This book is designed specifically for the RV traveler. It is a how-to guide on RV travel in the country and should make it easier and safer for you to explore on your own or with a group. It is not meant to tell you where to go and where to stay on your journey.

Traveling in Mexico can be an enriching experience. My husband and I have toured Mexico in our RV since 1987 when we first wandered down to San Felipe, Baja, on a whim with our off-road vehicles in tow behind our motorhome. After that first excursion we made sporadic trips into Baja until our official early retirement from the work force in 1993.

We felt apprehensive, however, about embarking on a long, solitary exploration even though we had driven our RV in Mexico and had also made several plane trips to the Yucatan to scuba dive in the warm, blue Caribbean waters. Then we stumbled on the answer for us: an RV Caravan. It allowed us to better familiarize ourselves with the country and roadways before we ventured off on our own.

Caravan companies take the worry out of touring in an unknown land. You travel in your own RV, with a group, on a pre-determined itinerary guided by the Caravan company's knowledgeable leaders. They handle reservations for campgrounds, side tours, events, and many meals. The guides are experienced, provide peace of mind, and add value to the travel experience. Caravan travel is not for everyone but it is still an excellant method of "getting your feet wet" in a foreign country and environment. Then you next trip you can go it on your own with a lot more confidence.

In early 1994 we embarked with Fantasy RV Tours, accompanied by fourteen other couples, on a trek from Nogales, Arizona, south along the west coast to Mazatlán and across the Sea of Cortez on the ferry to La Paz, Baja. From La Paz we traveled around the tip to Cabo San Lucas and then north on the only paved road back to the United States.It turned out not only to be a successful educational experience but also provided additional rewards in the form of permanent friendship with several caravan members. The experience also resulted in an offer of part-time employment by the caravan company. We joined the Fantasy wagonmaster staff in 1995.

Over the next three years we traveled Baja extensively, leading caravans for Fantasy RV Tours, and exploring by ourselves. We learned to appreciate the stark contrast in the landscape from desert to the beach. Baja has miles of accessible beaches along the Sea of Cortez with open camping areas for RVs. It also has some of the most expansive and unique desert vegetation areas that we have ever seen.

In 1996 we drove alone from McAllen, Texas, to Cancun where we joined the owners and other staff members on an exploratory tour of mainland Mexico, planning new commercial tour routes. We spent two months driving and mapping the routes, visiting cities and campgrounds, and attending proposed activities. It was an infectious experience. Mexico was becoming an aching desire in our hearts. After one more season leading caravans through the Yucatan and central Mexico, we decided we needed more time to explore on our own and retired as field staff.

After fourteen years of exploration and over 100,000 miles of travel in our current motorhome, we have found our "paradise" in a small village north of Puerto Vallarta on the west coast of Mexico. We have built a home base there where we will spend our days between trips. We plan to continue visiting our favorite places and exploring this fascinating and diverse country in our RV for years to come.

CHAPTER 1 : WHY MEXICO?

We're asked this question so often that we now just answer, why not? People tell us that they have been to Tijuana, Juárez, or Cancun and did not see anything special. Border towns and high tourist areas are not a good representation of the majority of the country. Much of Mexico is small rural communities, where a visit is a joy indeed.

The next question usually revolves around security. Tales have been perpetuated and embellished about "banditos" and unscrupulous officials. Thousands of foreigners who travel or live in Mexico will tell you that they feel safer there than their own homeland. We find the incidence of crime and random violence so low that we echo that feeling. This is not to say that Mexico is without criminals but your chances of running into them are considerably lower than at many other destinations. As with traveling anywhere, use common sense, be aware of your surroundings, and obey the laws of the land.

Mexico is a large and diverse nation with an estimated 90 million people, and ranks eleventh in the world in terms of population. More than half reside in the central states and at least one quarter reside in Mexico City. It is the largest city in the world with more than twenty million people within its limits.

Away from the metropolises, most people support their families by farming, ranching, or fishing. These out-of-the-way places have afforded us many of our lasting memories and captured our souls. We feel strongly attached to the country and its hard-working, generous, gentle people.

Visits to the major cities have all been interesting, places where unique old architecture mixes in with newer familiar places such as McDonald's or Wal-Mart. However, our favorite memories come from the villages where we can interact with the locals one on one, enjoy being part of their everyday life, and observe the beauty of ingenuity and craftsmanship that is becoming obsolete in our country with so much mass production.

In Mexico, entire villages specialize in crafts that are taught and handed down generation to generation. On one trip to Arazola, outside of Oaxaca city, small children led us on tours of all the village factories, which are actually the craftsmen's homes. We watched with fascination as artisans, using rudimentary tools, turned pieces of wood into beautifully carved and painted whimsical animals, called alebrijes. Other villages demonstrated skills of exquisite pottery-making. We made friends with the local salesman in the RV park who offered handmade Zapotecan wool rugs for sale. We accepted an invitation to his home in nearby Teotitlán del Valle and were treated like royalty on a day visit. The home was filled with looms and activity. The entire family contributes to the trade, spinning wool, coloring it with natural dyes made from plants and insects, and designing and weaving magnificent works of art.

Driving out of the cities and exploring to the ends of the road has led to such amazing discoveries as the quaint seashore restaurant with the best fish meal we've ever had and miles of deserted white sand beaches. Long treks down dirt or poor roads have yielded fabulous natural wonders like the petrified waterfalls of Herve de Aqua, the caverns with swimming ponds at Balankanche Caves, crystal waterfalls of Aqua Azul, beautiful rain forests, and a boat trip through the grandeur of Sumidero Canyon in Chiapas. On top of all this is the awe of exploring the ancient ruins and cities of the Olmecs, the Mayas, the Aztecs, the Toltecs, the Mixtecs, and the Zapotecs.

We've been widely accepted by the people throughout the country and afforded hospitality unlike anywhere else we have traveled. We sought a simpler way of life when we left the hustle and bustle of the work force and have truly found it through our travels in Mexico.

Some people will not see it as we do. Many cannot see past the poverty, roadside trash, the sometimes inadequate roads, and rudimentary houses. But those who search with an open mind and heart will discover infinite pearls within the shell. Check out every road no matter how un-promising it seems and don't pass up any open doorway without looking inside. Real Mexico is hidden in charming villages at the end of dirt roadways and behind huge wooden doors and high walls of buildings that appear deserted. You'll find architecture to amaze and delight you, and you will be enriched by extraordinary cultural experiences. Open your eyes and your hearts to this remarkable country.

CHAPTER 2: INSURANCE

IMPORTANT! Mexican law requires that you carry an accident liability policy underwritten by a Mexican-owned company. While it is rare to be asked to show proof of this policy, except in the event of an accident, to travel without such a policy would be extremely unwise. If you are involved in an accident in Mexico with another vehicle, person, animal, or personal property, you will be subject to the laws of the country, state, and local municipality. Even if it is not your fault, your vehicle can legally be impounded until determination of liability and proof of insurance is verified. Without proper insurance, you could be arrested and detained by the authorities.

You can purchase a policy to cover driver's liability insurance only, or you may prefer to obtain full coverage, including comprehensive and collision on your vehicle or vehicles. Several companies in the United States can provide RV insurance and include comprehensive and collision protection for your vehicle while traveling in Mexico. They do not, however, provide the Mexico accident liability portion. This coverage must be underwritten by a Mexican provider. Aon Recreation Insurance at (800) 521-2942 or online at http://www.aonrecreation.com, has underwriters that can provide comprehensive and collision coverage while traveling in Mexico, usually at no extra charge. RV Insurance Associates is another option and can be contacted online at http://www.rvinsurancepro.com or by phone at (877) 784-6787 or (888) 467-4639 (toll free). Sanborns can also provide insurance for RVs and tow vehicles. Contact them by telephone at (800) 222-0158 or online at http://www.sanbornsinsurance.com. Check out the Online Information section on page 176 for more insurance options.

Mexico's required accident liability policy is an inexpensive addition, often costing in the range of $50 to $100 per year. Be sure to check out the company thoroughly when you purchase the insurance. Sanborn's Travel, American Automobile Insurance Company (http://www.aaa.com) and the Canadian Automobile Insurance Company (http://www.caa.ca) all provide public access to information about Mexican insurance carriers.

You may choose to purchase your policy in advance or at one of several offices that are located at border entry points.

Each insurer in Mexico must post a bond, but if you have an accident while under a particular company's coverage and it is not financially stable, your claim could take months to settle. If the accident is your fault, your vehicle may be detained until the Mexican courts can secure a settlement from the company's assets.

The length of time you plan to travel in Mexico will determine whether it is more economical to purchase a short-term policy or a yearly one. Normally, the breakeven point for cost is about two weeks.

Some of the commercial RV caravan companies will assist you in securing the required insurance. They have been dealing with insurers for years and have the expertise and historical data to recommend a reliable company. Fantasy RV Tours can help you obtain a policy even if you are not traveling with them. Contact them by phone at 1 (800) 952-8496, or you can visit their website at http://www.fantasyrvtours.com.

We have used Ada Vis Global for years with a great deal of satisfaction. Contact them by phone at (909) 506-6644 or access their website at http://www.mexicoinsurance.com for more information.

You may additionally want to consider a policy, offered by Mexican insurance companies, that provides legal aid services in the event of an accident. Such policies will afford you representation by an English speaking Mexican lawyer to assist with the authorities if required. It also allows for speedy release if you are detained for an accident or traffic infraction. These policies are inexpensive and offer great peace of mind.

If you are involved in a minor accident with no injuries, it is usually best to attempt to settle it directly between the parties involved without notifying the authorities. Even if you are at fault, a compensatory settlement can normally be negotiated. Be sure to get written estimates from the other party and sign some sort of receipt that they accept the compensation as payment in full for the damages. When the accident is caused by another party, you should ascertain the expenses you will incur for repairs and negotiate payment directly.

CHAPTER 3: CROSSING THE BORDER

Crossing the border into Mexico for the first time will likely be a source of anxiety. Not understanding the language, the regulations, or customs can cause stress. It really is easy, however, provided you have the necessary documentation and know what to expect. The basic requirements are dictated by law but some officials are more lenient and will allow deviations while others expect you to comply precisely with all requirements. Having all the necessary and correct paperwork will make the process uncomplicated and expedient. The information provided in this chapter will help you to prepare.

No formal documents are required for short trips (up to 72 hours) to border towns or points within the approximate twelve-mile customs border limits, also known as Border Zones.

The State of Sonora is also considered a "Free Trade Zone." Special limited passes are issued for travel within its borders. "Sonora Only" visitors are not required to present normal proof of citizenship documents or to pay the vehicle importation fee. The driver needs only have a valid drivers license, issued outside of Mexico, and proof of ownership or legal possession of the vehicle. This can be the vehicle title or registration in the name of the driver. A notarized letter of permission from the leasing or rental car agency allowing entry into Mexico is sufficient for leased or rented vehicles. If driving a company owned vehicle then you must provide proof of labor relationship between yourself and the company along with permission from that company allowing it to be taken into Mexico.

The Baja Peninsula is a "Free Trade Zone" and does not currently require vehicle importation permits unless you are crossing to the mainland with your vehicles on the ferry. If you plan to do this, the appropriate paper-work will be completed in La Paz before boarding the ferry. For travel in Baja, except to San Felipe, you are still required to obtain a Tourist Visa.

WHAT YOU NEED TO ENTER MEXICO

First you must have proof of citizenship from your country of origin. As of January 1, 2008, passports will be required for all U.S. citizens traveling to or from the United States via air, land or sea, regardless of destination. Passports are taking a long time to acquire due to the increased volume, so allow plenty of time to get one. Persons visiting Mexico from Canada are currently not required to present a passport to enter Mexico; but will be required to have one in order to drive through the U.S. Nationals of countries other than the USA or Canada should verify requirements that apply to them with the Embassy of Mexico in their home countries.

You will be issued a Tourist Visa (FMT) at the Immigration (*Migración*) office or window. This will be valid for up to 180 days. Some border stations will only issue this permit for 90 days unless you ask for more time. Always request the maximum time allowed.

The Tourist Visa (FMT) currently costs about $20 US. Most border stations have a payment window at the *Banjercito,* that will collect the funds and validate the document upon entry into Mexico. If there is no payment facility at the border (like Tijuana) then you will need to take the document to any Mexican bank and pay the fee. They will validate it for you at that time.

If you are entering Baja you must now get your Tourist Visa (FMT) at the border as they no longer issue them in Ensenada. You can also obtain your Visa (FMT) at a Mexican Consulate in the U.S. or an agent such as Vagabundos del Mar or Discover Baja prior to crossing the border but you are still required to stop at *Migration* and have it stamped along with your passport.

As with most Migration laws in Mexico, they have been loosely enforced in the past but with the advent of electronic tracking at *Migration* that is changing rapidly. Legally you are required to have a valid (paid) Tourist Visa (FMT) while traveling in Mexico.

They are also beginning to post signs (in English) at the border stations instructing you to read and comply with the rules for entry into Mexico which are on the back of your Tourist Visa (FMT). The rules are explained as follows on the next page:

The Tourist Visa (FMT) has to be returned **IN PERSON** to any *Migration* office (not to the Consulate), right when you are leaving the country and before the expiration date. Currently only some *Migration* officers are stamping your passports upon entry even though they are required to do so. You should request that the officer stamp yours and make sure you have it stamped again upon leaving the country as a receipt for returning (canceling) your Tourist Visa (FMT).

If you got a Tourist Visa (FMT) previously and you lost it, you don't have it with you and/or your passport shows lack of a stamp out, you may not be able to get a new one unless you get a Comparecencia por Perdita de Documentos, (loss of Federal Documents Report) from the Averiguaciones Previas Office (police department). Return of the Tourist Visa (FMT) has not been previously enforced but better safe than sorry. You could incur large fines and/or be refused entry into Mexico for not complying with the law. If an untimely opened stamp on your Tourist Visa (FMT) has to be closed (or returned), a fine of $50.87 pesos may be assessed for each day that it is overdue.

Don't get confused, when you cancel your vehicle permit, you are **NOT** canceling the Tourist Visa (FMT), this migratory permit has to be cancelled in the Mexican immigration offices, *Migration*. These are two entirely separate entities.

The *Banjercito* is also the place at which you pay for your vehicle permits. Be prepared to move from window to window or even building to building and back and forth a couple of times to complete the process. Be patient and keep your sense of humor.

The law states that foreigners may temporarily import only one vehicle per person for up to 6 months at a time. Each motorized vehicle requires a separate driver with a valid drivers license from their home country. This rule applies to importation only. Once imported then either spouse or an adult child may drive the vehicle. Anyone else, except a Mexican citizen, may also legally drive the vehicle so long as the owner is aboard. The following items are required to receive an importation permit. You may be able to fill out your vehicle permit online and take it to the border to save time. Check the following webpage for instructions: http://www.banjercito.com.mx/site/imagenes/iitv/instruccionesIITV_ing. html.

If you own the vehicle:
You must have **EITHER** the original registration **OR** ownership title showing your name.

Leased, company owned, or financed vehicles:
In addition to the vehicle registration or title, you are required to have a letter from the lessor, company of ownership, or lien holder, giving you permission to temporarily import that vehicle into Mexico. Notarization has not as yet been required but it is still prudent to have this done. We have hear reports that at some border stations they are not issuing permits if the applicant is not listed on either the title or registration. This could be isolated incidents but check before you go. It is always best to present only the document (title or registration) that has the driver's name on it.

If you are driving a motorhome and towing another vehicle, you are now allowed to register both the motorhome and the tow vehicle in one person's name. Drivers license, registration or title, and credit card for fees must all be in the same name as the individual applying for the vehicle permit.

Currently RV's (motorhomes, travel trailers or fifth wheel trailers) are issued a ten (10) year permit while the towing or towed vehicle still only has a 6 month permit. Trucks with campers fall under the regular vehicle guidelines (6 month permit).

Be aware however, that if you leave Mexico without returning your ten year permit on your RV and sell it; trade it in; have it stolen; or wrecked, it is virtually impossible to cancel the permit without appearing with that vehicle at the border. The price difference is negligible so we recommend that if you are not absolutely sure you will be returning with that vehicle, cancel and return the permit when you leave. You will not be issued future permits for any vehicle in your name if you have not cancelled your previous one.

The fee for this permit is approximately $50 U.S. per RV (ten year permit) and about $30 U.S. per car/truck (6 month permit). This must be charged on a revolving credit card (VISA, Mastercard, American Express). The credit card must display the same name as the drivers license and vehicle registration paperwork for each vehicle. Debit charge cards are not currently accepted.

In lieu of the credit-card charge, you may post a cash bond based on the vehicle's age and value. This can be quite costly and difficult. It is not advisable. The bond will be refunded when you return to the United States, and we have had no reports that this does not happen. The credit card method is just the simplest and safest.

You will receive a completed importation permit and a holographic sticker for each motorized vehicle. The system is computerized and you are given the stickers to apply yourself. Verify that the VIN numbers are correct and place the sticker inside your windshield as instructed on the permit. Keep the original permit in a secure place in the RV and keep an extra copy in a seperate location in the vehicle. You will need it in the event of vehicle theft, damage, or an accident. We keep an extra copy of the RV permit in our tow vehicle and vice versa just for extra insurance.

During the course of your trip, you may be asked at check points for the vehicle importation paperwork as well as the Tourist Visa. Keep both handy to save time. Authorities have the right to confiscate any vehicle found in Mexico with expired or invalid documentation.

The temporary vehicle importation documents allow you to cross back and forth at the border multiple times within the authorized time frame. However, when you return to the U.S. border for the last time, you must return the permit and stickers to Mexican border or customs officials. You are not required to exit via the same border crossing at which you entered.

This is a simple process that helps to maintain good border relations and keep controls to a minimum. Learn the rules and comply with them. The more people who ignore the rules, the harder it will become for returnees and future new travelers. You can help keep RVers welcome in Mexico by simply obeying its laws.

Many of the border stations are open 24 hours a day, seven days a week for crossing between the United States and Mexico. A list of all official border stations follows, along with hours that they are open. However, not all services such as Vehicle Importation (*Banjercito*) and Tourist Visa offices have the same hours. Preferred crossing points for RVs are detailed later in this chapter.

Technically, the government limits foreign tourists as to what items they may bring into the country while traveling. These limitations cover a wide range of categories, including electronic equipment such as cameras, VCRs, computers, and televisions. For instance, you are allowed to bring in only one television. However, many RVs are equipped with two that are permanently mounted in the vehicle.These restrictions were created in trade agreements between Mexico and other foreign governments, including the United States. They are designed to limit the flow of goods between the countries that might impact the trade laws in place. Recreational vehicle travelers present an entirely unique set of circumstances. In the past fifteen years, the number of travelers who live full time or travel extensively in their RVs has increased significantly. Those who do so have complete households on board that exceed the allowed items and amounts. You are also allowed to enter by land with gifts, excluding alcohol and tobacco products, valued at $50.00 U.S.per person.

RV travelers have occasionally been requested to provide a list of high value items on board for the Customs officials to keep on file. Be prepared and make a list of all personal and household equipment in your RV. You should have this anyway, no matter where you travel, for insurance purposes. Just keep it handy in case it is required.

We have personally had no problems with Customs officials at any of our numerous border crossings regarding the items we carry in our RV, even though taken together, they exceed the legal limits. None of the groups we have escorted have experienced difficulty either. Customs inspection stops are covered in more detail in the Inspections chapter. Officials are generally very quick and seldom have they ever come inside our coach. In the cases where they have requested to look inside, the inspection has been only cursory. They usually just ask a few questions about our destination and nature of our visit,—business or vacation,—to which we reply "vacation."

Before your trip, contact the Mexican Ministry of Tourism, *SECTUR*, at one of the numbers listed on Page 163. They can provide up-to-date information on regulations, restrictions, and enforcement. They usually have English speaking personnel available. You should also contact your country's embassy to check for changes in the re-entry procedures to your home country.

 OFFICIAL BORDER CROSSING STATIONS

ARIZONA	HOURS OF OPERATION
Douglas, Arizona, at Agua Prieta, Sonora, Mexico. Poor RV crossing due to parking issues and local traffic congestion.	**Border crossing**: Open daily, 24 hours. **Banjercito:** Open daily, 24 hours.
Lukeville, Arizona, at Sonoyta, Sonora, Mexico. Good RV crossing, streetside parking for Banjecito business.	**Border crossing:** Open daily, 6 a.m. to midnight. **Banjercito:** Open daily, 8 a.m. to midnight.
Lukeville, Arizona at Garita San Emeterio, Sonora, MX. Good alternate location for Banjercito business if you cross at Lukeville/Sonoyta.	**Border crossing:** Open daily, 6 a.m. to midnight. **Banjercito:** Checkpoint KM 26.5, located on Hwy 2, 17 miles east of Sonoyta. Open daily, 8 a.m. to midnight.
Naco, Arizona, at Naco, Sonora, Mexico. Poor RV crossing.	**Border crossing:** Open daily, 24 hours. **Banjercito:** As of early 2007 this office was closed.
Nogales, Arizona, at Nogales, Sonora, Mexico. Good RV crossing with plenty of parking at the KM 21 Checkpoint.	**Border crossing:** Mariposa Bridge is the only crossing suitable for RV's. Open daily, 6 a.m. to 10 p.m. **Banjercito:** KM 21 Checkpoint located at KM 258, Hwy 15 S. Open daily, 6 a.m. to 10 p.m.
San Luis, Arizona, at San Luis Río Colorado, Sonora, Mexico. Poor RV crossing due to parking issues and local traffic congestion.	**Border crossing:** Open daily, 24 hours. **Banjercito:** Open daily, 8 a.m. to midnight.

 OFFICIAL BORDER CROSSING STATIONS

CALIFORNIA	HOURS OF OPERATION
Calexico, California, at Mexicali, Baja, Mexico. Two crossings: Downtown Calexico West (Garita I) & Calexico East (Garita II). Garita II/East is preferred and easiest RV crossing.	**Border crossing:** Calexico West, Garita I open daily, 24 hours and Calexico East, Garita II open daily, 6 a.m. to 10 p.m. **Banjercito:** Garita I, open daily, 24 hours. Garita II, open 8 a.m. to 4 p.m. Monday-Friday; 10 a.m. to 2 p.m. Saturday; closed on Sunday.
San Ysidro, (San Diego) CA., at Tijuana, Baja, Mexico. Poor RV crossing especially, northbound, due to heavy border congestion. No parking for big rigs for Banjercito business.	**Border crossing:** Puerta Mexico, Open daily, 24 hours. **Banjercito:** Open daily, 8 a.m. to midnight.
San Ysidro, (San Diego) CA., at Otay Mesa, Baja, Mexico. Best RV crossing point in this area.	**Border crossing:** Truck and auto crossing. Open daily, 6 a.m. to 10 p.m. **Banjercito:** Open daily, 8 a.m. to midnight.
Tecate, California, at Tecate, Baja, Mexico. Poor RV crossing.	**Border crossing:** Open daily, 5 a.m. to 11 p.m. **Banjercito:** It has been reported a/o June 2007 that this location has been permanently closed.

NEW MEXICO	HOURS OF OPERATION
Columbus, New Mexico, at Palomas, Chihuahua, Mexico. Good RV crossing, streetside parking available for Banjercito business.	**Border crossing:** Open daily, 24 hours. **Banjercito:** Open daily, 8 a.m. to midnight.

 OFFICIAL BORDER CROSSING STATIONS

NEW MEXICO

Santa Teresa, New Mexico at San Jeronimo, Chihuahua, MX. Located just east of El Paso, TX. Good RV crossing.

HOURS OF OPERATION

Border crossing: Open daily, 6 a.m. to 10 p.m

Banjercito: Open daily, 8 a.m. to 10 p.m.

TEXAS

Brownsville, Texas, at Matamoros, Tamaulipas, MX B & M & Gateway Bridges. Poor RV crossing due to parking issues and local traffic congestion.

HOURS OF OPERATION

Border crossing: Open daily, 24 hours.

Banjercito: Open daily, 24 hours.

Brownsville, Texas, at Matamoros, Tamaulipas, MX Veteran's International Bridge. Good RV crossing.

Border crossing: Open 6 a.m. to midnight. Monday through Saturday.

Banjercito: Open 8 a.m. to 11 p.m., Monday through Saturday.

Del Rio, Texas, at Ciudad Acuña, Coahuila, Mexico. Good RV crossing.

Border crossing: Open daily, 24 hours.

Banjercito: Open daily, 24 hours.

El Paso, Texas, at Ciudad Juárez, Chihuahua, Mexico. Four border crossing points in this area, downtown Paso del Norte, Stanton Street & Bridge of the Americas; to the west is Zaragosa Bridge. Zaragosa is the easiest of the four with a big rig.

Border crossing: All of these border crossings are open daily, 24 hours.

Banjercito: KM 30 Checkpoint is located just south of Cd. Juárez at KM 342 on Hwy 45 S. for all of these crossings and is open daily, 24 hours.

**Also check out the New Mexico section, Santa Teresa crossing just west El Paso. It has it's own Banjercito and you don't have to go to the KM 30 Checkpoint.

 OFFICIAL BORDER CROSSING STATIONS

<ins>**TEXAS**</ins>	<ins>**HOURS OF OPERATION**</ins>
Eagle Pass, Texas, at Piedras Negras, Coahuila, Mexico. Good RV crossing.	**Border crossing:** Bridge II, open daily, 24 hours. **Banjercito:** Open daily, 24 hours.
Laredo, Texas, at Nuevo Laredo, Tamaulipas, Mexico, Bridges I & II. Poor RV crossing due to parking issues and local traffic congestion. Suggest alternate Columbia crossing.	**Border crossing:** Bridge I and II are open daily, 24 hours. **Banjercito:** Bridge I office, open from 7 a.m. to 11 p.m. & Bridge II office is open daily, 24 hours.
Laredo, Texas, at Columbia, Tamaulipas, Mexico. Good RV crossing.	**Border crossing:** Open daily, 8 a.m. to midnight. **Banjercito:** Open daily, 8 a.m. to 11 p.m.
Los Indios, Texas at Lucio Blanco, Tamaulipas, Mexico. Good RV crossing.	**Border crossing:** Open daily, 6 a.m. to midnight. **Banjercito:** Open 8 a.m. to midnight, Monday through Saturday, closed on Sunday.
McAllen/Hidalgo, Texas, at Reynosa, Tamaulipas, MX, Poor RV crossing due to parking issues and local traffic congestion.	**Border crossing:** Open daily, 24 hours. **Banjercito:** Open daily, 24 hours.
McAllen/Pharr, Texas, at Reynosa, Tamaulipas, MX. Good RV crossing.	**Border crossing:** Open daily, 6 a.m. to midnight. **Banjercito:** Open daily, 8 a.m. to midnight.

 OFFICIAL BORDER CROSSING STATIONS

TEXAS	HOURS OF OPERATION

Presidio, Texas, at Puente International Ojinaga, Chihuahua, Mexico. Poor RV crossing due to current access roads to this point and remote location.

Border crossing: Open daily, 24 hours.
Banjercito: Open daily, 24 hours.

Progreso, Texas at Nuevo Progreso, Tamaulipas, MX. Poor RV crossing, mostly local traffic.

Border crossing: Open daily, 24 hours.
Banjercito: Open Monday through Friday from 8 a.m. to 6 p.m. & Saturday & Sunday, 9 a.m. to 5:30 p.m.

Rio Grande City, Texas, at Cd. Camargo, Tamaulipas, Mexico. Poor RV crossing due to parking issues.

Border crossing: Open daily, from 7 a.m. to midnight.
Banjercito: Open Monday through Friday, 8 a.m. to midnight.

Roma, Texas, at Ciudad Miguel Alemán, Tamaulipas, Mexico. Poor RV crossing due to parking issues.

Border crossing: Open daily, 24 hours.
Banjercito: Open daily, 24 hours.

You will have to cross toll bridges at nearly all the border crossing points so don't forget to have cash available. Whether it is on the U.S. or Mexico side they normally accept either U.S. dollars or Pesos for the toll.

 OFFICIAL BORDER CROSSING STATIONS

The following website shows all the border crossings (including Canadian crossing points) with nearly real time crossing wait times as well as any changes in hours of operation: http://apps.cbp.gov/bwt/

The following pages have maps for specific information about the most common border crossings. We have chosen to describe the easiest RV entry points. The location where you cross will be determined by your intended destination in Mexico. We recommend an early start on the first day. This will allow adequate time for any delays with paperwork processes at the border and give you plenty of daylight hours to reach your first destination. Stay relaxed and follow instructions of the officials. Don't expect any sense of urgency from the staff at these facilities. Consider it your first taste of the slow pace of the Mexican lifestyle.

SAN YSIDRO, CALIFORNIA, AT TIJUANA, BAJA CALIFORNIA

Since this is the main border crossing for all travelers to Baja it's a very busy entrance point. It is still relatively easy to enter at this location but very difficult to exit from here in an RV. Baja is a "Free Trade Zone" and there are no vehicle paperwork requirements for traveling the Baja Peninsula. You still are required to have an (FMT) Tourist Visa for Baja.

Interstate 5 and Interstate 805 from San Diego come together just before the border so either is good for access. Stay in the right lanes, not the truck lanes, as you proceed. After crossing the border, get into the center lane and go straight under the overpass following the signs for "Rosarito-Ensenada, Scenic Route." Go up and onto the highway and move into the third lane to the right. Stay in this lane and continue following signs for the "Rosarito-Ensenada, Scenic Route" as you curve to the left. This is well marked so just watch the signs. Climb for a couple of miles then go downhill, curving to the right and merging with the traffic from town. For the very scenic toll road south, take the left fork following the signs for "Ensenada *Cuota*." On this route, you'll stop three times to pay tolls but they are nominal and well worth the cost for the beautiful ocean vistas. The free or *libre* road winds through the hills and adds many miles to the drive.

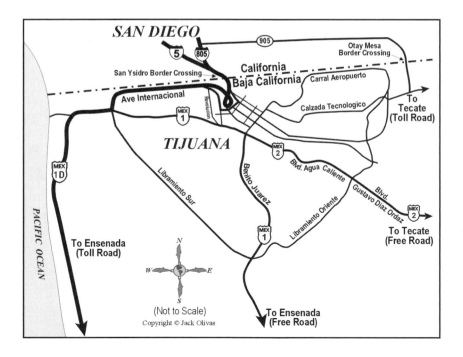

NOGALES, ARIZONA, AT NOGALES, MEXICO

Nogales is used frequently for access to all points on the western coastline of Mexico as well as Guadalajara. The old downtown of Nogales, Mexico, is popular with tourists who park on the U.S. side and walk across to shop. If entering by vehicle with intentions to travel beyond the city, you do not stop for documents until you are about fourteen miles south of the actual border at the KM 21 Checkpoint. The bypass around Nogales provides easy access to the highway southbound, but you must pay a toll.

Take Interstate 19 south from Tucson. Go right (east) on Highway 189, also known as Mariposa Road, and follow the signs for the Mexico border. Stay in the far right lanes, designated "Autos", as you cross the border. You will pass an inspection station about seven miles farther along. A cursory vehicle inspection may be required at this point. Proceed straight ahead approximately seven more miles to the KM 21 Checkpoint. Stop in the parking area on the right side just before the buildings. After securing your vehicle permits & Tourist Visa, you will pass through Customs for an inspection and then you have smooth sailing on four-lane toll roads all the way south to Mazatlán.

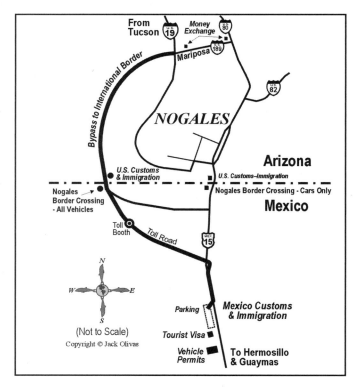

COLUMBIA, NUEVO LEON, MEXICO (LAREDO TEXAS AREA)

To avoid the extreme congestion that is always present at Laredo, we use the Columbia border as our preferred RV entrance and exit point near San Antonio, Texas. It's an easy route through north central Mexico through Guadalajara and on to the western coast as well as other points south and east within Mexico.

Columbia has no actual U.S. counterpart city It is located northwest of Laredo, Texas with a convenient, inexpensive toll road connecting it to Hwy 35 from San Antonio. You do not have to go anywhere near the city of Laredo and there is a currently free section of nice two lane road that connects it to Hwy 85 south towards Monterrey and keeps you out of Nuevo Laredo on the Mexican side. The crossing is small and quiet with a large, easy access Pemex just past the border.

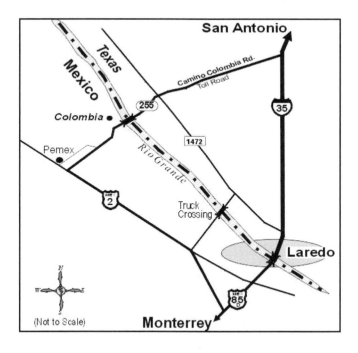

El Paso, Texas, At Ciudad Juárez, Chihuahua, Mexico

To enter central Mexico this is the best and most logical border crossing. El Paso provides several points where you can physically cross, but all routes end up about 20 miles south of Ciudad Juárez where you prepare all required entry paperwork.

For RVs, we prefer a route on the eastern outskirts of El Paso. It avoids congestion in the city of El Paso as well as Ciudad Juárez. From Interstate 10 on the east side of El Paso, go south on Avenue of the Americas. Follow the signs for the "auto" crossing at the Zaragoza International bridge. Once across the border follow the signs for Chihuahua to the KM 30 Checkpoint and Customs (*Aduana*) station. Just before the buildings, turn right and go around back to a large parking lot. An attendant at the entrance may charge a parking fee.

As you enter the building, go directly to the left to the *Migración* window to secure your Tourist Visa permits. Then take those along with all your other documents to the copy window. It is usually easier to just hand over all your original papers. Since procedures change with whomever is on duty at the time, let the official sort out what he or she needs. Copies cost 25 cents each so be sure to have quarters or small bills available. No change is made. After receiving your copies, proceed back toward the entrance and the vehicle-permit (*Banjercito*) windows. Here your vehicle permits will be issued.

After receiving all your documents, drive back around to the the front of the building for your possible Customs inspection. Then you're off to Chihuahua on good, four-lane divided toll highway.

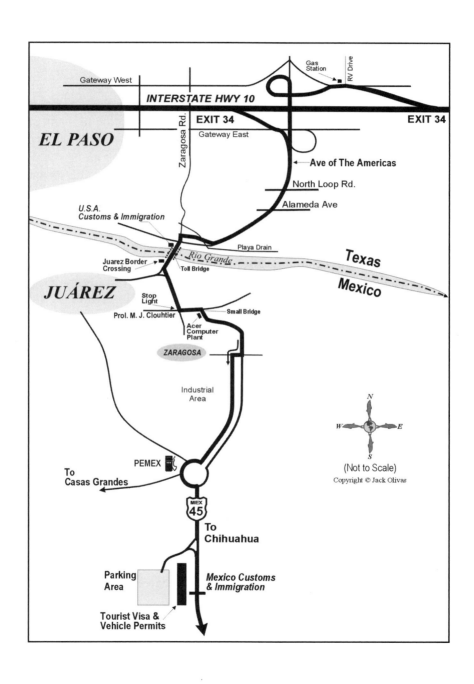

PHARR, TEXAS, AT REYNOSA, TAMAULIPAS, MEXICO

To travel south along the east coast of Mexico, the easiest entry point for RVs is across the Pharr bridge near McAllen, Texas. The Hidalgo crossing into Reynosa can be very confusing and busy and you must go through the congested city once across the border. It is not recommended.

From Highway 83, take Highway 281 south and follow the signs across the Pharr toll bridge to the Mexico border station. Stay in the far right auto lanes as you cross the border. Be careful not to enter the commercial truck lanes just after the bridge. Parking is limited here; just stop along the road near the buildings. A dirt parking lot is located to the left on the southern end of the area. However, it may have a treacherous entry driveway so use caution if you choose to park there.

A cursory vehicle inspection will possibly be performed when you arrive at the border. The first building after crossing is where you receive your Tourist Visa documents. After securing the Visa, take it to the building at the south end, and officials there will prepare the vehicle permits. Another twelve to twenty miles farther south, depending on the route you have chosen, are the Customs (*Aduana*) stations where you may be asked to show all the documents and your vehicles may be inspected again.

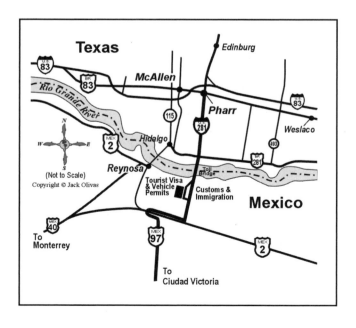

CHAPTER 4: ITINERARIES

Three main routes take travelers into mainland Mexico. Baja California has only one major paved highway so the choice there is simple. A general routing map and chart follows for each of the four itineraries. We have chosen to list the cities in a direct course from north to south within the country. You might choose to take other paths but those listed are the most popular and well traveled ones. The suggested destination cities are safe one-day drives apart, and have facilities for camping. Many also provide sightseeing opportunities.

We suggest you also purchase the book, *Travelers Guide to Mexican Camping,* by Mike & Terri Church. It contains very specific information on how to locate RV parks and assess their suitability for your needs. They also have a website that provides relatively current updates on any campground changes: http://www.rollinghomes.com/.

Mileages will vary slightly depending on whether you travel toll or free roads. The charts reflect toll-road mileages where applicable and those in parentheses are from the border to the first campground. Daily travel times are based on toll road usage.

Tolls are charged according to the vehicle type and size, so they vary. Over the past year the Mexican government has standardized how tolls are levied for RVs. Class "A" RVs are typically charged the *autobus* rate and if towing a vehicle, then the standard vehicle rate is added.

You have the option of taking a free or *libre* road between most of the selected cities. The majority of the time either option is an acceptable route and should allow you to arrive at each location safely before dark. *Libre* roads will take you through populated areas and have considerably more traffic, especially trucks, than the *cuota* (toll) roads. If time is not a consideration for a daily drive, the free route will generally afford you better scenery and a "taste of Mexico." However, we believe that toll roads are the most suitable and the most secure routes through the very mountainous regions.

Toll roads are normally divided, four-lane highways with less traffic, fewer trucks, straighter stretches, and more manageable grades through the mountains. But do not assume that you are paying for the privilege of driving on the toll road that it will have a better surface than the free one. We have specified sections where the toll road section is the safest route for RVs due to either the width of the free road, steep windy grades or both conditions. Those free road sections take considerably longer to navigate safely and we personally consider the toll worth the cost.

Our maps delineate the most direct course to maneuver a large RV through or around the more difficult destination-cities. Maps are also included for large cities you must pass through along the suggested route. A road that is designated on the map or road sign as a *periférico* is typically a direct through road or a ring road designed to keep heavy vehicle traffic from the city center. These are normally the preferred route for large vehicles.

You might see signs that direct trucks to take a specific route such as *"Ruta Camiónes"* or *"Tránsito Pesado."* These routes will take you on streets that can handle large heavy vehicles and away from the narrow downtown streets. In many small towns and villages, the main highway unavoidably leads you through the town center. Just proceed slowly and carefully while you enjoy the scenery, curious stares, and welcome waves from the village residents.

Several cities are especially difficult to maneuver in. A few places even make it illegal or impossible to drive through in an RV. Check the information on each city map for details. These maps provide general directions; they do not show fine details about intersections or off ramps. They should, however, still safely guide you. Highway signs often indicate city destinations well beyond the next geographical one. Study the maps ahead of time to familiarize yourself with place names along your proposed route and keep a list handy for the navigator to assist. Signage in general is pretty poor throughout most of Mexico. Even when properly signed, they are often located in awkward or barely visible locations.

Fuel stations and campgrounds depicted on the maps are for landmark purposes only and do not denote all available or suitable stations or campgrounds. Nor are they necessarily recommended by the author.

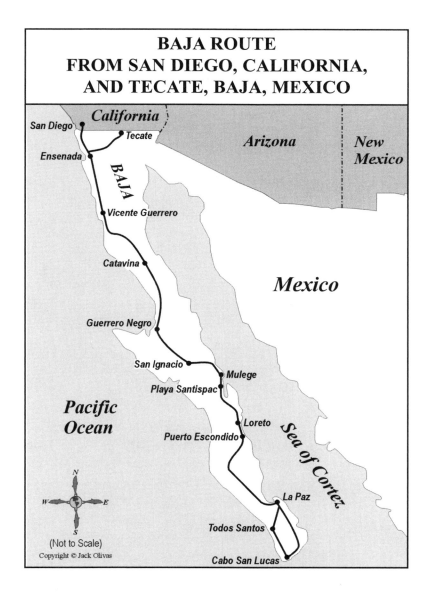

**BAJA ROUTE
FROM SAN DIEGO, CALIFORNIA,
AND TECATE, BAJA, MEXICO**

BAJA ROUTE SOUTH	MILES	HOURS
SAN DIEGO TO ENSENADA*	(72)	1:30
TECATE TO ENSENADA	(74)	2:00
ENSENADA TO VICENTE GUERRERO	109	3:00
VICENTE GUERRERO TO CATAVIÑA	129	4:00
CATAVIÑA TO GUERRERO NEGRO	146	5:00
GUERRERO NEGRO TO SAN IGNACIO	96	2:00
SAN IGNACIO TO MULEGÉ	87	2:00
MULEGÉ TO BAHÍA CONCEPTIÓN	13	0:20
BAHÍA CONCEPTIÓN TO PUERTO ESCONIDO	89	2:00
PUERTO ESCONDIDO TO LA PAZ	209	7:00
LA PAZ TO CABO SAN LUCAS	135	3:15
CABO SAN LUCAS TO TODOS SANTOS	50	1:00
TODOS SANTOS TO LA PAZ	60	1:15

ENSENADA is the first major city south of Tijuana. The traffic is not exceptionally heavy, and it is relatively easy to maneuver on the highway along the waterfront. Through roads are mostly divided with four lanes. Just observe all traffic signs and signals as you traverse the route south along the coast and out of the city. This is a destination city for cruise ships from California and is a nice town for sightseeing, shopping, and dining. There are also several RV parks in the area.

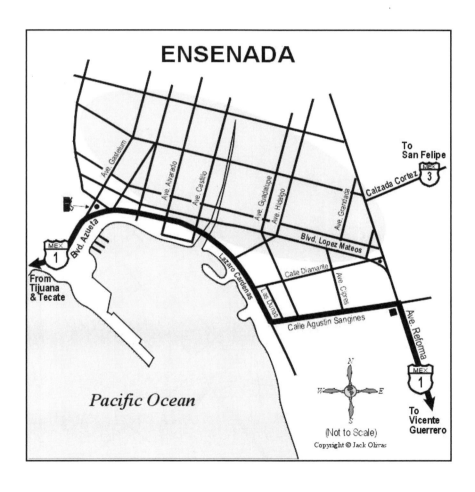

LA PAZ is the capital and Baja's largest city. You enter the city from the southwest end of the peninsula on Highway 1. The campgrounds and vehicle-ferry dock are easily accessible from the coastal road north (Highway 11.) Traffic in the downtown area is heavy and many narrow one-way streets can waylay you. It is not recommended to drive in the commercial area with large vehicles.

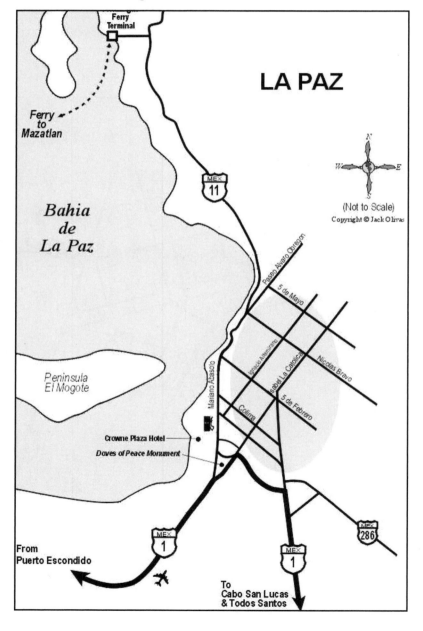

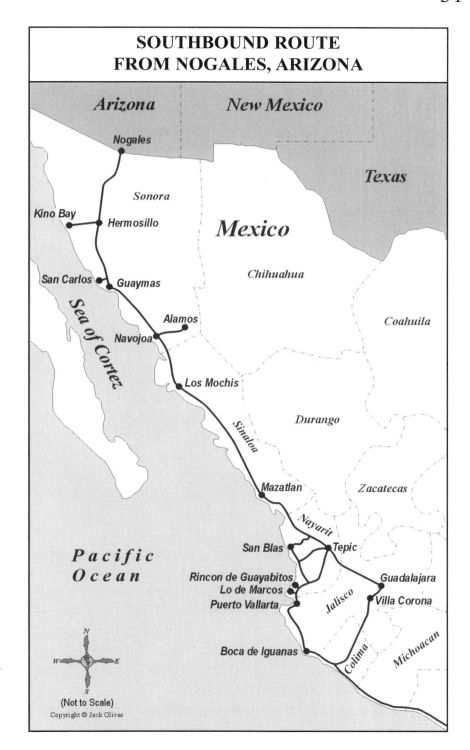

SOUTHBOUND ROUTE
FROM NOGALES, ARIZONA

WEST COAST ROUTE SOUTH	MILES	HOURS
NOGALES TO KINO BAY*	(252)	7:30
KINO BAY TO SAN CARLOS	165	3:00
SAN CARLOS TO GUAYMAS	15	0:30
GUAYMAS TO ALAMOS	157	5:40
ALAMOS TO LOS MOCHIS	133	3:30
LOS MOCHIS TO MAZATLÁN **	260	6:30
MAZATLÁN TO SAN BLAS	186	6:00
SAN BLAS TO RINCÓN DE GUAYABITOS	45	1:30
RINCÓN DE GUAYABITOS TO PUERTO VALLARTA	45	1:30
PUERTO VALLARTA TO BOCA DE IGUANAS	130	6:00
BOCA DE IGUANAS TO VILLA CORONA	211	8:00
VILLA CORONA TO GUADALAJARA	24	1:00
GUADALAJARA TO TEPIC **	149	3:30

* Toll road is the only route available.
** Toll road is the safest & most expeditious option in an RV.

HERMOSILLO will be the first major city you encounter after leaving Nogales southbound on this west coast route. You have two options for bypassing the city. If traveling on south, the eastern route is the most direct and well signed. If going to Kino Bay, turn right just after the toll booth at kilometer marker 16 and follow the signs for "Bahía Kino." Traffic is not too heavy on either route and both have adequate directional signage.

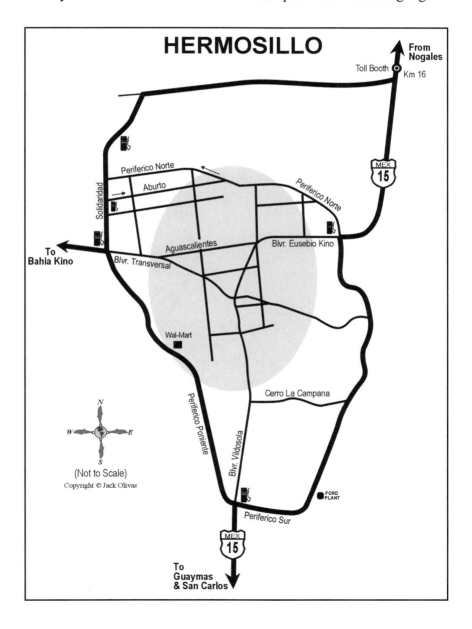

MAZATLÁN is a popular tourist destination city. Since many RVers winter there, you will find numerous campgrounds available along the coast. Highway 15 skirts the eastern side of the city and the coastal road is best accessible from the north via El Habal-Cerritos, or from the central access roads, Carretera International to Calz. Rafael Buelna. Traffic is heavy but manageable along both routes, even in big rigs. The vehicle ferry arrives from and departs here for La Paz, Baja.

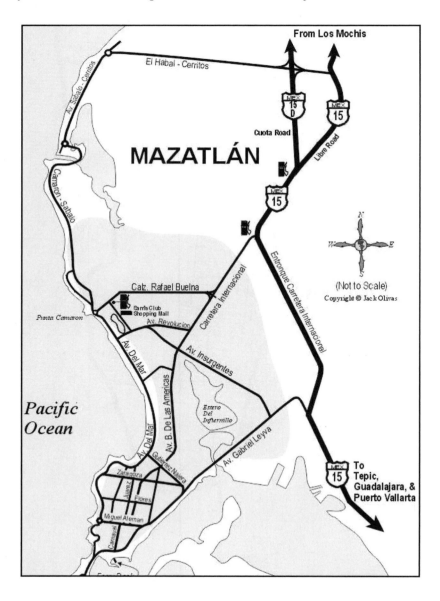

PUERTO VALLARTA is another popular RV destination, especially in winter. You will see small villages with many RV parks from about fifty miles north all the way to the city. Downtown is restricted for large vehicle traffic so be sure not to miss the bypass road on the eastern side of the city. This leads you through two tunnels and around the narrow, one-way streets. Driving south, the turn onto this bypass is a left near the Fiesta Americana Hotel. The sign says "Barra de Navidad." Driving north, it is a right turn just a short distance past the *Pemex* fuel station onto Ave. Basilio Badillo. The sign at this junction says "Tepic."

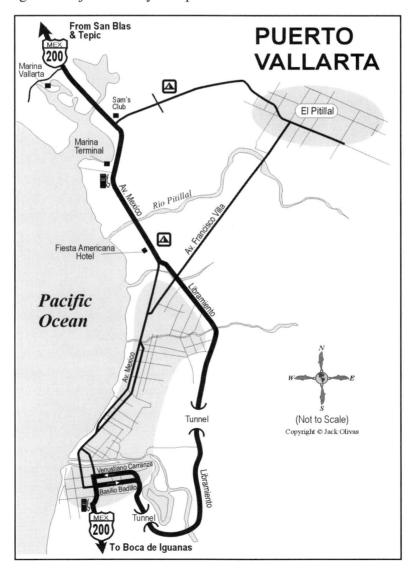

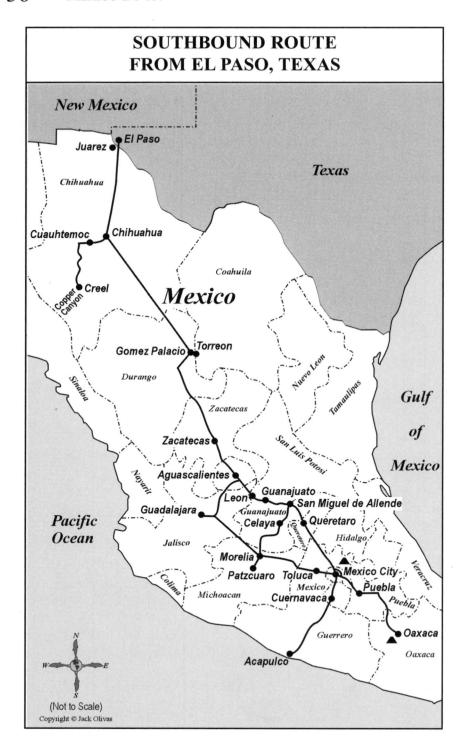

SOUTHBOUND ROUTE
FROM EL PASO, TEXAS

New Mexico

El Paso

Juarez

Chihuahua

Texas

Cuauhtemoc

Chihuahua

Coahuila

Copper Canyon Creel

Mexico

Gomez Palacio Torreon

Durango

Nuevo Leon

Sinaloa

Zacatecas

Tamaulipas

Zacatecas

San Luis Potosi

Gulf

of

Aguascalientes

Mexico

Nayarit

Leon Guanajuato

Guadalajara San Miguel de Allende

Guanajuato Queretaro

Pacific Ocean

Celaya *Queretaro*

Hidalgo

Jalisco

Morelia

Mexico City

Veracruz

Patzcuaro Toluca

Puebla

Colima

Cuernavaca *Mexico*

Puebla

Michoacan

Puebla

Guerrero

Oaxaca

Acapulco

Oaxaca

N
W E
S

(Not to Scale)
Copyright © Jack Olivas

CENTRAL ROUTE SOUTH	MILES	HOURS
EL PASO TO CHIHUAHUA*	(237)	5:30
CHIHUAHUA TO CUAUHTÉMOC*	65	1:30
CUAUHTÉMOC TO CREEL	103	3:30
CHIHUAHUA TO GÓMEZ PALACIO	290	6:00
GÓMEZ PALACIO TO ZACATECAS	230	6:30
ZACATECAS TO GUADALAJARA **	255	7:30
ZACATECAS TO GUANAJUATO	197	5:00
GUANAJUATO TO SAN MIGUEL DE ALLENDE	47	1:30
SAN MIGUEL TO MEXICO CITY **	141	5:30
SAN MIGUEL TO MORELIA	120	4:00
MORELIA TO PATZCUARO	30	1:00
MORELIA TO MEXICO CITY **	210	6:30
MEXICO CITY TO PUEBLA **	114	4:30
PUEBLA TO OAXACA **	224	6:00
MEXICO CITY TO CUERNAVACA **	83	3:00
CUERNAVACA TO ACAPULCO **	200	5:30

* Toll road is the only route available.
** Toll road is the safest & most expeditious option in an RV.

CHIHUAHUA city is simple to negotiate around so long as you stay on one of the outside *periférico* ring roads as shown on the map. Entering the city from the north, you can avoid one toll by taking the two-lane *libre* bypass (Mexico Highway 45) for a few miles. Though narrow, it is an otherwise good road and rejoins the toll road beyond the last toll booth. As you approach the city, traffic moves very quickly and can be heavy at peak times. As in most large Mexican cities you should avoid the downtown area except in your smaller tow vehicle. The inner *periférico* roadway was once the city bypass road, but is now just part of the main city street system. It should be avoided in your rig. You can easily reach the Chihuahua KOA without entering the main city area.

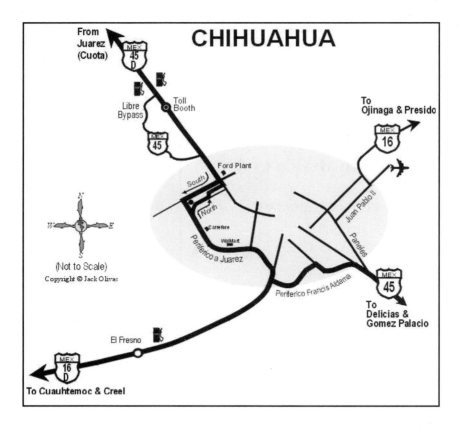

GOMÉZ PALACIO and **TORREÓN** are two large, busy cities divided by the state line but little else. This is a necessary overnight stop because of the distance between Chihuahua and Zacatecas. There are currently no campground facilities in the area so we ask permission and stay at the large Pemex located just north of Goméz Palacio.

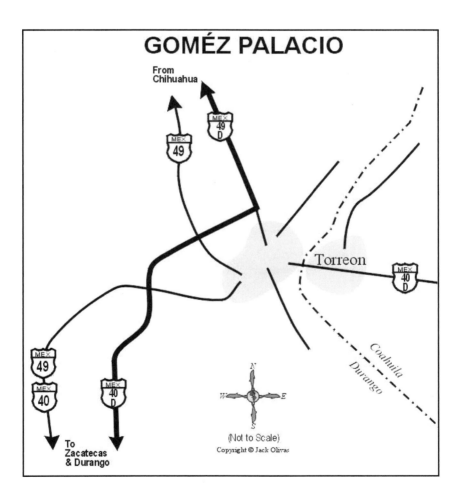

ZACATECAS's downtown area should be avoided in large RVs. Streets are narrow and winding. Highway 49 bypasses the entire city area; the two-lane truck bypass is also a good route. Highway 49 keeps you out of the older portion of the city. It has moderate traffic and several traffic lights but should present few problems for travelers.

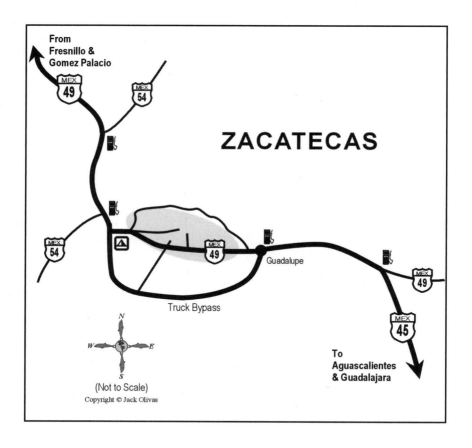

AGUASCALIENTES is another major city you must circumnavigate in order to head to points south. We suggest the eastern bypass route. As you approach from the north, watch carefully for and make a left turn onto the street, 3er Anillo. Signage is not prominent. Stay on this road as it becomes Blvr. Siglo XXI, a four-lane divided roadway. You'll travel through about a dozen stop lights until you come to Highway 45 south of the city.

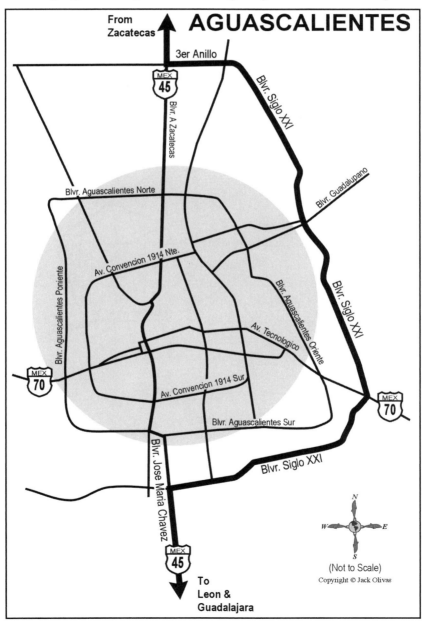

GUADALAJARA will likely be stressful the first time you drive through it. While the *periférico* roads are several lanes wide, traffic can be heavy. RVs must remain in the far right lanes on the Anillo Periférico, and failure to do so can result in a traffic citation. Intersections and exits generally have good signage, but you should carefully study your route before entering the city. Getting lost in Guadalajara, especially in an RV, can be an unsettling experience.

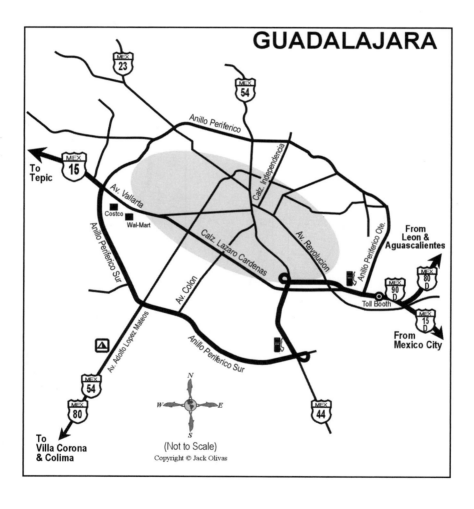

LEÓN is a major city which you will have to pass through or around as you head to central Mexico.The easiest route is on the *cuota* road, Highway 45D. This takes you directly around the city on the west side, traffic moves smoothly, and it is well signed. If you choose to enter from the *libre* road, there is a bypass around the eastern side of the city, Libramiento Jose Maria Morelos. Traffic on this bypass is manageable, but signage leading to it is poor. If you miss the turn to the bypass you may end up downtown in a very large, busy city. Be sure to study your maps carefully before entering.

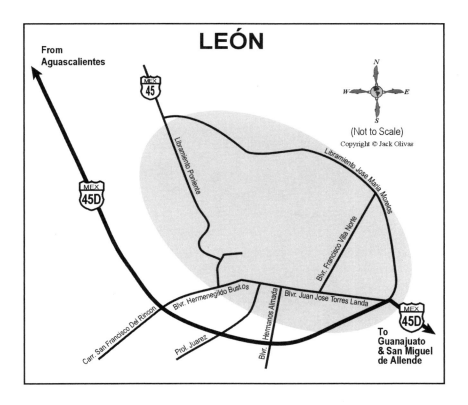

GUANAJUATO is one city where you definitely do not want to drive downtown with your RV. Much of the city area has narrow, one-way streets and an underground tunnel roadway system that is impossible to negotiate with a large vehicle. Even in your tow vehicle you may find driving in this city overwhelming and confusing. Tourist maps are readily available and plenty of licensed guides at the city entrance will show you around for a fee. A ring road (Carretera Panoramica) circles the entire area high along the hillsides, offering extraordinary views. Take that drive only in a smaller tow vehicle. Also avoid Highway 110 (*libre*) along the west side of the city area. It is tricky to get to if you don't know it and ascends a long, steep, winding hill to exit that direction. It is not recommended for most RVs. Mexico Highway 110D (*cuota*) is fine and bypasses the entire city.

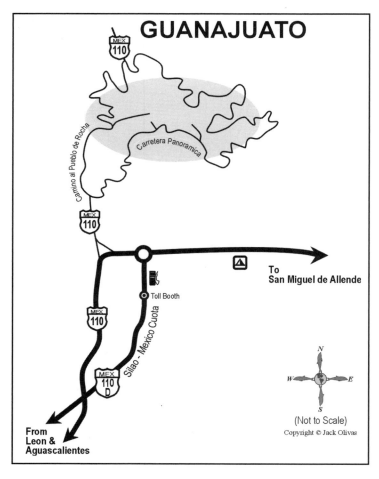

SAN MIGUEL de ALLENDE is another city where the downtown area is not negotiable in your RV. The cobblestone streets are narrow, and turns are very tight with buildings right up to the corners. Do not venture into the city area with your RV.

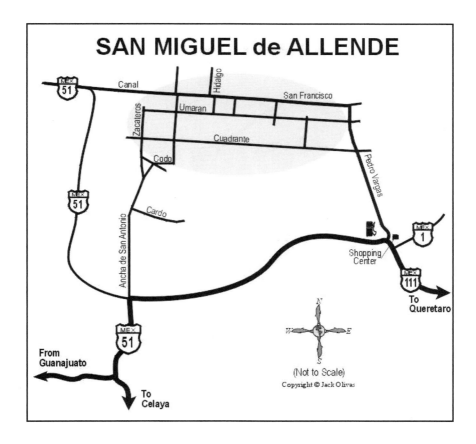

QUERÉTARO may be totally avoided by choosing to travel the *cuota* route to Mexico City. From San Miguel de Allende, Highway 111 intersects Highway 57D and completely bypasses the area. The *libre* road, Highway 57, circles around the western and south sides of the city. This road has traffic but is not particularly difficult. You just follow the signs for Mexico City on the *Autopista* and it will intersect with Highway 57D.

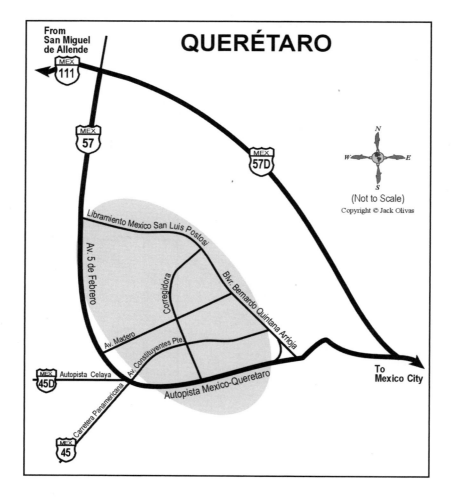

CELAYA is unavoidable if you choose to travel on Highway 51 between San Miguel de Allende and Morelia. It is possible to drive straight through town, but streets are narrow and traffic is nerve wracking. Both sides of the city have bypass roads; however, the eastern one is poorly marked and confusing. The western bypass route is easy to locate. Traveling south, you turn right at the *glorieta* intersection just after the junction of Highway 45D on the north side of the city. After that, the next turn is at a "T" intersection, where you turn left and follow the signs to your chosen destination, Morelia.

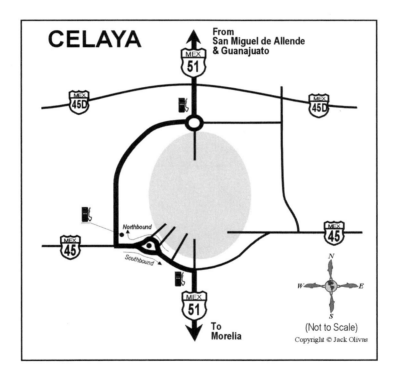

MORELIA has a *periférico* that circles the city and is accessible from all highways that enter the area. Most of it is a four-lane, divided roadway and well signed. Traffic signals and moderately heavy traffic at peak hours will slow you down, but the road can be easily traversed. If entering from the north, the western loop road is recommended to reach Patzcuaro or other towns located to the south. Avoid the downtown area with large vehicles. Streets are narrow, turns are tight.

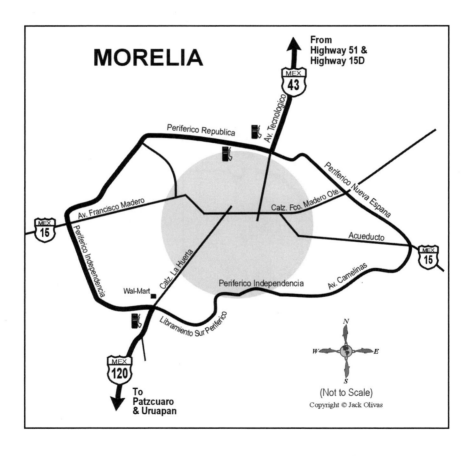

TOLUCA poses problems. Unfortunately, you can do little to avoid it when trying to get to the areas around and beyond Mexico City. We have traveled the route indicated on the map many times without difficulty but it can be tricky as it is poorly signed. An ordinance forbids large vehicles downtown, and the traffic police can give a hard time to travelers who do not know about it. The local tourist bureau offers 24-hour free escort through the city.

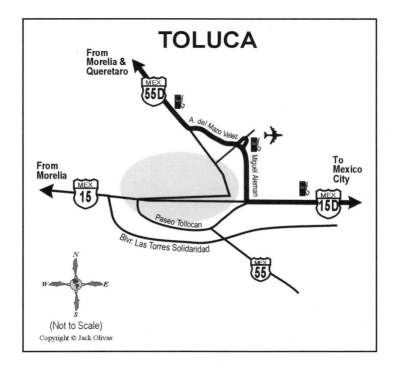

MEXICO CITY is difficult to negotiate in any vehicle and presents a unique challenge to the RVer. Unfortunately, because of its central location and importance as the nation's capital city, all roads lead there, and few suitable bypasses are available. Most other major cities in the country have *periférico* ring roads that funnel vehicles around them, but that is not the case here. The highlighted routes shown on the map are combinations of four-lane highways and city streets. Most are not very clearly marked. If you plan to move about in this city, the *Guía Roji* detailed city map is a necessity, as is advance planning.

Smog-abatement regulations complicate city travel. Travel restrictions are determined by the ending number on your license plate. This applies to the vehicle being driven. For a motorhome towing a car, use the motorhome license number. For a truck or car towing a trailer, it applies to the motorized vehicle, not the trailer. Vehicles are restricted from driving one day each week. The last number on your license plate determines the day that vehicle is not permitted. Look for signs on the outskirts of the city to learn which applies on the day you arrive. If you ignore the rule, you could be cited. Fines for citations on these restrictions run around $350 U.S. A safe bet is to always travel through or around the city on the weekend because the number-based rules do not apply on Saturday or Sunday. Sunday mornings are great for travel because traffic is generally lighter than on Saturdays or weekdays. Green Angel escorts can be hired for very nominal rates (usually under $20) to escort you around the city. With advance notice, they may also provide temporary permits that exclude your vehicle from the travel day restrictions. Contact information for the Green Angels can be found on page 158 of this guide. Pepe's RV park manager can also arrange this service for you.

As a destination city for sightseeing and tours, Mexico City has much to pique interest. One could easily spend a couple of weeks exploring the highlights of museums and architectural sites. We recommend that you do not explore on your own. A good base is Pepe's RV park, located on the northern edge of the city, easily accessible via Highway 57D from San Miguel de Allende and Querétaro. From there you can arrange tours of the city, to the canals of Xochimilco, or to the ruins of Teotihuacán.

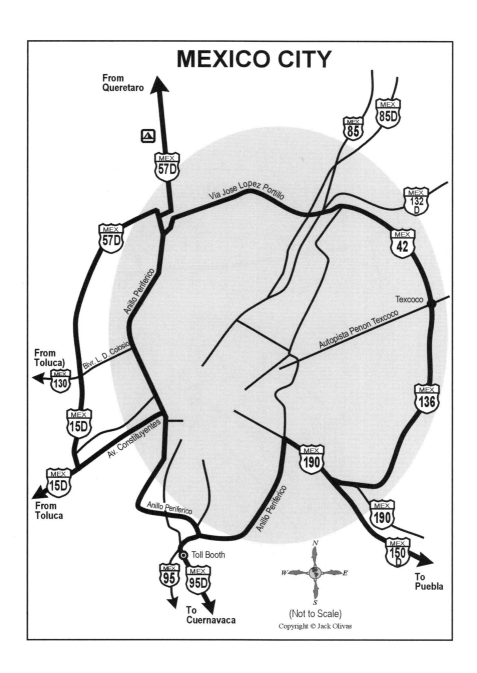

PUEBLA's roadway system makes it easy to bypass the metropolitan area. Highway 150D skirts the northern side of the city, and a *periférico* ring road on the western side leads to Cholula and the local campground, Las Americas Hotel and RV Park. The downtown area is bustling, and most of the streets are not suitable for big rigs. The smaller town of Cholula has very narrow, one-way streets so avoid that as well, except in smaller vehicles.

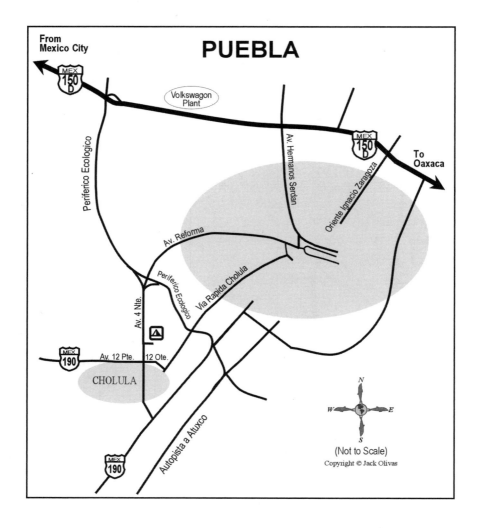

CUERNAVACA has winding, narrow, confusing roadways. Natural gorges created barriers for the city architects, and many roads seem to go around in circles to simply get to the other side of the street. Big rigs will have problems in the downtown area. If you stay out of the *centro* area and on the major highways with your RV, you will have little difficulty.

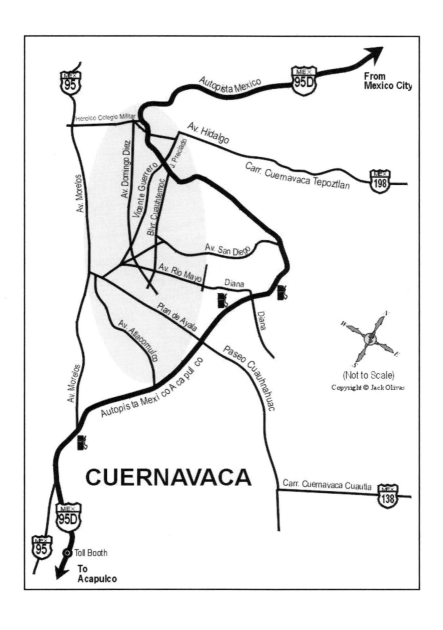

OAXACA traffic is heavy most of the time. So long as you remain on Highway 190 or the *periférico* road with your RV, you'll be fine. The city center has too many tight turns and narrow, one-way streets to attempt in a large vehicle. It is recommended that you use public transit or taxis in and out of the central area because parking is also very limited downtown. The city is surrounded with smaller towns and villages rich with wonderful artisan crafts. Plan to stay here at least a week for sufficient exploration.

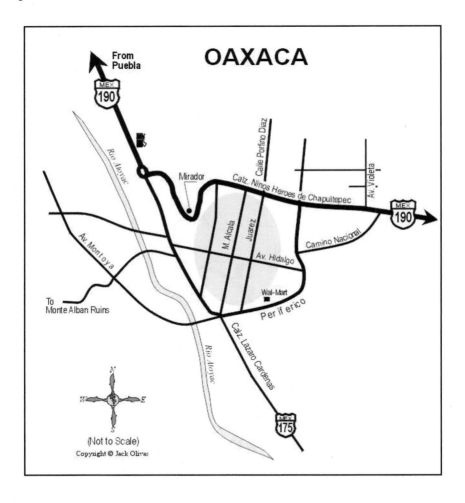

ACAPULCO is located on a large, crescent-shaped bay where the surrounding mountains lie almost on the shore. You must climb and wind around a hillside to enter the city. The views are spectacular. Fortunately, the two most popular campgrounds on the eastern side of the city are on the lower side of the hill and conveniently located, one off Highway 200 and the other just at the end of Highway 95D. A third campground located in the downtown area is usually booked with long term residents and is tricky to locate. The Acapulco Diamonte Trailer Park is easy to access where Highway 95D ends at the coast road. Its proximity to the city makes it a good stop for exploring. While the bay road in town is large enough for bigger rigs, it is not advisable due to the traffic, limited parking, and confusing signs.

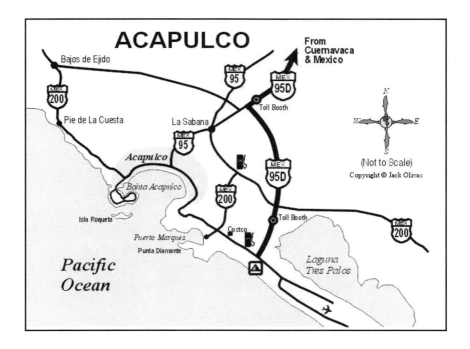

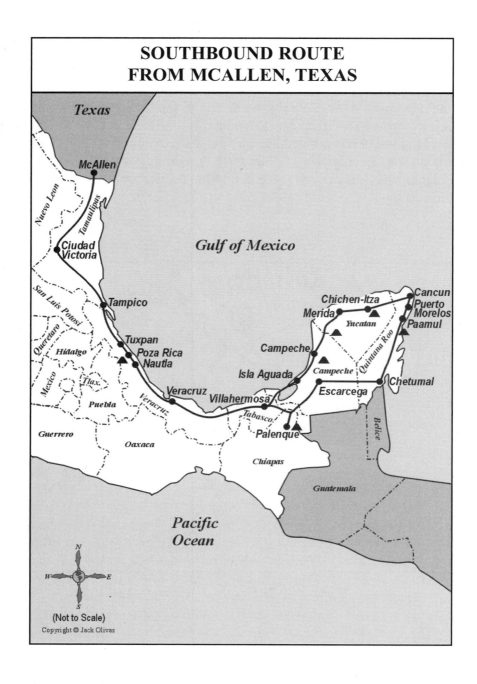

SOUTHBOUND ROUTE FROM MCALLEN, TEXAS

Texas

McAllen

Nuevo Leon

Tamaulipas

Ciudad Victoria

Gulf of Mexico

San Luis Potosi

Tampico

Chichen-Itza Cancun
Merida Puerto Morelos
Yucatan Paamul

Queretaro

Hidalgo Tuxpan
Poza Rica
Nautla

Campeche Quintana Roo

Mexico

Tlax. Campeche

Puebla Veracruz Isla Aguada Campeche Chetumal

Veracruz Escarcega

Guerrero Villahermosa Belice

Oaxaca Tabasco

Palenque

Chiapas

Guatemala

Pacific Ocean

N
W — E
S

(Not to Scale)
Copyright © Jack Olivas

EAST COAST ROUTE SOUTH	MILES	HOURS
McAllen to Ciudad Victoria	(207)	6:00
Ciudad Victoria to Tampico	150	6:00
Tampico to Poza Rica	170	7:00
Poza Rica to Nautla	51	1:30
Nautla to Veracruz	110	4:30
Veracruz to Villahermosa	307	8:00
Villahermosa to Isla Aguada	138	6:30
Villahermosa to Palenque	95	2:30
Isla Aguada to Campeche	97	2:30
Campeche to Mérida	115	4:00
Mérida to Chichén-Itza	79	2:30
Chichén-Itza to Cancun	130	4:00
Cancun to Paamul	56	1:30
Paamul to Chetumal	185	5:00

CIUDAD VICTORIA is the first recommended stopover when headed south along the eastern side of Mexico. It is an easy drive from the border and the recommended campground, Victoria RV Park, is conveniently located just as you enter the city limits. The *periférico* and bypass roads are the routes you should use to avoid the busy city center in a large RV.

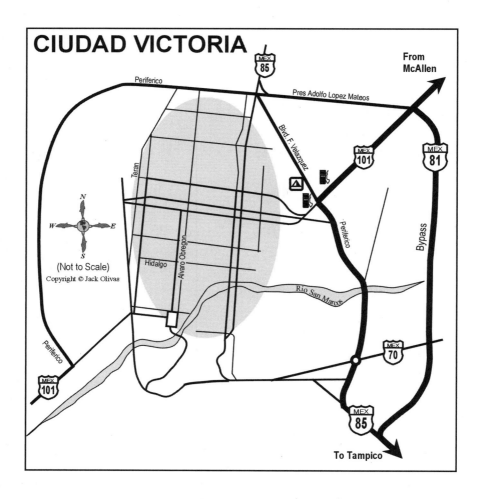

TAMPICO is approximately 150 miles south of Ciudad Victoria. The city offers little in the way of historical significance or sightseeing but it's a good stopover with plenty of places to shop for essentials. Major vehicle repair facilities can be found here too. Traffic is heavy and traffic laws are strictly monitored by the local *policía* so be sure to observe the signal lights and signs. The Maxilibramiento bypass is a toll road that takes you around the city area but it is a minimal cost and well worth it as the route through town can be difficult to navigate in a large rig.

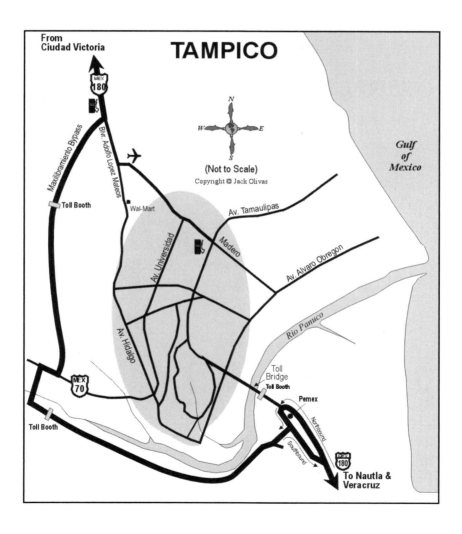

VERACRUZ presents a challenge to the navigator as well as the driver. Roads are wide enough, but the traffic can be heavy and street signs are not always easy to see. It is best to take the Hwy 180 bypass and enter the city from the south. Follow the signs to the Aeropuerto, *Playas* (beaches), or the town of Boca. If you get confused, just ask for directions to Sam's Club or Wal-Mart and you'll get to the coast road!

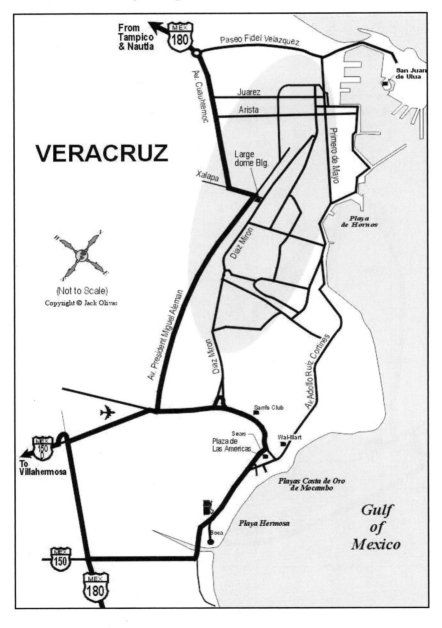

VILLAHERMOSA should present few problems since the main road through the city has been modernized. There are lateral roads for local traffic and raised bridge overpasses that limit the number of busy intersections you have to cross. Traffic does move rapidly, so use caution as in all city areas. Watch carefully for the signs that indicate turns for your exit highway as you approach the east side of town. Be sure to visit the La Venta Archaeological Park and Museum for a few hours.

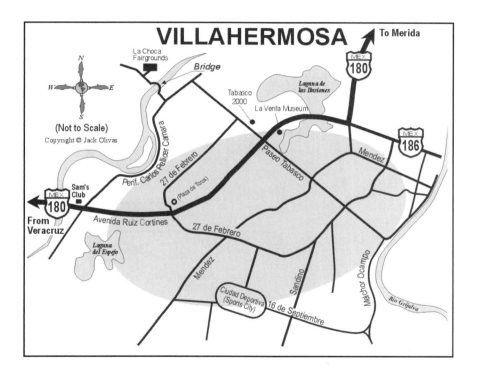

MÉRIDA is a very large, modern city. A *periférico* circles the entire population area. Access to the campground and major shopping centers is simple from this ring road. You'll find a major shopping center, a Carrefour grocery store, and Sam's Club. You can safely drive and have adequate rig parking to those points but do not venture beyond and into the *centro* area of town with a large vehicle.

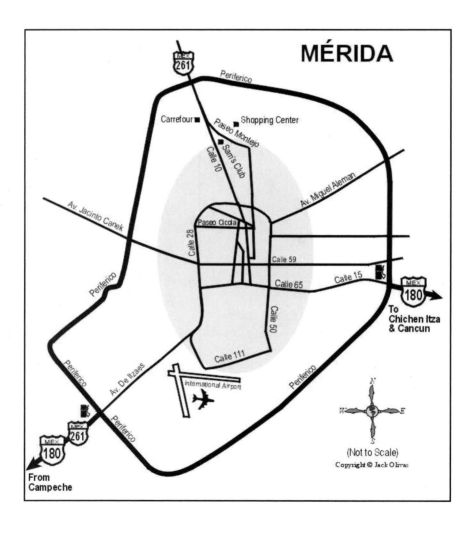

CHAPTER 5: INSPECTIONS

During the course of your trip through Mexico, you may encounter at least four types of inspections. These are required and customary for Mexican citizens as well as foreign travelers. Do not be alarmed, follow instructions, answer questions, and allow inspectors on board for examination if requested. The more open and relaxed you are, the quicker you will be on your way. We have found that they often board just out of curiosity to see the inside of the rig. Never offer any of the inspection agents money, refreshments, or any items from your vehicle. We have heard unconfirmed stories of people being asked for these things. It has never been our experience, but we are not so naïve to say unscrupulous officials do not exist.

Do not be afraid to firmly and politely refuse if asked for gifts or money. Request a superior if the inspector persists. Ask for name, title, and rank. Write it down and send a letter to the Mexico Government Tourism Office (*SECTUR*) with the details. The government does not want foreign tourists harassed by anyone. Contact info is located on page 163.

CUSTOMS INSPECTION

Upon first entering the country, you will likely have a cursory inspection at the entry point where you prepare the Vehicle Permit forms and Temporary Visa documents. Since you are allowed to drive between U.S. & Mexican border cities and several miles beyond without any special permits, you will not encounter the Customs inspection station until approximately twelve to twenty miles south of your border entry point.

You will be required to produce all entry documents and will likely be boarded by officials for a brief look inside your RV. Customary household items are permitted without question. Occasionally, computer equipment is questioned but not often. These officials are primarily watching for the importation of goods for sale without proper documentation and payment of import taxes.

At the Customs station you will likely be asked for your Vehicle Permit and Temporary Visa documents. They may compare the numbers on your paperwork with your vehicle stickers. Another cursory check of your vehicle interior will be performed. Most often the agent simply stands in the doorway and asks where you are going. Answer promptly and honestly, and you will be allowed to continue on your way.

MILITARY INSPECTIONS (PUESTO DE CONTROL MILITAR)

These are the most common inspections you will encounter on your drive through interior Mexico. Some of these checkpoints are permanent installations. You will also encounter several transient patrol sites. Some even move from place to place in a specified geographic region on a daily basis. These checkpoints are more frequent as you near the U.S. border on the northbound side of the highway.

Military checkpoints are staffed by personnel in green Mexican Army fatigue uniforms and armed with weapons. Do not be alarmed! They are merely doing their required government duty and are not a threat to your safety. On the contrary, their presence makes travel on their roadways safer for everyone. Soldiers will be stationed at either end of the check-point in temporary bunkers. Nearby will be a wicked-looking device that can be quickly pulled across the roadway to puncture the tires of any vehicle whose driver tries to escape examination when instructed to stop.

Occasionally you will be waved through without question. Most times you will be routed to the side or stopped on the roadway and asked a few questions. Speaking and understanding Spanish is not required, but does help. The most common questions are "*¿a dónde viene?*"(where are you coming or traveling from?) and "*¿a dónde van?*" (where are you going or traveling to?) If you do not understand Spanish, one or two of the soldiers can usually speak some English and will attempt to communicate. If you continue to stare blankly without comprehension, they often just give up and send you on your way.

When the soldiers want to enter for inspection, they will politely ask or point to the door for permission to enter. We open the door and allow them inside. Our experience is that they do a quick visual once-over and then exit, sending you on your way. One of us always goes along with the soldier, and this has never been a problem. Since I speak and understand Spanish fairly well, I usually attempt friendly conversation. The soldiers are curious about the RV lifestyle and amazed at what they find inside in the way of comforts. If you do not speak or understand Spanish, a friendly smile is always helpful.

At one checkpoint, we were busy talking to the soldier doing the interior survey. He exited, said goodbye, and waved us on. As we began to drive away, we heard a clamor on the roof and laughing and yelling from the outside. One of the soldiers had decided to climb on the roof to inspect our storage pods, and neither we nor the officer inside were aware of it. This resulted in a very embarrassed soldier as he descended the ladder to the laughter of his colleagues. We had quite a good laugh as well. In our vast experience going through these military examinations, they have never caused any more than a short delay in our travel day.

PGR AND PGF INSPECTIONS
These checkpoints are less common than the military stops but occasionally are at the same locations and may be staffed by military personnel as well. Most often the officers will wear black shirts or uniforms carrying the initials PGR (*Procuraduría General de República*) or PGF (*Procuraduría General de Federal*). They might also have drug-and-firearm sniffing dogs.

Guns are illegal in Mexico. You should not attempt to take guns or ammunition into the country. Under strict guidelines you can import a sport rifle or shotgun for hunting purposes with a special permit. Contact the Mexican Customs authority for a permit before entering the country.

MIGRATORY INSPECTION POINTS
You may also encounter inspection stops designed to prevent illegal migration from countries south of Mexico. They are most common in southern Mexico near the state borders. The routine is to check Vehicle Permits and Tourist Visa paperwork. You should always keep those documents readily accessible in your rig as you travel.

AGRICULTURAL INSPECTION STATIONS

Agricultural products are one of the primary exports both domestically and internationally for some states in Mexico. Procedures have been established to prevent movement of certain devastating pests as well as diseases between Mexican states. You will encounter these stations mostly at the state borders. The most stringent mainland ones are located between the borders of the states of Sonora and Sinaloa in the north. Yucatan, Campeche, and Quintana Roo in the south monitor the transport of pork, chicken, and all their byproducts between these states on the Yucatan peninsula. Signs are posted with current restrictions at these locations in both English and Spanish. Even if no signs are posted, you should assume restrictions apply to the transport of fruits, especially citrus.

Baja has less agricultural checkpoints than the mainland. Officials there are primarily concerned with fruits and vegetables, especially citrus and potatoes. On a couple of occasions we have had the undercarriage and tires of our vehicles sprayed with pesticide at these checkpoints.

UNITED STATES CUSTOMS

RVs are routinely sent to secondary inspection for agriculture checks when re-entering the United States. Horticultural, as well as other types of restrictions, apply when you return through U.S. borders. Fruits, plants, vegetables, uncooked pork or chicken, and eggs cannot be taken from Mexico to the United States. Clean out your refrigerator and food storage bins before arriving at the U.S. border.

When returning to the United States you are required to declare all items purchased in Mexico. Each person is allowed $400 in goods without paying a duty. Normally, an oral declaration is sufficient if you have less than the permitted value per person. As you travel, keep receipts and a list of the things you buy and make it available, if requested, when you return.

You may not return to the United States with more than one liter per person of alcohol purchased in Mexico. Any alcoholic items you take into the country will not be subject to this limitation if you can produce original receipts proving they were purchased outside of Mexico. For more information visit the U.S. Customs website:
http://www.customs.ustreas.gov/xp/cgov/home.xml

CHAPTER 6: MONEY MATTERS

 How should you handle access to spending money while traveling in Mexico? The first and simplest way, of course, is to deal in cash, which has its advantages and disadvantages. Security is always an issue when carrying large quantities of cash in your RV. If you have a secure, hidden, and fireproof safe on board, you are set. However, obtaining large amounts of *pesos* in advance may prove difficult. Such an approach will also put you at a disadvantage in seeking the best exchange rate for your dollar.

BANKS

Banks are located in towns of nearly every size except the very small villages. They are generally open convenient hours six days a week. Teller service is often slow due to long lines. Also note that most locations only exchange foreign money to *pesos* in the morning. Some will only exchange for customers of the bank. The majority of larger grocery stores also have at least one bank on their premises. Foreign banks such as Lloyds and Scotiabank have branches in Mexico. Other common Mexican banking institutions you will see are *Bancomer*, *Banamex, Inverlat, BanCreer, Santander Serfin, BanNorte, BBV,* and *HSBC (formerly Bital)*.

 Twenty-four hour ATM machines (*Caja* or *Cajera Automática*) are conveniently located in most banks as well as in retail areas and grocery stores. ATM is the simplest way to exchange or access your money safely and at convenient hours. When you withdraw funds from your checking account with your ATM card, you get the international rate for the day of withdrawal, which will usually be the same or better than the local bank rate. The majority of ATM locations provide a secure cubicle accessed by swiping or inserting your card at the door entrance. They are simple to use and many allow you to obtain instructions in English.

Remember that you will receive Mexican *pesos* from most ATMs in Mexico. U.S. banks will charge your account a flat fee (usually about $5.00) for use of a non-affiliated branch ATM machine. Your home bank will also have a limit on daily withdrawals. Check with your bank before leaving home to determine maximum daily withdrawal limits, ATM usage charges, and international acceptance of your card. Some banks such as Bank of America have affiliate banks in Mexico where the ATM charges are waived if you use one of those affiliated ATM's.

You can also access funds from your credit card through these ATM machines. A personal identification number (PIN) is required as with an ATM card. The process is the same and you will receive the most favorable international rate for the date of withdrawal. Your bank will assess a cash-advance fee, usually 2 percent to 4 percent of the amount advanced and will charge you interest on this amount even if you pay your entire balance monthly. Maximum daily withdrawal rates may apply to this type of transaction also. Check with your bank before leaving home to determine fees and procedures.

Although convenient, this method can be costly in fees and interest. It may be more cost effective to purchase all that you can with your credit card directly and pay the full balance monthly to avoid extra fees and interest. Charging purchases at merchants guarantees the most favorable international *peso* rate and will not incur finance charges with most banks if the balance is paid on time each month. You can even arrange for your bank to deduct the full amount due monthly. If you use this method often, simply account for the charges as if you were writing a check so as not to exceed your checking account balance. This also eliminates the need to write checks for the bills. You will then have receipts for these purchases. Many retail merchants in the larger towns and cities as well as many grocery chain stores and restaurants will accept credit cards.

PERSONAL AND TRAVELERS CHECKS
Personal checks are almost never accepted anywhere in Mexico. Travelers checks are more difficult to cash, even at banks. The ones that do cash them require time-consuming paperwork and personal identification. In busier international tourist destinations such as Cancun, Mazatlán, and Puerto Vallarta, it is simpler to get them cashed but not always at the same favorable rate as cash exchanges.

MONEY EXCHANGES (*CASA DE CAMBIO*)

Exchanging foreign cash for *pesos* is simple at one of these locations. United States currency is always accepted and, in the larger cities, Canadian and other foreign currency can be exchanged. Some, but not most, will accept travelers checks. Look for the "*Venta*" rate. This is the rate that they "sell" *pesos* for the dollar. The "*Compra*" rate is the one that you would use if selling *pesos* back for dollars or other currency. Exchanges usually offer a slightly less favorable rate than the banks. Unless you are exchanging large amounts of cash, money exchanges are your best bet.

Always shop around before changing money at an exchange house. The most conveniently located money exchanges may charge a fee or pay at a lesser rate. You might receive more around the block. Consider and choose the most important value for yourself. For instance if exchanging $100 U.S. dollars for *pesos* at the rate of 9.5 you would receive $950 *pesos* and at 9.3 you would receive $930 *pesos*. That is a difference of roughly $2.10 U.S. per $100 exchanged. Deciding how much cash to exchange at what rate can be tedious, especially if the dollar is fluctuating a lot on a daily basis. During 2006, and into the first half 2007, the range was from 10 to 11 *pesos* to the U.S. dollar.

Mexican *pesos* are most commonly issued in the following denominations: 500, 200, 100, 50, and 20 *peso* notes, as well as 20, 10, 5, and 1 *peso* coins. You will also receive 50, 20 and 10 centavos coins. Ten centavos is worth roughly one penny in U.S. currency.

Mexico is a country without change! Keep your cash mostly in smaller bills and coins. We normally set aside our larger bills for use at fuel stations and toll booths. Don't expect to pay for a 20 *peso* item from a street vendor with a 200 *peso* note. They rarely have adequate change and this can be very frustrating to you as well as to them when attempting to make a purchase.

In the United States we are not accustomed to coins that are worth one or two dollars each. You'll be surprised at how much you are able to buy with a handful of what appears to be small change. This will not seem as foreign to the Canadian visitor.

We discipline ourselves to think only in *pesos* while in Mexico. Use the back of a business card to make yourself a quick exchange list to carry along or have a small portable calculator available. Then you can easily determine if the item you wish to purchase is a relatively good bargain by your home currency standards. Commercial retail outlets have set prices, but local markets and vendors will generally negotiate. If you like to haggle for sport, shopping in Mexico will be a rewarding experience.

Calculate the exchange rate for each denomination of coin or bill. Make one list for converting *pesos* to dollars and another to convert dollars to *pesos*. These cards will fit in your wallet or pocket and are easy to carry. See the examples below. For sample purposes, we used the exchange rate of 10.5 *pesos* to $1.00 U.S.

DOLLARS TO PESOS	PESOS TO DOLLARS
1 Dollars = $ 10.50 *P*	1 *Peso* = $.095
5 Dollars = $ 52.50 *P*	5 *Pesos* = $.476
10 Dollars = $ 105.00 *P*	10 *Pesos* = $.950
15 Dollars = $ 157.50 *P*	15 *Pesos* = $ 1.430
20 Dollars = $ 210.00 *P*	20 *Pesos* = $ 1.900
25 Dollars = $ 262.50 *P*	25 *Pesos* = $ 2.380
30 Dollars = $ 315.00 *P*	30 *Pesos* = $ 2.850
40 Dollars = $ 420.00 *P*	40 *Pesos* = $ 3.800
50 Dollars = $ 525.00 *P*	50 *Pesos* = $ 4.750
100 Dollars = $1050.00 *P*	100 *Pesos* = $ 9.500

CHAPTER 7: MECHANICAL PREPARATION AND ASSISTANCE

With proper advance preparation and a little luck you should be able to avoid having to avail yourself of mechanical or other repair assistance while on your trek through Mexico. We have learned, however, that one should always expect the unexpected and be prepared to react accordingly.

Before departing, you should have your RV and tow vehicle thoroughly inspected and serviced. Tires must be in good condition with adequate tread wear for the trip. Always carry spares. Tires are easily obtained for most vehicles in Mexico, but larger or odd sizes are difficult to locate outside of large cities.

Gasoline-powered vehicles should be tuned and spark plugs and wires replaced as needed. Alternators, water pumps, fuel injectors, or fuel pumps should also have a thorough inspection by a qualified, trusted mechanic and be replaced if necessary. Have the valves adjusted and transmission serviced. Make sure the radiator does not have leaks and is free of rust. Flush the cooling system if necessary and add antifreeze.

Have all filters (oil, air and fuel) replaced and carry a spare for each. Hoses, clamps, and belts should all be examined and replaced as necessary. It is a good idea to carry spares of these items no matter where you travel.

Good brakes are essential because much of Mexico is mountainous. If your vehicle has conventional brakes, be sure the shoes are adequate. For disc brake systems, check brake pads and rotors. Be sure that the calipers are in proper working condition. Those who are pulling travel-trailers or fifth-wheel trailers should also make sure that the brake controller and the trailer brakes are working correctly. Check exhaust brakes and service them if your vehicle is so equipped.

Be confident that your batteries, both engine and coach, are reliable. Check the water level and carry extra distilled water. Clean all terminals and replace battery cables if they are worn or severely corroded. Make certain the converter and/or inverter are functioning properly. The time will come when power is not adequate and you will need a good coach battery system.

Examine the wheel bearings and have them repacked if applicable. Have the drive shaft and universal joints inspected and serviced or replaced if worn. All joints should be lubricated, including the steering mechanism.

Scrutinize all springs, shocks, and air bags. You will be traveling on roads that occasionally test the limits of these components. It is highly recommended that all travel-trailers and fifth-wheel trailers carry spare springs, spring hangers and U-bolts. In our experience, broken springs are the No. 1 breakdown problem with this type of vehicle in Mexico.

GETTING REPAIRS

Larger cities and towns have automobile sales and service centers as in the United States and Canada. These include Ford, Chevrolet, Chrysler, Dodge, Volkswagen, and Honda, and Toyota. Many of these service centers can perform warranty work on qualified vehicles at no charge, as well

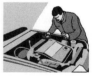

as repairs on those out of warranty. They carry supplies of factory parts on vehicles imported to Mexico and those built in Mexican factories.

Drivers of diesel-engine vehicles, such as Cummins, should have few problems locating parts within Mexico. These engines are used in trucks and buses and have repair and parts facilities strategically located throughout the country. However, owners of newer U.S.-manufactured diesel engines such as those used by Dodge, Ford and Chevrolet, may have to order parts from the United States. They could take considerable time (a week or more) to arrive.

Tire repair (*Llantera*) shops are frequent, but you may have to travel to a larger city to purchase a replacement tire. A used or retread tire will likely be available for emergency use at even the smallest facility.

Auto parts stores, called *Refaccionerías*, are also numerous and located in most towns and villages. The same applies to welders and general mechanics who can work on practically all types of engines. You will notice numerous signs along your route that read *"Taller Mecánico."* These indicate that a mechanic shop is located there. Types are specified by a designation such as *Eléctrico* for electrical, *Mofles* for mufflers, *Soladura* for welding, *Hojateria & Pintura* for paint and body repair, and *Gral.* or *General* for general mechanical repair.

Much of the population depends on buses for transportation, and goods are transported throughout the country by truck. As a result, it is generally easier to find mechanics and parts for RVs, because RVs, trucks, and buses share common parts and common types of failures.

You will be amazed at the efficiency and speed of repairs in Mexico, not to mention how economical they are. The majority of the time you can secure assistance without an appointment and without waiting. Arrangements can be made, often for no extra cost, to carry out necessary repairs in a campground. The campground manager or owner is frequently the best source of information and contacts for these services. Mexican mechanics are accustomed to improvising and even fabricating many of their own parts. They understand how to repair a variety of vehicle types and do an astonishing job of it. Expect to pay considerably less than you are used to for both parts and labor. Tips are greatly appreciated for a job well done.

Since we have escorted many groups into all parts of Mexico, we have had numerous experiences with a variety of mechanical needs. Brakes, water pumps, fuel pumps, fuel injectors, air bags, springs, and tire problems are the most numerous. In the majority of cases, the parts were replaced or repaired in less than a day. If the part can be repaired, rest assured you'll likely find someone resourceful enough to do so.

We have seen brakes, transmissions, and engines rebuilt on the roadside and even traveled along with friends in a fifth-wheel trailer who got replacement springs fabricated for their rig. This was done in a matter of hours for a fraction of the cost you would expect to pay. Body work and painting are also quite inexpensive, and minor body work may be done right at your campsite!

Fortunately, we have never personally been stranded or in need of any major repairs while in Mexico, but we have traveled with some who were not so lucky. The outcomes of those instances have all been positive. We once had fellow travelers who required replacement parts to be shipped from the United States for their coach. Managers of the dealership making the repairs allowed them to park on-site and provided security and electricity free of charge for the seven days it took to receive the parts and complete repairs.

SUGGESTED MECHANICAL SPARE PARTS LIST

Mexico has an abundance of parts supply stores but not all components are available, especially for RVs and newer vehicles. It will save time and confusion if you carry appropriate parts for both your RV and tow vehicle. You will eventually require many of these items in the future.

- ☑ Fan belts. Carry spares of each including air conditioner belts.
- ☑ Replacement hoses and clamps.
- ☑ Fuel filters. Some vehicles require more than one.
- ☑ Air filters.
- ☑ Oil filter and extra motor oil.
- ☑ Light bulbs and fuses.
- ☑ A good assortment of bolts, straps, and screws for temporary repairs.
- ☑ Spare springs, spring hangers, U-bolts & nuts for trailers and fifth wheels.
- ☑ Spare tire for each vehicle.
- ☑ Engine computer chips. This is important if your vehicle has one of the newer computer-controlled engines. Some dealers will sell you the chips to carry along on a trip, with a money-back guarantee if you return them in the original packaging within a specified time frame. This is true of some other parts as well. Check with your dealer dealer or service provider.

COACH SPARES

While engine, transmission, or chassis parts and service is readily available, RV coach components are scarce in Mexico. You won't find any RV parts stores. Some items may be common with high-end boats or yachts, and you might locate parts in facilities near a popular destination resort with a harbor such as Puerto Vallarta or Mazatlán. Wal-Mart stores may have a limited supply of items such as holding tank chemicals and replacement sewer hoses and connectors but don't count on it. You should carry spare parts for any items that you consider essential, such as potable water pumps and water heaters.

The following list of items are optional, but recommended, especially if you are planning on spending an extended length of time on your tour.

- ☑ Water filter replacements.
- ☑ Holding tank chemicals.
- ☑ Spare holding tank drain hose and connectors. You'll need this for an extension in some parks as well as replacement for a damaged or lost one.
- ☑ Spare water pump for your potable water system. At the least, carry a pressure switch and seal replacement kit.
- ☑ Twelve-volt light bulbs and electrical fuses.
- ☑ Propane regulator.
- ☑ Holding tank gate valves. (Spare for both the grey and waste tanks.)
- ☑ Thermo-coupler for refrigerator & hot water tank.
- ☑ Voltage tester and electrical adapter to convert to 15 amp and 30 amp outlets.
- ☑ At least 30 feet of electrical cord for your coach. Hookups tend to be inconveniently located in the parks.

MECHANICAL TERMINOLOGY AND TRANSLATIONS

Below is a list of common translations for items and terms you might find necessary or useful during your trip to Mexico.

ENGLISH	SPANISH
Accelerator	*Acelerador*
Adjust	*Ajustar*
Air (for tires)	*Aire*
Auto parts	*Refacciones*
Axle	*Eje*
Battery	*Batería/Acumulador*
Bearings	*Baleros*
Bolt	*Tornillo*
Brakes	*Frenos*
Brake fluid	*Liquido de frenos*
Brake shoes	*Zapatas de frenos*
Cable	*Cable*
Carburetor	*Carburador*
Clamp	*Abrazadera, tornillo*
Clutch	*Embrague*
Coil (electric)	*Bobina de encendido*
Condenser	*Condensador*
Differential	*Diferencial*
Distributor	*Distribuidor*
Exhaust pipe	*Tubo de escape*
Fan	*Ventilador*
Fan belt	*Banda, cinta*
Filter	*Filtro*
Fuel pump	*Bomba de gasolina*
Gasket	*Empaque*
Gear	*Engranajes*
Gearshift	*Palanca de Cambios*
Generator	*Generador*
Grease	*Grasa*
Headlights	*Faros*
Hose	*Manguera*

ENGLISH	SPANISH
Jack	*Gato*
Leak	*Tirando*
Lubricate	*Engrasar*
Manifold	*Múltiple*
Muffler	*Mofle*
Noise	*Ruido*
Nut	*Tuerca*
Oil	*Aceite*
Radiator	*Rediadora*
Spark plug	*Bujía*
Spring	*Muelle de remolque*
Starter	*Arranquedora*
Suspension	*Suspensión*
Tank	*Tanque*
Thermostat	*Termostato*
Tighten	*Apretar*
Tire	*Llantas*
To check	*Revisar*
To repair	*Arreglar*
To start	*Arrancar*
Tools	*Herramientas*
Tow truck	*Grúa*
Turn signals	*Direccionales*
Universal joint	*Cruceta*
Valve	*Válvula*
Voltage regulator	*Regulador de voltaje*
Water pump	*Bomba de Agua*
Weld or Solder	*Soldadura*
Wheel	*Rueda*
Wheel alignment	*Alineanacion*
Wheel bearing	*Cojinete de la Rueda*

MEXICAN "GREEN ANGELS"

The Mexican government, through the Department of Tourism, operates a fleet of more than 1,000 green trucks that patrol the highways for mechanical and breakdown assistance. Called *Angeles Verdes* in Spanish, they will help in any way possible. They stock some minor parts, gasoline, and first-aid kits. They are also equipped with radios to summon tow vehicles or medical personnel. No fee is charged for this service, but tips are appreciated. Patrols cover nearly 250 routes in the country during the daylight hours.

The Ministry of Tourism (*SECTUR*) has a special Green Angels hotline for travel assistance within the country. From the interior of Mexico call the toll free number: 01 (800) 903-9200. Service is available 24 hours a day, seven days a week or you can call the *SECTUR* hotline toll-free from the interior of Mexico: 01 (800) 987-8224.

One of the things we have found so comforting on our travels has been the hospitality of the Mexican people. They routinely go out of their way to assist with any problems. We have had shopkeepers close their stores and personally drive us around looking for an item or repair part for a fellow traveler. Normally they won't even take any compensation for this type of service. On one trip with a group we had need of a mechanic for one of the rigs on Sunday in a remote area. A nearby fuel station attendant directed us to the local mechanic's home. He immediately came to the aid of the stranded vehicle and improvised repairs that got us on the road again in less than an hour. You won't often find that kind of service in the United States or Canada.

We had an exhaust brake on our rig quit working. The mechanic came to the campground and removed the part, taking it to his shop on the weekend. He returned the part stating he could not find the problem and even reinstalled it. During that process he discovered a worn wire from the coach leading to the unit. He fixed that, and the brake functioned properly. He did not want to charge us for the time he worked in his shop because he stated he actually did not repair the unit. We insisted, of course, and paid him accordingly. Numerous similar experiences have reinforced our confidence. We have no fear of mechanical troubles on the road in Mexico.

CHAPTER 8: FUEL

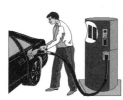 The Mexican Federal government controls the fuel company named *Pemex*. It is currently the only company authorized to sell fuel. That fact creates standard prices for fuel throughout the country. In mid 2007 the price of gasoline was about $2.45 U.S. per gallon and diesel about $1.90 U.S. per gallon. It is convenient to have set fuel prices throughout the country so one can adequately budget. We have noticed a few stations near the U.S. border do have slightly higher prices. This is due to the large number of people crossing from the U.S. to take advantage of lower fuel prices in Mexico.

Availability of fuel stations is excellent, with the exception of Baja, where there are fewer stations. Building of more stations is currently in the works. Most of the older stations (*gasolineras*) are in the process of being rebuilt, and the modern stations offer good access for RVs of any size. Despite the the number of stations, we still recommend that you travel on the top half of your tank at all times. Stations occasionally run out of fuel, and you may expect to fill up at a particular location only to find it closed or out of fuel. Keeping your tank at least half full at all times means more frequent stops for fueling, but doing so will help you avoid serious problems along the way. We also recommend that you always top off your tow vehicle before traveling each day. You never know when you might need it to secure assistance for mechanical problems.

TYPES AND QUALITY OF FUEL
Gasoline is available in two types, *Magna Sin*, which is regular unleaded (87 octane), and *Pemex Premium* (93 octane), which is unleaded premium gasoline. Diesel is sold at almost all highway stations. In the past, diesel was in red, purple or black pumps. As stations remodel, all fuel will be in green pumps with only the name designation in different colors, green label for regular, red label for premium, and black label for diesel. Diesel pumps are commonly located at the side or rear of the station, making easier access for trucks, buses and RVs.

Fuel is generally reliable. Always use the newest station available and preferably on a well-traveled route. These stations will have the modern storage tanks and do not store their fuel for long periods of time. In more than 85,000 miles of Mexico travel in our diesel rig and 25,000-plus miles in our gasoline-powered tow vehicle we have never had a problem with fuel.

An attendant will always pump fuel for you at no additional charge. Tipping fuel attendants is not expected. You should, however, tip a small amount if someone washes your windows at the station. We suggest that you have a locking fuel cap.

Stories abound about how foreign tourists have been cheated at fuel stations. Most are just over-embellished tales, but some are true. The vast majority of stations have honest employees, but you should always watch the station attendant to be sure the pump is turned back to zero before pumping is begun and remain with him as he pumps the fuel. Always count your change carefully. Pay the exact amount whenever possible to avoid being confused as attendants make change. A few stations have separate pay windows but usually you pay the attendant. Receipts (*recibos* or *notas*) are not common, but you may get one if you ask.

As of early 2007, stations still require cash (*pesos*) for fuel. A few stations near the U.S. border will take dollars but do not always offer a favorable exchange rate.

Some RVers find it easier to just put in a specific dollar amount or specific number of liters each fuel stop. If you want it filled up, tell the attendant, "*Lleno, por favor .*"

The larger *Pemex* stations make excellent places for rest and lunch breaks. In a pinch you can even arrange to stay overnight at stations, although they are often quite busy and noisy. Many have tire-repair facilities and some even have limited to full-service mechanics available. A portion of the new stations have many of the same facilities you would find at modern Interstate highway truckstops in the United States. Restaurant or independent food vendors and minimarket facilities are common as well.

LITERS TO GALLONS/*PESOS* TO DOLLARS, IT'S SO CONFUSING!

Jot down how many liters of fuel you use and how much you spend on each fillup along with the mileage you drove as well as the price per liter. This will make it easier to quickly calculate each time how many liters and *pesos* you will require on a given stop. Use the following formula to convert liters to gallons and *pesos* to U.S. dollars.

Multiply number of liters by *peso* price per liter:
(i.e., 200 liters × $6.1 *peso* price per liter) = $1220 *pesos*

Convert *pesos* to U.S. dollars:
Number of *pesos* divided by exchange rate
(i.e., $1220 *pesos* ÷ $10.5 *pesos* per U.S. dollar) = $116.19 U.S.

Convert number of liters to gallons:
(i.e., 200 liters ÷ 3.7854 liters per gallon) = 52.834 gallons

Convert to price per gallon in U.S. dollars:
(i.e., $116.19 U.S. ÷ 52.834 gallons) = $2.20 per gal.

FUEL CONVERSION QUICK REFERENCE				
1	U.S. Gallon	=	3.785	Liters
10	U.S. Gallons	=	37.854	Liters
20	U.S. Gallons	=	75.708	Liters
30	U.S. Gallons	=	113.562	Liters
40	U.S. Gallons	=	151.416	Liters
50	U.S. Gallons	=	189.270	Liters
100	U.S. Gallons	=	378.540	Liters
1	Imperial Gallon	=	4.546	Liters
10	Imperial Gallons	=	45.459	Liters
20	Imperial Gallons	=	90.918	Liters
30	Imperial Gallons	=	136.377	Liters
40	Imperial Gallons	=	181.836	Liters
50	Imperial Gallons	=	227.295	Liters
100	Imperial Gallons	=	454.590	Liters

WHERE TO GET PROPANE FOR RVS

Mexican residents use propane (known as *gas* in Spanish) for water heaters and most cooking appliances. Propane stations are located on the outskirts of every city. Most provide easy access, even for big rigs, to drive in and fill up. Propane companies will also deliver to RV parks for a nominal surcharge. Check with the campground owner or manager as the parks may have regular scheduled delivery dates for their own tanks or customers. If you have portable propane tanks, you will need take them to a propane station for filling because the trucks are not equipped to fill small tanks.

HOW FAR IS A KILOMETER?

The quick reference chart below will make it easy to convert distances from kilometers to miles at a glance. You can also use it as a rough guide for converting speed limits. The majority of newer U.S. manufactured vehicle speedometers indicate both kilometers per hour (KPH) and miles per hour (MPH) on the display, but some older models do not.

KILOMETERS TO MILES QUICK REFERENCE CONVERSION		
1 Kilometer	=	.6 Miles
5 Kilometers	=	3.1 Miles
10 Kilometers	=	6.2 Miles
15 Kilometers	=	9.3 Miles
20 Kilometers	=	14.4 Miles
25 Kilometers	=	17.5 Miles
30 Kilometers	=	18.6 Miles
40 Kilometers	=	24.9 Miles
50 Kilometers	=	31.1 Miles
100 Kilometers	=	62.1 Miles

CHAPTER 9: DRIVING THE MEXICAN ROADWAYS

NEED TO KNOW This section is not intended to scare you away from driving your RV to Mexico. On the contrary, it is to help prepare you for safe and easy travel through this scenic and diverse country. You can safely travel with almost any size rig. Negotiating turns and campgrounds can be more challenging in larger vehicles, however, if you are a skilled driver and take your time, you'll be fine.

The highways in Mexico were not designed for high-speed travel, especially in an RV. Almost any size rig can safely maneuver the roads if you drive cautiously and stay alert. This means drive slowly! Be aware that speed limits posted on signs are in kilometers per hour, not miles per hour. You will miss the wonderful scenery and sights if you drive too fast anyway. Slower speeds allow for more vehicle control and also will be easier on your rig. We drive a motorhome and can easily gauge if we are going too fast for a surface by the sounds of things rattling or shifting inside.

The No. 1 Rule is—do not drive at night! Roads are narrow and full of dangers hidden in the darkness. Animals wander or sleep on the highway, and broken down vehicles may be in the roadway because shoulder and pull off areas are limited. Should you have any mechanical problem, you may be left in harms way, parked on the highway until you can find assistance. In our experience, the majority of the *bandito* stories seem to be just myth. It stands to reason, though, that if they are out there, the dark deserted highways are where they will be.

The road surfaces vary from state to state and even from year to year. In the areas where the most rain falls, the roads deteriorate more rapidly. Repair is an ongoing process and reconstruction doesn't happen quickly because most of it is done without the use of heavy equipment. Small repairs are performed by hand with rudimentary tools. It is not uncommon to see a road crew filling potholes with a dirt and gravel mixture and drizzling hot tar on top from a bucket with a piece of tree branch.

The two-lane roads tend to be much narrower than average and with virtually no shoulder. No shoulder means no shoulder—not even a gravel or dirt area alongside the pavement! The edge of the road can drop from a few inches to a foot. Repaving is typically done by just adding over the existing road, so the road beds keep getting taller and taller. Sloping the edge of the pavement to form a shoulder is just not a common practice.

Dropping a wheel off the edge of the pavement could cause major damage or even an accident. Don't forget this especially if you are towing a fifth-wheel or travel-trailer. The wheel base on these vehicles is normally wider than the truck used to tow it and you need to allow for that fact. Broken springs on fifth-wheel and travel trailers in Mexico are very common because the towing vehicle is narrower and the driver is not aware that his towed rig is bouncing off the edge of the pavement and into every pothole. This is also a cause of tire blow-out because it weakens the sidewalls of the tires.

Going past approaching vehicles in the other lane or having vehicles pass you from behind can be nerve-wracking. If you slow down significantly when large vehicles approach from the opposing or rear direction, you will maintain enough control to move all the way to the edge of the roadway on your side and allow extra room for vehicles to pass safely on the narrow roads.

COMMON DRIVING CUSTOMS

Drivers customarily warn each other of impending road hazards. You should also practice this as you drive. Flashing headlights repeatedly at oncoming traffic warns them of impending obstacles in their path such as disabled vehicles, animals in the road, and construction. You may get routinely flashed if your vehicle is equipped with headlights that stay on all the time as that is not the norm in Mexico. It is a common custom to turn on your headlights when you are passing another vehicle.

You will usually have help passing a disabled vehicle in your lane. The vehicle occupants often watch out for oncoming traffic and flag others around when safe. Road work crews also use the flagman method. Warning cones are not often available and makeshift signal devices such as piles of branches and rocks may mark hazards and roadwork.

When traveling on the highways, you should assist faster traffic in passing you. These drivers will try to pass anyway, so your assistance will ensure your own safety as well as theirs. As they approach, you should just let off on the gas and brake slightly to allow them to advance beyond your position quickly. This also leaves more space should they have to abruptly move back into your lane to avoid oncoming traffic. Drivers of passenger buses and trucks are notorious for passing at any time even on uphill blind curves.

A common Mexican driving custom is to put on your left turn signal as vehicles approach you from the rear indicating that it is safe for them to pass. This signals that you can see far enough ahead for them to safely pass your vehicle. While an effective tool on the open road, this can be a real problem in the cities or anywhere you actually wish to make a left turn. Always be extra cautious that no one is trying to pass you on that side when making left turns anywhere in Mexico.

CUOTA AND *LIBRE* ROADS

New toll or *cuota* highways are being added yearly. These often parallel the routes of the existing free or *libre* roads. The surface quality varies from state to state but tends to be consistently better than the *libre* roads. *Cuota* roads generally link major cities and are most prevalent in the center of the country leading to and from Mexico City. Prices for these roads vary greatly. A motorhome with a tow vehicle is normally charged the rate for a two-axle bus and a two-axle car. Vehicles towing standard travel trailers or fifth-wheel trailers seem to have the most disparity in pricing.

Toll booths are strategically placed at all exits from and entries to these highways for towns as well as intersections with *libre* roadways. You can take sections of *libre* road to avoid tolls, but it is only rarely worth it. Some travelers say they take only the *libre* roads because the *cuota* roads bypass towns and villages. They also cross all the *topes*! You should have plenty of small town experiences on roads that leave you no other option except driving through the villages. Missing a few will not likely be noticed. However, with the recent increase in toll prices, your decision on whether to travel toll or free roads may be based entirely on your budget.

Large and small population areas alike often have a *periférico* or bypass road of the *centro* area. Usually these have no toll charges and are highly recommended to avoid major traffic. Some cities and towns require all heavy traffic to use these or other bypass roads. Also watch for the signs, "*Tránsito Pesado*" (cargo or heavy vehicles), and follow them where available. Many of the major cities also have toll or *cuota* bypasses of the major population area.

Roadways with multiple lanes in each direction normally reserve the left lane for passing only. You should not be driving in that lane except to pass slower vehicles. This applies to *cuota* roads as well.

Once you get away from the coastal areas you will discover that Central Mexico is mountainous. Expect a lot of high-altitude driving with winding roads all over this entire area. Elevations throughout average from 4,000 to 6,000 feet and peak at 11,000. These are not ranges that you simply cross and then are on flat ground again. The cities and towns are located either directly in these mountains or in the high valleys among them. *Cuota* roads through these areas in an RV are a wise choice for time savings as well as safety.

Engineering, design, and construction of some of these toll roads is a site to behold. Where the *libre* road twists and turns to go around a mountaintop, these toll roads simply go across expansive suspension bridges above the canyons and rivers. They tend to have more manageable grades with long straight stretches, better road surfaces, and spectacular views.

You will arrive at your destination faster and more relaxed. The drawback is the cost of some sections. If you plan accordingly, in advance, the trade-off will be well worth the expense.

TOPES & VIBRADORES

Topes and *vibradores* (speed bumps) are more common in Mexico than traffic lights and stop signs in other countries. *Vibradores* are a series of very small *topes* placed together which cause a vibrating sound as you pass over it, hence the name. Many roads travel through the center of small towns and villages and traditional traffic controls are expensive and inefficient. Any city or town can build *topes* or *vibradores* to slow traffic passing through its boundaries.

Most speed bumps, but not all, come with warning signs as you approach them. Always expect and watch out for these at entrances to all small villages, in front of schools, and at the toll booths. Some are small and easily traversed, but others are bigger and can do serious damage to your vehicle if you hit them at speeds greater than a creep.

Don't forget about your towed vehicle whether it is a car, travel-trailer, or fifth-wheel trailer, when you cross the speed bumps. The unmarked or unsigned ones are easy to miss. No driver forgets that first one he or she hits at more than a creep. Even a five-mile-per-hour jump over a *tope* can be devastating. As much as they are hated, speed bumps are an effective way to slow traffic as it passes through the towns, ensuring a higher degree of safety for pedestrians and livestock.

OTHER ROAD HAZARDS
Nearly all bridges in the country, whether they span water or simply a depression in the terrain, can be rough to pass over, especially where they begin and end. Always slow down when crossing a bridge. You will save wear and tear on you vehicle as well as its contents.

Mexico has free-range livestock everywhere. That means fences to control the animals are few and far between. Often the only restraint is a long rope or a hobble on a horse or cow as it grazes alongside the road. Don't count on such restraints to keep the animal off the highway. Stay especially alert when you see livestock near the roadway. In the towns and villages, pigs, dogs, chickens, and turkeys (among others) will invariably dart out as you pass.

Road crews typically mark their presence only with a sign or flagman. Occasionally cones or small pots of burning tar are used. Highway danger spots that are not scheduled for imminent repair are often indicated by a painted area on the road. Two-way traffic is often routed onto controlled one-lane stretches around the work crews. Sometimes temporary dirt detours are cut to route traffic around construction zones.

Disabled vehicles are another common occurrence. With few shoulders, drivers have no choice but to block the roadway when a vehicle breaks down. You will know about such a hazard because oncoming drivers will signal you with several blinks of their headlights. You should then be prepared for a hazard in the roadway ahead.

Few Mexican vehicles carry flares so the drivers typically mark break-downs with piles of branches or other debris. Watch out for these frequent obstacles in the roadway. Rocks are regularly used to block tires on disabled vehicles, and drivers do not always remove these temporary brakes when they resume travel. In fact, the practice is so common that a road sign along many highways says "*No Deje Piedras Sobre el Pavimento*" (Don't Leave Rocks on the Pavement). See Road Signs section, Chapter 10, of this guide for more signs and explanations.

Traffic in the larger cities can be very unsettling. Taxis, *colectivos* (small passenger transport vehicles), and buses are the principal mode of transportation for the general population. You'll even encounter the occasional horse, donkey, or oxen drawn cart in the most unlikely places. In practically all cities, personal vehicles are not the norm. Public transportation is the most popular. Taxis and buses own the roads or at least their drivers assume they do. They will honk at you, crowd you, cut you off, and pass anywhere. Be aware and adjust accordingly. Defensive driving is a must in Mexico. When in doubt, we always concede the right of way to the other drivers. Remember you are on vacation, getting somewhere five minutes earlier is not worth the risk of an accident.

TRAFFIC LAWS AND RESTRICTIONS

The simplest way to avoid traffic citations is to always obey the laws. If you are stopped for a traffic violation, do not offer money to the officer to let you go. If the infraction is legitimate, he will issue a citation that you can pay at the local office. The officer will possibly even escort you to the station to pay your fine directly. If the officer demands cash, you should record his name and badge number and then politely but firmly request to accompany him to the station immediately. If you have not committed an actual traffic offense, you will probably be released at that point. Most officers are quite honest, but a few will take advantage of your unfamiliarity with Mexican laws and try to make an extra buck (*mordida*) here and there.

 Large vehicles (RVs included) should generally follow the traffic routes designated for buses and transit vehicles. When heavy vehicles such as trucks are routed along a cargo route, you should follow this path also. The same goes for designated lanes in larger cities.

When entering a *glorieta* or traffic-circle intersection, those already in the circle have the right of way. This can be very confusing. If you can't drive out of the circle immediately at the point you wish, don't panic. Simply go around again. Then you will have the right of way to safely exit at the desired location.

Traffic lights (*semáforo*) and stop (*alto*) signs are not always located at conveniently visible places. In any populated area, pay special attention and always be looking out for the *alto* sign. The green signal light will flash one or two times before it turns yellow. You should stop as soon as it flashes on green. By the time it turns yellow, you are required to be stopped. The laws for turning right on red lights vary from state to state. A good rule of thumb is to always wait for the light to change before turning. Better to wait a few minutes for the light than to spend a few hours dealing with payment of a traffic fine.

Left-turn lanes are seldom available. The main roadway in large cities is used for through traffic. The lateral roadways are for transit vehicles that stop often and for local traffic. These laterals are also used to make turns and to enter side streets and local businesses. When there is no designated left turn lane available, you will have to make left or U-turns only from the lateral roadway as in the diagram below. If there are signal lights at the intersection, you will see a green arrow when it is legal for you to make left or U-turns. You must stop when it begins to flash because there will be no yellow or red light, the arrow will just disappear.

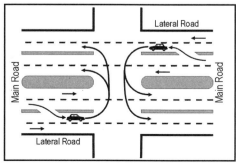

One way streets are common in cities and towns. Usually, but not always, they are pairs of parallel streets which alternate in opposite directions with a few two-way exceptions in between. The directional designation is most often found on the side of a building at the corners. If you don't see a sign, observe the movement of traffic. The way vehicles are parked on the street you wish to enter will also give you a clue whether the street is one way and what direction it goes. If you happen to end up the wrong way on a one-way street, other motorists will alert you with horns and lights. Even the police will often just make you turn off the street.

Always observe the parking restrictions. Signs are posted or curbs are painted; red means no parking anytime, yellow allows parking after normal business hours or for a limited interval, and white means no limits. Parking violations will most assuredly result in a citation. Your license plates may be removed as a guarantee that you, as a foreigner, will indeed pay the penalty. If you return to your vehicle and find them missing, follow the directions on the citation for payment of the fine and retrieval of you plates. Locals park when they please and where they please with no penalties. Sometimes this means double parking on a busy street. Do not attempt to follow suit because foreigners will be cited first.

Driving around Mexico City presents a whole set of new rules. Vehicles are restricted from driving in designated city limits one day each week. On any particular day, whether you can drive in and around the city is determined by the ending number on your license plate. If you are towing a vehicle, the restriction applies only to the motorized vehicle pulling it. However, we have heard reports that unscrupulous officials have attempted to collect fines for a towed vehicle traveling with the wrong plate number.

The Mexico City restrictions do not apply on weekends or holidays. As you enter the restricted areas you will see signs that designate the days and license numbers allowed. The fine for this violation is very expensive, up to $300 U.S. The system is occasionally changed or rotated so a list will not be provided in this guide. You can find out what the day and license-number restrictions are by calling one of the agencies such as *SECTUR* or the Green Angels listed in Chapter 19 of this guide.

CHAPTER 10: SIGNS

TRAFFIC AND RESTRICTION SIGNS
(White, Red, & Black)

STOP
(ALTO)

YIELD
RIGHT OF WAY
(CEDA EL PASO)

KEEP RIGHT
(CONSERVE SU
DERECHA)

HEAVY TRAFFIC
KEEP RIGHT
(TRANSITO PESADO
CARRIL DERECHO)

VERTICAL
CLEARANCE
(ALTURA LIBRE)
(IN METERS)

MAX. HORIZONTAL
CLEARANCE
(ANCHURA LIBRE)
(IN METERS)

NO
STOPPING
(NO PARAR)

PARKING
PERMITTED
(ESTACIONAMIENTO
PERMITIDO)

NO
PARKING
(NO ESTACIONARCE)

TRAFFIC AND
RESTRICTION SIGNS
(White, Red, & Black)

KEEP LEFT
(SOLO VUELTA
IZQUIERDO)

KEEP RIGHT
(VUELTA CONTINUA
DERECHA)

DIRECTION
OF TRAFFIC
(CIRCULACION)

DO NOT
ENTER
(PROHIBIDO SEGUIR DE
FRENTE)

NO LEFT
TURN
(PROHIBIDO LA VUELTA
A LA IZQUIERDA)

NO RIGHT
TURN
(PROHIBIDO LA VUELTA
A LA DERECHA)

TWO WAY
TRAFFIC
(DOBLE
CIRCULACION)

NO
U-TURN
(PROHIBIDO EL
RETORNO)

NO
PASSING
(NO REBASE)

SPEED
LIMIT
(LIMITE DE
VELOCIDAD)

NO
PEDESTRIANS
(PROHIBIDO EL
PASO DE PEATONES)

NO TRUCKS OR
HEAVY VEHICLES
(PROHIBIDO EL PASO DE
VEHICULOS PESADOS)

HIGHWAY WARNING
SIGNS
(Yellow & Black)

WINDING ROAD
(CAMINO SINUOSO)

TWO WAY ROAD
(DOBLE CIRCULACION)

DIVIDED ROAD
(CAMINO DIVIDO)

EXIT
(SALIDA)

INTERSECTION
(ENTRONQUE)

**FOUR WAY
INTERSECTION**
(CRUCE DE CAMINOS)

"T" INTERSECTION
(ENTRONQUE EN T)

"Y" INTERSECTION
(ENTRONQUE EN Y)

**LATERAL ROAD
ENTRANCE**
(ENTRONQUE LATERAL)

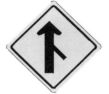

MERGING TRAFFIC
(INCORPORACION DEL
TRANSITO)

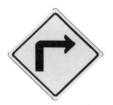

**ROAD CURVES
TO RIGHT**
(CODO)

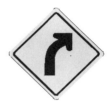

CURVE
(CURVA)

HIGHWAY WARNING SIGNS
(Yellow & Black)

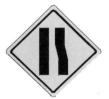

LANE ENDS
(ESTRECHAMIENTO
ASIMETRICO)

ROAD NARROWS
(ESTRECHAMIENTO
SIMETRICO)

**DIP FOR WATER
RUNOFF**
(VADO)

BRIDGE
(PUENTE)

SLIPPERY ROAD
(SUPERFICIE
DERRAPANTE)

FALLING ROCKS
(ZONA DE
DERRUMBES)

LOOSE GRAVEL
(GRAVA SUELTA)

**DANGEROUS
DOWNGRADE**
(PENDIENTE
PELIGROSA)

SPEED BUMP
(TOPE)

TRAFFIC CIRCLE
(GLORIETA)

STOP AHEAD
(ALTO PROXIMO)

TRAFFIC SIGNAL
(SEMAFORO)

HIGHWAY WARNING
SIGNS
(Yellow & Black)

RAILROAD CROSSING
(CRUCE DE FERROCARRIL)

SCHOOL CROSSING
(CRUCE DE ESCOLARES)

PEDESTRIANS
(PEATONES)

ROADWORKERS
(HOMBRES
TRABAJANDO)

LIVESTOCK
(GANADO)

**FARM MACHINERY
CROSSING**
(MAQUINARIA AGRICOLA)

4.20M

**MAXIMUM VERTICAL
CLEARANCE**
(ALTURA LIBRE)
(IN METERS)

3.50M

**MAXIMUM HORIZONTAL
CLEARANCE**
(ANCHURA LIBRE)
(IN METERS)

BICYCLIST
(CICLISTAS)

INFORMATION SIGNS
(Blue & White)

GASOLINE
(GASOLINERA)

INFORMATION
(INFORMACION)

TELEPHONE
(TELEFONO)

MECHANIC
(MECANICO)

RESTROOMS
(SANITARIOS)

RESTAURANT
(RESTAURANTE)

TRASH CAN
(DEPOSITO DE BASURA)

TOURIST ASSISTANCE
(AUXILIO TURISTICO)

MEDICAL
(MEDICO)

PARKING
(ESTACIONAMIENTO)

PARKING FOR RVs
(ESTACIONAMIENTO
PARA CASAS RODANTES)

CAMPGROUND
(CAMPAMENTO)

INFORMATION SIGNS
(Blue & White)

RECREATION AREA
(AREA RECREATIVA)

HOTEL OR MOTEL
(HOTEL 0 MOTEL)

TAXI

BUS STOP
(PARADADA DE
AUTOBUS)

AIRPORT
(AEROPUERTO)

TRAIN STATION
(ESTACION
DE FERROCARRIL)

AUTO FERRY
(TRANSBORDADOR)

BOAT DOCK
(MUELLE)

CAR FERRY
(CHALANA)

NATIONAL PARK
(PARQUE NACIONAL)

ARCHAEOLOGY ZONE
(ZONA ARQUEOLOGICA)

BEACH
(PLAYA)

INFORMATION SIGNS
(Blue & White)

SWIMMING
(BALNEARIO)

WATERFALL
(CASCADA)

CAVES
(GRUTA)

LAKE-LAGOON
(LAGO-LAGUNA)

**HISTORICAL
MONUMENT**
(MONUMENTO)

HANDCRAFTS
(ARTESANIAS)

MISCELLANEOUS SIGNS
(Black & White)

MANEJA CON PRECAUTION

DRIVE WITH
CAUTION

DISMINUYA SU VELOCIDAD

DECREASE YOUR
SPEED

DESPACIO

SLOW

NO REBASE

NO
PASSING

POBLADO PROXIMO DISMINUYA SU VELOCIDAD

POPULATION AREA
SLOW DOWN

NO REBASE CON RAYA CONTINUA

NO PASSING WITH
SOLID LINE

CARRIL IZQUIERDO SOLO PARA REBASAR

LEFT LANE FOR
PASSING ONLY

CONCEDA CAMBIO DE LUCES

DIM LIGHTS
FOR ONCOMING
TRAFFIC

MISCELLANEOUS SIGNS
(Black & White)

CRUCE DE
ESCOLARES

SCHOOL
CROSSING

PUENTE
PEATONAL

PEDESTRIAN
BRIDGE

UN SOLO
CARRIL

ONE LANE
ONLY

DESVIACION

DETOUR

PRINCIPIA TRAMO
IN REPARACION

BEGIN SECTION OF
ROADWAY UNDER
REPAIR

ESTE CAMINO NO
ES DE ALTA
VELOCIDAD

THIS ROAD NOT
FOR HIGH SPEEDS

RETORNO
CARRIL IZQUIERDO

RETURN/U-TURN
LEFT LANE

TERMINA
CAMINO DIVIDIDO

END DIVIDED
ROAD

MISCELLANEOUS SIGNS
(Black & White)

CARRETERA
CUOTA

TOLL
ROAD

CARRETERA
LIBRE

FREE
ROAD

ENTRADA

ENTRANCE

SALIDA

EXIT

PROTEJALOS

TAKE CARE OF
OR PROTECT

PUENTE

BRIDGE

NO MALTRATE
LAS SEÑALES

DON'T DEFACE
THE SIGNS

OBEDEZCA
LAS SEÑALES

OBEY THE
SIGNS

MISCELLANEOUS SIGNS
(Black & White)

NO TIRE
BASURA

DON'T
THROW TRASH

ZONA DE
NIEBLA

FOG AREA

ZONA DE
DERRUMBES

ROCKSLIDE
AREA

NO DEJE
PIEDRAS SOBRE
EL PAVIMENTO

DON'T LEAVE
ROCKS IN THE ROAD

NO SE ESTACION
EN CURVA

NO PARKING
IN CURVE

TRANSITO LENTO
CARRIL DERECHA

SLOW TRAFFIC
USE RIGHT LANE

CASETA DE
COBRO (COBRE)

TOLL BOOTH

UTILIZA CINTURON
DE SEGURIDAD

USE YOUR
SEAT BELT

CHAPTER 11: RV PARKS AND SERVICES

The majority of RV parks in Mexico could more accurately be called RV parking. Many are old, poorly designed for access, and limited in terms of services. They do, however, provide a safe environment for spending the night along the way. There are a number of very nice parks and these are the ones where you will find the long-term RV people wintering. Locations of and specific services at Mexican RV parks can be found in books and websites on the subject. The *Traveler's Guide to Mexican Camping,* as described in the Appendix of this guide is an excellent resource for all your camping needs in Mexico.

When an RV park owner advertises or the manager states that it has full hookups, that does not always mean the services are located at every site or that they are in working condition. Hook-ups are often inconveniently located for access from your space. Whenever possible, check out the available sites before you park. Pick one with the best possible necessary services. That will save the frustration of having to relocate once you have parked.

Electrical (*eléctricidad*) service is often very low voltage. Expect connections to be only 110-120 volts at 15 to 20 amps. Thirty and 50 amp service is scarce. RV parks are often serviced by undersized transformers and have single power lines for many spaces. That causes the voltage to fluctuate as power consumption varies in each rig plugged into the same line. We've been in campgrounds where voltage drops from 110 volts to 70 volts when every-one plugs in. Ability to run air conditioning on park power is extremely rare. In a few parks, you'll find adequate power to handle one unit.

We typically just plug in with a 15 amp cord and run any higher wattage appliances with the generator when necessary. This practice prevents possible damage to microwaves, air conditioners, and computers that can be caused by low amperage and power surges. Grounded outlets are a luxury. Reverse polarity is not uncommon so be sure to test before you hook up.

Since many outlets are only two prong & ungrounded anyway, just turn your plug over to correct the polarity problem. The voltage supplied is usually enough to keep the batteries in the coach charged and to run a few lights and low wattage items or a ventilating fan.

Water (*agua*) is an issue that concerns most travelers in Mexico. Stories have persisted for years about the poor condition of the drinking water, causing fear in the minds of most everyone. Great strides have been made to improve the water quality throughout the country. Most cities now have potable water systems for all of their residents.

Bottled water is readily available in markets and retail stores. The majority of RV parks have purified bottled water (*agua purificada*) on site or have daily deliveries of the 20-liter *garrafón* containers (5.29 gallons) for an average cost of 5 to 15 *pesos* (10 to 30 cents per gallon). The attendant will pour water directly into your RV tanks or other containers. Carry a funnel to facilitate water transfer.

If you are a seasoned traveler accustomed to different drinking water in many places, you should not have any problems. Always let the water run for a while first to check clarity and purge the pipes. We recommend filling your tanks with the water in most campgrounds and treating it with chlorine bleach (1 tsp. at 5.25 percent sodium hyperchloride concentration per 20 gallons of water). Be sure to use only the regular, unscented, household-type chlorine bleach. It is readily available in stores in Mexican supermarkets. Pour the bleach into your hose and then fill the tank. This will keep the hose and the lines into your RV clean. Chlorinating the water kills algae and bacteria. Use this water for washing dishes, flushing toilets, or showering. Use the bottled water for drinking and cooking. If you want to be extra cautious, boil your water for dishwater at least one minute.

Check with the campground owner, manager, or other residents about the quality of the water. To be safe, fill your fresh water tanks with the chlorinated water and use this up, then refill. Make sure to adjust bleach amounts if the tank is not empty when rechlorinating. Don't hook up directly to the RV park water system. Some campgrounds have designated potable water sites from which to fill, but you should still add the bleach.

Other water additives are commercially available, such as chlorine tablets and iodine, but we have found the chlorine bleach to be a safe, inexpensive, and effective way to treat our water supply.

Treated water may have a faint chlorine odor and can feel slightly slick. This should create no difficulties other than aesthetics. The only long-term effects we have noticed to this chlorination method is somewhat drier skin. If you color your hair, you may also notice a quicker lightening of it with daily use of this chlorinated water.

 Use a solution of 2 ounces of bleach to one half-gallon of water in your sink or a bowl for cleaning and sanitizing your fruits and vegetables. Soak them for several minutes and then rinse with potable water, either filtered or bottled. This will kill any general surface bacteria and has the added benefit of making the produce stay fresher longer.

Travelers with sensitive digestive systems should be extra cautious and use only purified water in fresh water holding tanks or install a filter system on your RV. Several types on the market today offer reliable protection. They vary from those that only filter for taste to those that provide filtering for most contaminants, including microbiological cysts found in water. Many also remove most inorganic contaminants such as lead, chlorine, asbestos, and mercury. We routinely drink either filtered or bottled water for the flavor value.

The "PUR" brand water filter sold at many retail outlets is inexpensive, compact, and easy to use. The entire unit fits on your faucet and offers the choice of filtered or non-filtered water at the flip of a wrist. It reduces or eliminates many of the above contaminants. A built-in gauge indicates when to change the filter. The filters are simple to replace. We have used this particular brand for several years with satisfactory results. Other manufacturers, such as Brita, are now retailing similar filters. More elaborate units can be installed on part of or the entire water system of your RV. Some travelers simply have a smaller separate tank installed with an additional spigot on the sink and fill this tank with purified water for drinking and cooking.

Do some research and choose the method that best suits your needs and budget. The FMCA motorhome magazine regularly publishes information on water filter systems for RVs with comparisons and quality evaluations.

RV sewer connection access varies widely. These are often inconveniently located and are frequently higher than your rig's connections, making drainage difficult. The older parks were designed when RVs were nothing more than small trailers pulled with automobiles, and the services have rarely been relocated or upgraded. You should carry at least 15 to 25 feet of drain hose with you. The Spanish terminology for dump services or dump stations is *"drenaje."*

Shower and restroom facilities are available at the majority of parks. These range from marginal shower stalls with only cold water to quite adequate hot and cold water ones. Don't expect the same attention to comfort, cleanliness, and modesty as in U.S. or Canadian parks. While many travelers prefer to use their own RV facilities, using the park's showers can extend the capacity of your holding tanks and save potable water for other uses. Showers are called *"regaderas"* in Spanish.

The 2007 average cost of a night's stay in a Mexican RV park was about $120 to $150 pesos, plus or minus a few pesos. Nicer parks located in popular coastal areas cost more. Many have better rates for weekly or monthly stays. Usually you drive in, pick a spot, then seek out the resident manager or attendant to pay for the site. A few parks have a dedicated following of permanent or semipermanent residents who rent spots on a yearly basis and occupy them during the winter season. Advance reservations are not usually required or necessary. Exceptions include the popular tourist and beach area parks from December through March. January and February is high season for caravan travel. You should check ahead for availability of campsites during this time frame.

CHAPTER 12: HEALTH SERVICES

Medical assistance in Mexico is easy to access, generally reliable, and inexpensive. Hospitals can be found in all larger cities and in many smaller towns as well. Those located in the more populated areas will have modern facilities and equipment. Healthcare is provided to citizens through socialized medicine. The federally funded healthcare system operates *IMSS* hospitals and clinics for Mexican Nationals. However, they will not likely turn you away if you need immediate assistance and no other emergency care is available.

Most smaller towns without hospitals have either an emergency medical clinic or a local doctor who provides twenty-four-hour service at his or her home or office. Many doctors will even make house calls to your RV for little or no extra charge. Laboratory and X-ray services are also commonly available.

In our personal experience, we have found that medical care is adequate and in some cases superior to U.S. medical services. You rarely have to wait for service even without an appointment. Many of the medical professionals speak English and a large number of doctors have studied or interned in U.S. hospitals. Diagnostic screening clinics offer a wide range of services including blood testing, MRI, CAT scans, and mammography. Chiropractic physicians as well as Acupuncturists are common. Costs for all types of medical care and services are considerably less than in the United States. Some U.S. insurance companies will reimburse the fees. The following website offers a wealth of free medical information helpful for foreign travel: http://www.iamat.org.

If you have a pre-existing or continuing medical condition, we advise that you write down the particulars and have it translated into Spanish before you leave home. Carry that information with you at all times, along with a list of prescription drugs that you take. Be sure to include the generic or common name of the drug as well as the brand name and dosage.

EMERGENCY MEDICAL EVACUATION SERVICES

Several insurance companies offer emergency medical evacuation to the United States and Canada. These companies have reasonably priced policies covering medical evacuation flights and attending personnel in case of a life-threatening emergency. They will also handle the return of your RV, family members, and pets to a predetermined location. For many, this insurance is extra piece of mind while traveling and coverage is in effect whenever you are away from home.

Skymed is one such company available to anyone. Call from the U.S. and Canada: 1-800-475-9633, Mexico (Toll Free): 001-866-805-9624, collect: (480) 946-5188 or check the website, http://www.skymed.com/ for more information and/or enrollment forms.

DENTISTS (*DENTISTA*)

Dental services cost a small fraction of what they do in the United States. Equipment is modern; techniques and services are comparable to those at home. Appointments are easy to make, even for evenings and weekends. Emergency dental help is also commonly accessible twenty-four hours a day.

OPTICAL SERVICES

Opticians and optometrists offer full examination services with modern facilities and extensive selections of all recognized brands of frames and contact lenses. We have purchased our eyeglasses in Mexico for years with complete success and a considerable savings.

PHARMACIES (*FARMACIA*)

A large variety of prescription drugs, excluding narcotics, are readily obtainable without a prescription in Mexico. You will not have to search hard to locate one. Farmacias are located in virtually every size town or village. Practically all grocery stores contain one also. Many are even open twenty-four hours a day, especially in larger cities.

Obscure or less common items can ordinarily be located with persistence. Hospital *farmacias* generally carry the largest variety. You may be surprised at the assortment of prescription drugs stocked in even the smallest store.

Nearly all common prescription brand names are widely available. You may need to check several stores to locate certain items or specific strengths of drugs. Always know the generic name as well as the common name for the drug ingredients, strengths and specific dosages along with the brand name and the manufacturer. Show the pharmacist the original package or insert to help find the correct equivalent. *Farmacias* have a cross-reference book to find the Mexican brand name or generic for a particular prescription item. If you can read Spanish, it is easy to look up items in their book.

New items requiring a prescription, even in Mexico, can also be easily obtained. A pharmacist can usually recommend a local doctor who will provide a Mexican legal prescription upon presentation of your own physician's prescription or bottle indicating remaining refills.

Most of the pharmaceutical products are the same as you would purchase at home. Medical maintenance prescriptions such as hormone, allergy, antibiotic, and nonnarcotic pain medications along with those prescribed for blood pressure, heart disease, ulcer, diabetes, and respiratory ailments are common. Quality of the products is not an issue. They are very often produced by the same drug companies that you find at home in the United States and Canada and simply exported to Mexico.

Many drugs are considerably less expensive than in the United States. If you have a prescription drug plan with your health insurance company, you probably won't be reimbursed for drugs purchased in Mexico. Seniors on Medicare with no drug coverage or only minimum reimbursement plans can save considerable money by purchasing at Mexican *farmacias*.

The current border restrictions (early 2007) allow you to enter the U.S. border with up to a three-month supply of your prescription drug items from Mexico. You are required to have a prescription from a Mexican doctor to export. Most *farmacias*, especially those near the borders, will issue a written prescription upon request to comply with this regulation.

There are stores dedicated exclusively to selling vitamin and mineral supplements along with holistic health aids. These stock most well-known items as well as other hard-to-locate ones. General Nutrition Center (GNC) have opened many stores throughout the country

"*TURISTA*"

This commonly recognized ailment has many causes, ranging from change of diet, to intolerance of certain foods, alcohol or water, to serious cases of bacteria or infection. The most prevalent cause is change in diet or overindulgence. Symptoms are generally temporary and little more than a minor discomfort.

Traditional remedies such as Kaopectate, Pepto Bismol, Immodium, and similar over-the-counter antidiarrheal medications usually remedy this simple discomfort quickly. If symptoms persist for more than a few days or are extremely severe, you should seek medical attention to determine if the problem is serious.

IMMUNIZATIONS AND PREPARATION

Have a routine check-up to insure your health status and have all your prescriptions up to date. It is wise to be certain your tetanus vaccination is current and that you have been immunized for tuberculosis. This is routinely done in childhood in the United States. Call your current physician or local health bureau for updates and information on any specific immunization needs or requirements before you depart.

INSECTS

Insect bites are the primary medical complaint we hear on our journeys. Prevention is the best cure. A good repellent applied daily before going outside will make you unattractive to the insect population. Coppertone produces "Bug & Sun" and Cutter offers a similar product, both of which offer not only insect repellent protection but also SPF15 sunscreen in a convenient lotion or spray. We have found both to be effective against most biting insects.

A popular product manufactured and sold in Mexico is called "*Autan.*" It comes in a clear lotion, cream, or spray. The lotion offers the most repellent protection. In our experience, it has proven very effective against the insect known commonly as the "no see um." These flying pests are usually found in densely forested jungle areas. Another similar variety called "sand fleas" reside on the sandy beaches but do not fly.

Both insects bite and leave a red, inflamed area that resembles a bulls-eye target. After a while it will itch incessantly and if not treated may become infected. Once bitten you should immediately open the center with a sterile needle, disinfect with alcohol or peroxide, and apply a topical anti-itching agent.

To calm the itch of many bites, you may need to take an antihistamine. Check with your doctor before leaving for treatment suggestions or prescription products. Mexican *farmacias* may be able to recommend products for itch relief. As with all medications, be cautious, follow directions, and know your own allergies or interactions with currently prescribed medications.

OTHER HEALTH PRECAUTIONS
Fun in the sun brings the need to prevent over-exposure and dehydration. Always use proper sun-screen, hats, sunglasses, and protective clothing. The sun in Mexico, especially on the beach and coastal areas, can be dangerous. With less pollution to filter out the harmful UV rays, you burn more quickly than you might expect. Drink plenty of fluids and enjoy the protection of umbrellas and palm trees. A shady hammock is a wonderful place for an afternoon siesta.

When traveling through the mountainous areas of Mexico make sure you account for the extreme altitude. Much of the central portion of country is 4,000 to 7,000 feet above sea level, and some population areas are 8,000 feet and above. You will tire easily, find breathing more difficult, and could experience altitude sickness until you adjust to the elevation. Just take it easy. No hurry anyway—remember you are on *"mañana time."*

All of the temperature measurements you will encounter will reflect degrees using the Celsius scale. To determine the temperature in degrees Fahrenheit, use this formula. Take the temperature in Celsius, multiply by 1.8 and then add 32, $(F° = (C° \times 1.8) + 32)$. A quick reference conversion chart is provided to make it simple. The lower portion of the Celsius to Fahrenheit conversion graphic will be helpful for evaluating the climactic temperature. The upper portion will prove useful when using package directions for cooking foods purchased in Mexican stores or recipes.

F°		C°
350		177
325		163
300		149
275		135
250		121
100		38
95		35
90		32
85		29
80		26
75		24
70		21
65		18
60		16
55		13
50		10
45		7
40		5
32		0

CHAPTER 13: COMMUNICATIONS

 To communicate with family, friends, and business associates back home, you have many choices. Most obvious is the telephone. The Mexican phone company, *Telmex*, has made significant strides over the past few years, and it is now considerably simpler and less expensive to use the phones in Mexico than it used to be.

TELMEX TELEPHONES AND CALLING CARDS

On just about every corner in every city you will find *Telmex* pay phones. These do not take cash. They are designed to accept a special prepaid debit card (*Ladatel*) that can be purchased in denominations of 30, 50 or 100 *pesos*. The cards are available nearly everywhere—in pharmacies, markets, retail shops. The vendors are indicated by a posted blue and yellow sign with a picture of a telephone handset and phrase stating "*De Venta Aquí Ladatel.*" Calls to the United States and Canada usually cost 5 *pesos* for the connection and 5 *pesos* a minute thereafter. This is one of the most economical ways to phone home. The only drawback we have found is that these phones are invariably in noisy locations and finding a quiet phone is difficult.

A second type of prepaid calling card is available in some locations. It allows you to access a toll-free number from any phone and make long-distance calls. A pin number appears on the back of the card along with instructions in English. The voice commands are also bilingual. Cards are purchased in specific denominations like the *Ladatel* cards.

Telecom USA's Minute Pass is a prepaid calling card which you can recharge at any time if you run low. It offers low calling rates from Mexico. For more info you can access their website at http://www.minutepass.com/. Canada Direct is an automated service that lets you call Canada and other countries from overseas but pay Canadian international long distance rates instead of foreign rates: http://www.bell.ca/. Check out the internet for other international calling cards you can purchase in advance online. There are numerous options currently available .

You may also use the *Telmex* phone to dial using your own long-distance calling card or to make collect calls directly. Simply pick up the handset and press the ABC button for your language of choice. The display will then indicate that you should either insert your *Ladatel* card or dial the toll-free access number for your long-distance provider. You must dial the appropriate country code first and then the toll-free access number for your long-distance service. That will put you in the network just as if you were back home. Then you follow the instructions given by your long-distance company.

Below are listed some familiar long-distance companies and their access numbers from Mexico to the United States and Canada. Be sure to call your long-distance provider before you leave home to verify the current access number and to confirm that you have international calling privileges.

COMPANY	TO ACCESS U.S.	TO ACCESS CANADA
AT&T	001 (800) 288-2872	001 (800) 123-0201
MCI Worldphone	001 (800) 674-7000	001 (800) 674-7000

TELEPHONE SERVICE VENDORS

Most cities and even very small towns have a long-distance calling center. These offices have an attendant who will dial the number for you, and then you can talk from a quiet, private booth to your party. This usually costs approximately 15 *pesos* per minute, including the surcharge for the service. Look for signs that advertise *"Servicio de Teléfono y Larga Distancia."*

COLLECT CALLS

Collect calls are the least expensive overall. Simply dial 090 and a bilingual international operator will place the call for you.

OTHER PAY TELEPHONES

You will also see many phones that display a sign "Call the United States or Canada by just dialing 0." These phones appear to be ordinary pay telephones. Using them to call internationally is very simple to do but extremely costly! The service connects you with an international operator who will charge the call to your Visa, American Express, or Mastercard. The rate is very high and could cost as much as $10 U.S. per minute. We do not recommend using these phones except in extreme emergencies.

MEXICO TELEPHONE CODES	
Long Distance Operator (National)	020
Directory Assistance (National)	010
Directory Assistance (Local)	040
Police/Fire/Red Cross	060
Emergency Information (Spanish/English)	070
International Operator	090
Highway Emergencies	066

Understanding the combinations of numbers to dial when calling within the country was once frustrating because they changed from state to state and city to city.

Telmex has finally standardized the dialing system throughout the country. There are now three digit area codes and the local calling areas have seven digit numbers like in the U.S. and Canada. Mexico City, Monterrey, and Guadalajara are exceptions to the rule as they have two digit area codes, but they have four digit prefixes. Long distance calls within the country require you to dial 01 first. You can visit the TelMex website at http://www.telmex.com/mx/hogar/ld_clavesld.jsp for a listing of all area codes for Mexico. Click on Listado de las Claves Lada de las 100 principales ciudades (formato PDF).

Helpful hint:—use the section of this guide (pages 169 to 171) that lists Mexico State Tourism offices to determine the area code for a particular city. The area codes are in parentheses for each city listed. If we find ourselves thoroughly stumped, we ask a local resident for assistance.

VOICEMAIL

Many phone companies in the United States offer voicemail services. This is a very inexpensive method of receiving messages from friends, family, and business associates. In your greeting to callers, tell them that you will retrieve messages at a certain time and day every week. That way everyone leaving messages can expect you to hear theirs within a timely interval. This works well whenever you are traveling, even in your home country. It also provides a sense of security for those back home if they have a way of contacting you on the road. Be sure to make a habit of checking on the appropriate day and returning calls promptly.

Here are instructions for using the *Telmex* phones. These same instructions are usually posted either at the booths or on the telephones.

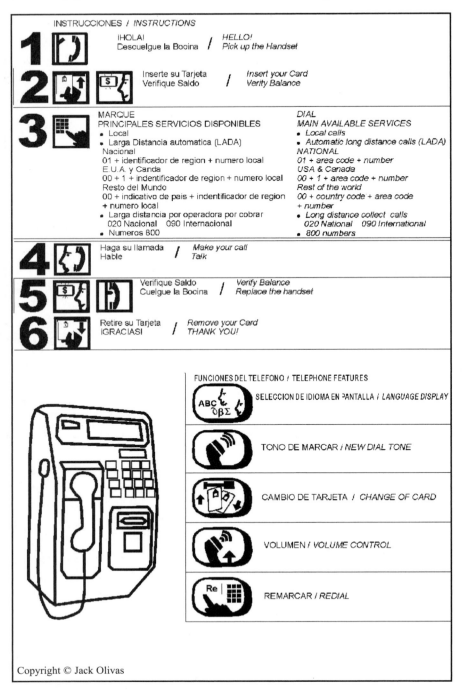

INSTRUCCIONES / *INSTRUCTIONS*

1 ¡HOLA! / *HELLO!*
Descuelgue la Bocina / *Pick up the Handset*

2 Inserte su Tarjeta / *Insert your Card*
Verifique Saldo / *Verity Balance*

3 MARQUE / *DIAL*
PRINCIPALES SERVICIOS DISPONIBLES / *MAIN AVAILABLE SERVICES*
• Local / • *Local calls*
• Larga Distancia automatica (LADA) / • *Automatic long distance calls (LADA)*
Nacional / *NATIONAL*
01 + identificador de region + numero local / *01 + area code + number*
E.U.A. y Canda / *USA & Canada*
00 + 1 + indentificador de region + numero local / *00 + 1 + area code + number*
Resto del Mundo / *Rest of the world*
00 + indicativo de pais + indentificador de region / *00 + country code + area code*
+ numero local / + *number*
• Larga distancia por operadora por cobrar / • *Long distance collect calls*
020 Nacional 090 Internacional / 020 *National 090 International*
• Numeros 800 / • *800 numbers*

4 Haga su llamada / *Make your call*
Hable / *Talk*

5 Verifique Saldo / *Verify Balance*
Cuelgue la Bocina / *Replace the handset*

6 Retire su Tarjeta / *Remove your Card*
¡GRACIAS! / *THANK YOU!*

FUNCIONES DEL TELEFONO / *TELEPHONE FEATURES*

SELECCION DE IDIOMA EN PANTALLA / *LANGUAGE DISPLAY*

TONO DE MARCAR / *NEW DIAL TONE*

CAMBIO DE TARJETA / *CHANGE OF CARD*

VOLUMEN / *VOLUME CONTROL*

REMARCAR / *REDIAL*

Copyright © Jack Olivas

CELLULAR TELEPHONES

Cellular phone service in Mexico is widespread. Whether you will be able to use your existing phone depends on the carrier. Contact your service provider before you travel to determine the specifics and the rates from Mexico. Short term rentals of equipment are also available in selected areas. Cellular Abroad rents and sells cell phones for use in Mexico. For more complete information visit their website, http://www.cellularabroad.com or call them toll-free at 1-800-287-5072.

FAX SERVICES

Many *farmacias* and small businesses offer fax services internationally. We find the small local vendors less expensive than traditional ones like Mailboxes, Etc. and Xerox. A fax to the United States usually costs from 10 to 20 *pesos* per page. This is an inexpensive, easy way to send personal letters and business communications.

E-MAIL AND INTERNET SERVICES

Cyber Cafes are available in almost any size town and many have high speed access. You'll find them in bars, restaurants, laundries, and stores like Office Depot. They have modern hardware and software and offer reasonable rates (at 10 to 30 *pesos* per hour) to access the Internet and E-Mail. Yahoo, AOL, and MSN Hotmail are currently the most common providers for access to E-Mail. Many campgrounds are now offering wireless internet access to their guests for a small fee.

If you have LAN capabilities on your laptop you can often just plug in and use your own computer. When using a computer at one of the local internet cafes you may find the keyboards slightly different and some of the keys won't work the same. The @ symbol is different from location to location. At some it is a combination of the ALT key and the number 64, all pressed together. Others use the ALT Gr key with the letter Q. Many post the symbol on their computers or you can simply ask.

Using your own PC will also enable you to use SKYPE internet phone service too. It's easy to use and very inexpensive Check them out at http://www.skype.com/intl/en/helloagain.html.

POCKETMAIL

This is an increasingly popular communication method for RVers. It is convenient and economical. The Pocketmail device has a small, portable keyboard unit attached. It is capable of sending and receiving E-Mail from most phones by placing the telephone handset in the receptacle on the back of the unit. Dialing a specified telephone number allows sending and receiving of messages in only a few minutes. Messages can be sent or retrieved to and from most Internet service providers. The service has a toll-free number for use while in the United States, but calls made from outside the country will require international long distance service to operate. Visit their website for more info: http://www.pocketmail.com/.

POSTAL MAIL

Sending and receiving mail within Mexico presents a problem even today. Regular mail from Mexico to other countries, while relatively reliable, can take weeks. If you want to send letters or post cards that don't have to reach their destination at a specific time, the most economical method is to use the *Mexpost*. Stamps are available at the local Post Office (*Correo*). Long lines are rare. Air mail is the most expeditious.

For receiving mail from home or for sending important items and documents from Mexico, we suggest using an international package service such as DHL, UPS or Federal Express. All are very reliable internationally and, while more costly, they offer tracking services and guarantee that your package will arrive in a timely manner. Simple mail and/or documents usually can be sent or received within 48 hours. These companies also make it easier if you wish to receive mail but don't have a viable Mexico address. They offer counter services, which means you can pick up incoming items at their offices.

All packages that contain items other than documents must go through customs in Mexico City and could experience delays up to two weeks. Any packages with declared monetary values will be assessed duty. Be sure to advise the person forwarding your mail to label the package as documents and not to add any insurance. Mailboxes, Etc., has 5-to 7-day guaranteed mail service, called "MBE," available in some cities for relatively low rates.

INTERNATIONAL PAGERS

In the event you require immediate notification or contact with family or business associates while you travel, you can arrange for an international pager through one of many companies that provide the service in your home country. Several offer a wide range of plans and coverage in Mexico. New services even include the ability to receive limited E-Mail and internet access via the pager. Choose the one that best suits your needs and budget.

NEWSPAPERS

English-language newspapers are available in larger cities and towns, especially those with significant English-speaking resident populations and those who receive a substantial volume of English-speaking tourists. In the Yucatan Peninsula area, the Miami Herald produces a local version with news from the United States and the world. USA Today and the Wall Street Journal can also be found if you check around. Ask at the larger hotels and news stands for copies of English-version newspapers.

Accessibility to the internet is so easy and inexpensive you might also consider getting your news that way. You can access many American and Canadian newspapers online. Listed below are are just a few available free sites for daily updates:

U.S. Based Websites:
http://www.chron.com
http://www.latimes.com
http://www.nytimes.com
http://www.washingtonpost.com

Canadian Based Websites:
http://www.canada.com/calgaryherald
http://www.canada.com/montrealgazette
http://www.canada.com/vancouversun
http://www.globeandmail.com
http://www.thestar.com

CHAPTER 14: GROCERY SHOPPING

WHERE ARE ALL THE STORES?

Modern, well-stocked grocery stores can be found throughout Mexico. Over the past few years Costco, Sam's Club, and Wal-Mart Supercenter Stores have opened more and more outlets. Wal-Mart store locations with maps and directions can be found on their website: http://www.walmartmexico.com.mx. The most common large Mexican "*supermercado*" stores are *Gigante* (Big G), *Soriana*, *Commercial Mexicana* (easily recognized by the large orange Pelican symbol), *Chedraui*, *Carrefour*, and *Ley Stores*.

Many smaller grocery markets, privately or locally owned, have good selections and tend to cost slightly less than the larger chains. A multitude of minimarkets or *tiendas* exist, especially in less-populated areas. Often they're called "*Abarrotes*" or "*Mini-supers*," with the name of the owner following the designation. These have basic food items available.

Larger markets are often located within a shopping plaza. At first glance you may not think there is much of a store there. Don't be fooled—go inside and you will discover a very large store that contains groceries, pharmacy, banking, bakery, liquor, clothing, hardware, household items, hair salons, internet, photo processing, and many miscellaneous supplies.

WHAT DO THEY STOCK?

Many of the items you are accustomed to purchasing are readily available. Vegetables (*verduras*) and fruits (*fruta*) are vine ripened and more flavorful than what we often find in stores at home. You can purchase these fresh items in many other locations too. Fruit and vegetable stands can be

found on nearly every block, and each state has roadside outlets with regional specialties. Fresh items are also available in the weekly open markets (*tianguis*). These are held outdoors, usually the same day each week, and resemble flea markets in the United States. You will find most of the same items as in regular stores along with produce, livestock, handcrafts, used goods, and new goods at prices well below retail.

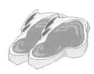

Meat is usually pre-packaged or deli style, but many markets still have a butcher who will cut and package per your specifications. When ordering, remember that Mexico uses the metric system of weights and measures. (See the conversion chart at the end of this chapter.)

Fresh seafood (*mariscos*) is a bargain in coastal areas. It can be purchased at the grocery store, directly from the fishermen on the beach, or at specialty fish markets. Fish is as much a part of Mexican cuisine as the tortilla, rice, and beans.

Nearly every market has a bakery (*panadería*) on site where bakers make wonderful breads and baked goods daily. You grab a tray and a set of tongs and just browse through the aisles, selecting what you like. Take it back to the register in the department, and the attendant will bag and price it for you. Mexican *bolillos* are small French-style bread rolls, almost as much a staple as tortillas in the local's diet. Baguettes, cakes, pies, cookies, doughnuts, and many other interesting items can keep you tasting new things for weeks. If we don't recognize a particular item, we buy just one and sample it. These fresh-baked items are sinfully inexpensive. Baked goods, except brand-name, prepackaged items, do not contain preservatives so they should be consumed within a day or so of purchase.

Tortillas are indeed a staple of the Mexican diet. You will rarely have a meal where they are not served as part of the dish or accompanying it. Corn tortillas are the most popular, since corn is grown most everywhere in the country and widely used. Flour tortillas are less prevalent except in the northern, dryer regions where corn doesn't grow as well. You can usually buy either type prepackaged in the markets, but they don't compare in flavor to fresh ones. Fresh corn tortillas are commonly sold for 5 to 6 *pesos* a kilogram at the markets as well as "*tortillerías*" you will pass on the streets. Roll one up and eat it steaming hot for a yummy snack.

In some respects, Mexicans food companies are far ahead of their American counterpart with their packaging. They use far less glass and plastic and more environmentally friendly disposable packaging, which is great for the RV traveler. The selection of juices is overwhelming. These are commonly packaged in individual drink boxes complete with a straw or in liter boxes. The larger package is less expensive by the ounce and fits nicely in an RV refrigerator. The smaller sizes offer you daily variety and are easy to carry along. You can purchase your favorite brands along with many exotic ones like Mango, Guanabana, Papaya, Guayaba (*guava*).

Fresh milk is not always available. Owing to lack of adequate refrigeration in some homes and transportation limitations, it is most commonly sold packaged in liter boxes. This milk is ultra pasteurized at very high temperatures. The benefit is that it does not have to be refrigerated until opened and generally has a six-month shelf life. Check the expiration date on the box when purchasing. The date system always shows the day first, the month second, and the year last (May 14, 2007 will appear as 14-5-07.) When opened and stored in the refrigerator, it also tends to last longer than regularly processed fresh milk. The flavor is comparable (a little less rich tasting than fresh) and it comes in all the same varieties. "*Leche Entera*" is whole milk, "*Leche Semi Descremada*" or Light (*ligera*) is 2 percent fat, "*Leche Descremada*" is 1 percent fat. Some brands carry Skim or nonfat also. The many different brands all seem comparable. Look for percentage of fat (*grasa*) on the label. We always carry a couple of boxes for emergency use even in the States.

Other milk products such as yogurt (*yogur*), butter (*mantequilla*), margarine (*margarina*), cream cheese (*queso crema*), cottage cheese (*requesón*), and sour cream (*crema ácida*) are easily located and available in many of the most common familiar brand names. You'll see a lot of the popular Mexican cheese (*queso*) called "*Manchengo*," a mild white cheese similar to Jack or Mozzarella. Imported cheeses such as Gouda, Camembert, and Brie can be purchased at favorable prices. Cheddar or Colby, however, is often difficult to locate. Processed American cheese slices and Velveeta brand cheese are both common.

 Well-known brands of condiments such as mayonnaise, mustard, and ketchup are easily found. Soy sauce, marinades and barbecue sauces are less common. Watch for gourmet or specialty food stores for such items.

Familiar U.S. snack foods are now becoming more accessible in Mexico. Tortilla chips, pretzels, and potato chips are common items. However, if you love BBQ potato chips, bring along a good supply. We have yet to discover them in any store. You'll have the opportunity to sample many flavor varieties not exported to the United States.

Familiar brands of cleaning products, dish soaps, window cleaners, and laundry soaps are also easily obtained. The most popular native brand name of laundry soap is *Ariel*. It has a strong, pleasant scent and really whitens and cleans your laundry, but it contains bleach. Be careful.

Many brand-name personal hygiene products—soap, toothpaste, shampoo, mouthwash, deodorant, and many recognizable variety store cosmetics—are in ample supply. Fragrance shops and retail beauty supply outlets are located in larger cities. High-end cosmetic items are not obtainable except in larger cities with major department stores.

 Mexico is well known for its *tequila*. You will find so many brands it will make your head spin. Tasting rooms and stores are dedicated just to the beverage. Mexican brands of other liquors such as brandy, kahlua, vodka, and gin are available. All of these are generally less expensive when purchased in the grocery store. Items such as bourbon, scotch, and most other whiskey is imported and will be high priced due to import duty.

Mexican beer (*cerveza*) is well renowned for its quality and flavor. If you purchase bottles, be prepared to pay about 4 *pesos* per bottle (*envase* or *botella*) for deposit. A few brands, such as *Tecate*, sell in nonreturnable bottles and many are available in cans (*latas)*. The best bargain is to buy at a "*deposito*" or distributor by the case (*cartón*). The deposit is refunded when you return the empties or may be applied to another case. You can return the bottles anywhere in the country so long as you go to a depository operated by the same manufacturer. In this system you usually pay less than 5 or 6 *pesos* each for a beer.

National brands such as *Corona, Pacifico, Estrella, Victoria, Modelo Light, Modelo Negra, Modelo Especial,* and *Montejo* are all produced by *Cervecería Modelo, Inc. Tecate, Sol, Superior, Bohemia, Dos Equis XX, Dos Equis XX Lager, Dos Equis XX Obscura,* and *Indio* are produced by *Cervecería Cuauhtémoc Moctezuma.* You will find local brands in different regions of the country. If you are a beer lover, you won't be disappointed with the selection. Be aware that Mexican beer contains 4.5 percent alcohol so it is more potent than U.S. brands.

SHOPPING TIPS

Before you go to the market, make a list of items to purchase. Use your Spanish dictionary and translate as much as possible to Spanish. This will make locating the items simpler. If you can't find something you want, ask or show your written list to store employees. They will be more than happy to assist you. On your first visit to the store spend time familiarizing yourself with what it carries and how the store is laid out. As in other countries, different market chains carry different specialty brands and items.

Experiment! Buy one or two new food items each trip and taste test. You may be surprised at what you find. We usually end our trips with a shopping excursion to stock up on favorite nonperishable items that we like before our return to the United States.

WHAT SHOULD WE BRING ALONG?

Until recently, paper products such as toilet tissue, facial tissue, paper towels, and napkins seemed of lesser quality to those purchased in the United States or Canada. That is beginning to change. More familiar brands of paper products seem available in the larger cities, however they tend to be more expensive in Mexican stores. Stock up on all nonperishable items that you have storage room for and would feel inconvenienced if you could not find. A limited list follows of items or brand-name products that we have found difficult or impossible to purchase in Mexico. Assume that products particular to your specific area won't be available in Mexico.

BRING WITH YOU
(Hard to find in Mexico—or pricey)

- ☑ Canned meats such as chicken, ham, and turkey for salads and sandwiches (tuna is in ample supply)
- ☑ Packaged sauce mixes (gravy, seasoning mixes)
- ☑ Canned biscuits or breads
- ☑ Pickles (sweet and dill; relish is often difficult to find)
- ☑ Favorite canned goods (i.e.; green beans, black olives)
- ☑ Favorite brands of cleaning products
- ☑ Cheddar or Colby cheese
- ☑ Spices such as Italian seasoning, thyme, rosemary, and basil
- ☑ Snack crackers such as Wheat Thins, Triscuits, Carr's Water Crackers, Better Cheddar, Goldfish, and hors d'ouerve types
- ☑ BBQ potato chips and pretzels
- ☑ Favorite brands of cookies
- ☑ Coffee
- ☑ Caffeine-free diet cola
- ☑ Specialty or gourmet favorites
- ☑ Dietary restricted food items such as sugar-free candy and snacks
- ☑ American, European, or Canadian brands of alcohol, especially scotch, rye or other whiskey.
- ☑ U.S., Canadian, or European beers.

HOW DO WE CONVERT TO METRIC?

Grocery items are sold by "dry" weight in grams and kilograms or "liquid" weight in milliliters and liters. Check the charts below for the common equivalents. A liter is just barely under a quart and 4 liters is slightly more than a gallon. If you want a pound of an item ask for a half kilo (*medio kilo*). That will give you roughly 17.6 ounces, just over a pound. For less than a pound just round up to even numbers in grams. A *cuarto kilo* is about half a pound. It's easy, even if you do not speak Spanish. Written figures are the same in most languages, so write the quantities on a piece of paper and show it to the clerk, then point to the item you wish to purchase and smile!

DRY WEIGHT	METRIC DRY WEIGHT	
2.2 pounds/*libras*	1 kilogram	(kg)
1 pound/*libra*	453.6 grams	(g)
½ pound/*libra*	226.8 grams	(g)
¼ pound/*libra*	113.4 grams	(g)
1 ounce/*onza*	28.35 grams	(g)

ENGLISH & SPANISH LIQUID MEASURE	METRIC LIQUID MEASURE
1 pinch/*pizca*	
1 teaspoon/1 *cucharadita*	.5 ml
1 Tablespoon/1 *chucharada*	15 ml
2 T = 1 fl. oz./*chucharadas*	30 ml
16 T = 1 cup/16 *chucharadas*/1 *taza*	236 ml
1 pint = 16 ounces	473 ml
1 quart = 2 pints or 32 ounces	946 ml
2.1 pints = 33.6 ounces	1 liter
4 quarts = 1 gallon or 128 ounces	3.78 liters

SEASONINGS (CONDIMENTOS)	
ENGLISH	**SPANISH**
Baking Soda	*Carbonata*
Bay Leaf	*Laurel*
Capers	*Alcaparras*
Chives	*Cebollino*
Cinnamon (ground)	*Canela Molido*
Cinnamon (stick)	*Raja de Canela*
Coriander	*Cilantro*
Coriander (sprigs)	*Ramas de Cilantro*
Cumin (ground)	*Comino Molido*
Curry	*Curry*
Dill	*Eneldo*
Garlic Powder	*Ajo en polvo*
Garlic Salt	*Sal de Ajo*
Garlic (clove)	*Diente de Ajo*
Ginger	*Jengibre*
Marjoram	*Mejorana*
Mint (dried)	*Menta Seca*
Mint (leaves)	*Hojas de Menta*
Mustard (dried)	*Mostaza Seca*
Nutmeg	*Nuez Moscada*
Onion Powder	*Cebolla en polvo*
Oregano	*Hojas de Orégano*
Parsley	*Perejil*
Pepper (ground)	*Pimiento Negra Molido*
Poppy (seeds)	*Semilla de Amapola*
Rosemary	*Romero*
Saffron	*Azafran*
Sage	*Salvia*
Salt	*Sal*
Sesame (seeds)	*Semilla de Ajonjoli*
Sunflower (seeds)	*Semilla de Girasol*
Tarragon	*Estragón*
Thyme	*Tomillo*
Vanilla	*Vainilla*
White Pepper	*Pimiento Blanca*

VEGETABLES (VERDURAS)	
ENGLISH	**SPANISH**
Avocado	*Aguacate*
Bean Sprouts	*Brotes de soya*
Broccoli	*Brócoli*
Brussels Sprouts	*Col de Bruselas*
Cabbage (Green)	*Repollo or Col*
Cabbage (Red)	*Lombarda*
Cauliflower	*Coliflor*
Carrot	*Zanohoria*
Celery	*Apio*
Chickpea	*Garbanzo*
Corn	*Elote or Maiz*
Cucumber	*Pepino*
Eggplant	*Berenjena*
Endive	*Lechuga escarola*
Fennel	*Hinojo*
Green Bean	*Judia Verde*
Green Pepper	*Pimiento Mórron Verde*
Jicama	*Jicama*
Lettuce	*Lechuga*
Mushrooms	*Champiñones*
Onion	*Cebolla*
Parsnip	*Chirivia*
Potato	*Papa*
Pumpkin	*Calabaza*
Radish	*Rábano*
Rhubarb	*Ruibarbo*
Scallion	*Cebolleta*
Shallot	*Cebollín or Chalote*
Soy Bean	*Semilla de Soya*
Spinach	*Espinacas*
Sweet Potato	*Batata*
Tomato (Cherry	*Jitomatitos Cereza*
Tomato (Red)	*Jitomate*
Watercress	*Berro*
Zucchini	*Calabacitas*

FRUITS (FRUTAS)	
ENGLISH	**SPANISH**
Apple	*Manzana*
Apricot	*Chabacano*
Banana	*Plátano*
Blackberry	*Mora*
Blueberry	*Arándano*
Cantaloupe	*Cantalupo or Melón*
Cherry	*Cereza*
Coconut	*Coco*
Cranberry	*Arándano*
Date	*Dátil*
Grape	*Uva*
Grapefruit	*Toronja*
Lime	*Limón*
Lemon	*Lima*
Mango	*Mango*
Orange	*Naranja*
Papaya	*Papaya*
Peach	*Durazno*
Pineapple	*Piña*
Pomegranate	*Granada*
Prune	*Ciruelas Pasas*
Raisin	*Pasa or Pasita*
Raspberry	*Frambuesa*
Strawberry	*Fresa*
Tangerine	*Mandarina*

The following chart should help you interpret recipes and directions found on pre-packaged food items in the stores.

COOKING TERMINOLOGY	
SPANISH	**ENGLISH**
ablandar	tenderize
agregar	add
asar	grill
azotar	whip
caldo	stock or broth
cocer a fuego bajo	simmer
cocidas	cooked
combinar	combine
cortar	cut
cubrir	cover or top
derretir	melt
destrozar	shred
disolver	dissolve
en polvo	powdered
escurrir (*vacia de liquido*)	drain
freír	fry
licuan	blend (in blender)
marinar	marinate
hervir	boil
mesclar	mix or toss
moler	grind
molido	ground
pelar	peel
picar	chop
puré	pureé
rallado	grated
rallar	grate
rebanar	slice
remover	stir
saltear	sauté
vapor	steam

What's in all those stores with the names that are so hard to pronounce? The following chart will assist you in locating items sold in specialty stores within Mexico.

SPANISH NAME	TYPE OF SHOP OR FACTORY
Bloquearía	Blocks, Bricks
Bonetería	Lingerie
Carnicería	Meat
Cervecería	Beer
Dulcería	Candy
Farmacia	Pharmacy
Ferretería	Hardware
Herrerería	Ironwork & Welding
Hielera	Ice
Hoyatería	Vehicle Body Shop
Joyería	Jewelry
Lavandería	Laundry or Laundromat
Madería	Wood, Lumber
Mercería	Thread & Sewing Notions
Mueblería	Furniture & Appliances
Nevería	Ice Milk, Frozen Fruit Bars
Paletería	Ice Cream
Panadería	Bakery
Papelería	Gift Wrap & Office Supplies
Pastelería	Pastry Shop
Peluquería	Barber Shop
Plomería	Plumbing
Pollería	Chicken
Refaccionaria	Auto Supply
Tapicería	Upholstery
Tintorería	Dry Cleaners
Tortillería	Tortillas
Zapatería	Shoes

CHAPTER 15: DINING OUT

Dining out in Mexico can be a real pleasure and a challenge. You will find a particular food in one region that you love and order it by the same name in another only to find it entirely different! Mexico is much like the United States and other countries with regional cuisines. From place to place cooks follow a few basic recipes, creating many variations on the original dishes. If you keep an open mind and have experimental tastes, you will enjoy the most wonderful meals. And even if every meal isn't the best meal, remember it's only food, not the end of the world! For those not quite so adventurous or experienced in Mexican dining, this section should assist you in ordering a meal in almost any restaurant.

WHERE TO EAT

Locating a restaurant will not be difficult; there appear to be almost as many as there are people. Competition is stiff, and it is not uncommon to be beckoned into an establishment with promise of free drinks or other enticements. Menus in both Spanish and English are becoming more and more common. In a great many restaurants, if you don't see what you want, you can request and receive a variation on a menu item with little difficulty. You will find the restaurants very accommodating. Large cities and places frequented by tourists will have familiar fast-food and pizza places such as McDonald's, Burger King, Pizza Hut, and Domino's. We have even run across a few Kentucky Fried Chicken restaurants.

A few RV parks also have restaurants on their premises. These are excellent places for great meals. Ask the locals or the RV park manager where to eat if one is not located on site. They will usually direct you to a restaurant they frequent, and you will likely not be disappointed. Larger cities have tourist directories with lots of restaurants. Places that get included are primarily the more expensive ones but they can be counted on if you are nervous about dining in unknown establishments.

TAQUERÍAS AND FOOD CARTS

You will encounter several other ways to get a bite to eat. The most obvious will be the small establishments that are set up on homemade carts, under makeshift *palapa* roofs, on sidewalk card tables, and on front porches of resident's homes. These are usually operated by one family who cooks and serves the food personally. You can eat there or get it to go (*para llevar.*)

Food fare at these outfits is normally limited to variations on the *taco*, *burrito*, or *torta*. In some areas seafood, roasted chicken, hamburgers, or hot dogs are sold. Menus are either written on a board or on the wall, or you simply just point at something you see cooking. Though lacking the best aesthetics, we have found that food stands offer delicious food at sinfully low prices. First-time travelers to Mexico usually wait a while before trusting this dining experience. We personally love eating the "street food," but it's not for everyone. Choose according to your own dietary tolerances.

COMEDORS AND LONCHERÍAS

Usually only open during breakfast and lunch hours, these restaurants offer simple, home-cooked meals. Signs may be displayed with menu specials offering *"comida económica,"* promoting their economical pricing. The term *"comida corrida"* means they have a lunch special of the day. Similar to the "blue plate special", these dishes are usually very tasty indeed. These restaurants are often tucked into small spaces throughout the commercial areas and frequented by nearby business employees. Table service is available and various types of regional cuisine are served.

FONDAS

This type of restaurant is typically a small, locally owned establishment, often with pleasant surroundings including brightly colored tablecloths and eclectic decorations. These also tend to be family owned and operated and offer savory meals at economical prices.
You will find simple, full-selection menus of national or regional cuisine as well as full bars along with attentive table service. In coastal areas such restaurants line the beaches with tables right out on the sand under umbrellas or *palapas*, allowing you to experience lovely views as you dine.

CENADURÍAS

These restaurants, like *fondas*, are family owned and often located in or near the residence. Open only for evening meals, they have menus limited to a la carte appetizer (*antojito*) type items. These could be plates of *tacos*, *tamales*, *gorditas*, *enchiladas*, *tostadas*, *birria*, *pozole* and *sopes*. The food is authentic Mexican as they would serve their family.

RESTAURANTS

The final classification is the slightly upscale or trendy restaurant that targets tourists and the more affluent Mexican. These tend to have more of the "back home" atmosphere. Many offer very extensive menus with continental cuisine while others specialize in Italian, French, Seafood, or Mexican. You'll even find Japanese, Chinese, and German restaurants in some areas.

These restaurants are concentrated in cities frequented by tourists and in or near hotels. They offer a range of cuisine from average to excellent quality. Prices are often slightly less or fairly comparable to those in the United States. Mexico also has many five-star, world-renowned restaurants in its larger cities.

Currently, the majority of restaurants in Mexico use purified water for table service as well as meal preparation. Never hesitate to ask if they use "*agua purificada*." Your request will not be received negatively.

If you are apprehensive about eating in a new place, just observe these few simple rules to help prevent problems.

 —Ask about the water they use to prepare food as well as that used for ice. If not sure, always order bottled water, beer, or sodas to drink.

 —Avoid salads and uncooked vegetables. These are the most likely to harbor surface bacteria that can cause minor digestive upset. Cooked vegetables and fruit that has been peeled is normally safe.

 —Order your meat cooked medium-well or well-done. You will rarely get food that is not well cooked. In fact, except in the upscale restaurants, you'll find most meats a bit overcooked.

TYPICAL CUSTOMS

You should be aware of several customs associated with dining in Mexican restaurants. The first is that, once you are seated at a table, you basically "own" it for the duration of your visit there. Your check will not be presented until you request it—"*la cuenta, por favor*." Mexicans consider it rude to rush anyone at a meal. You are welcome to stay at the table as long as you wish, even if you stop ordering additional food or drink.

Restaurants are usually not known for their speed of food service. Waiters will occasionally bring things out of order such as the hot meal first, then a few minutes later the silverware and condiments. You may have to request items more than once. Be patient.

No matter how small the establishment or where it is located you are likely to encounter roving musical entertainment. This may be a single musician or a large *Mariachi* band. If the musicians come to your table and you ask or allow them to provide music for you, then a tip (*propina*) is expected. If you do not wish the service, wave them away with a "no thank you" ("*gracias, no*") or enjoy the *música*. Five to ten *pesos* a song is the current going rate. If it is a full band, the rate is higher. Ask how much before the group plays or sings.

CUSTOMARY MEALS AND MEALTIMES

Desayuno (breakfast) is the first meal of the day as in most countries. During the week it typically consists of simply one or more of the following items: sweet pastries (*pan dulce*), French-style bread rolls called *bolillos*, toast (*pan tostado*), or *tortillas* served with juice and coffee. Cereals are also customarily offered.

Larger breakfasts (*almuerzo*) are usually reserved for weekends, special occasions, and holidays. Served later in the morning, they include eggs (*huevos*), and a meat item such as the bacon (*tocino*) or ham (*jamón*).

Eggs are served fried (*frito*), scrambled plain (*revueltos*), scrambled with peppers, onions, and tomatoes (*a la Mexicana*), or *ranchero* style. The last option consists of fried eggs served on a tortilla with a thin red *chile* sauce on top. This sauce can be either mild or spicy. Ask before ordering.

Another popular breakfast item is *chilaquiles* made from fried tortilla chips covered with a *chile* sauce and baked. These can also include a popular spicy sausage called *chorizo*, chicken, eggs, or other items. Pancakes and French toast are common breakfast menu choices. Beans are usually served and fried potatoes (*papas*) are occasionally available.

Many of the street stands will be open early in the morning. Food fare is usually a traditional breakfast platter or a variation on the *taco* or *burrito*. Many Mexicans stop to eat breakfast at these establishments on the way to their workplace.

Comida (second meal of the day) is comparable to lunch, although it is eaten later in the afternoon, usually between two and four o'clock. It is often the largest meal of the day.

Cena (dinner) is eaten much later in Mexico, between eight and ten o'clock in the evening. It is normally a lighter meal since the larger one was consumed in the afternoon.

THE MENU CHOICES
Following is a list of typical dishes offered for lunch or dinner and a brief description of what they generally consist of. Remember, each region has its own twists on the same cuisine. You will find most of the food contains only mild spices. *Salsa* and *chile* sauces are added by the customer at the table to spice it up to individual taste. Most basic meals are accompanied with rice, beans, and sometimes cooked vegetables.

Often you will be served fresh vegetables such as cucumbers, jicama, or carrots, sliced and sprinkled with mild *chile* powder as an appetizer, usually on the house. On the table you might also find a bowl or plate of pickled vegetables containing carrots, garlic, onions, and *chile* peppers. Approach this offering with caution. They can be mild—or extremely spicy hot.

Totopos are fried tortilla chips, often served with your beverage as a free snack (*botana or tapa*), while you are preparing to order you meal. You will have a selection of *salsas,* and if you like hot stuff (*picante*), you'll find much of it satisfying.

Tortillas are a staple of the Mexican diet. They are usually made from corn meal dough (*masa*) that is flattened into a round shape and cooked on a hot flat grill. You will find flour (*harina*) *tortillas,* especially in the northern states where wheat flour is more readily available. Fresh tortillas are sold commercially in "*tortillerías.*" A kilogram of corn (*maíz*) *tortillas* costs only 5 to 6 *pesos,* and flour *tortillas* cost slightly more. *Tortillas* are served with most meals. Mexicans eat almost anything on top of or rolled inside of one.

 Salsas are as varied as the terrain in Mexico.They are used for dipping, topping, and cooking nearly everything. Most establishments have their own special recipes, and we have yet to find canned or bottled brands to match the fresh ones. *Salsa* can be very mild or extremely hot, depending on the type of *chile* pepper from which it is prepared. Ask if it is hot (*picante*), or taste test a tiny amount before piling it on your chips or other food items. *Chile* peppers used in *salsa* preparation include *jalapeño, poblano, serrano, colorado,* or the near-nuclear hot *habanero* pepper. *Salsa* can be red, brown, or green and either pureed or chunky with lime juice, chopped tomatoes (*jitomate*), onions (*cebolla*), peppers, and *cilantro.*

Antojitos are what most people would consider appetizers or light snacks. These can be anything from chips with *salsa* or *guacamole* to small plates of *tacos, quesadillas, sopas, ceviche,* seafood cocktails, or raw vegetables. For the light eater, these items can constitute a full meal.

Guacamole is made from mashed avocado (*aguacate*) mixed with lime juice, chopped onions (*cebolla*), chopped *cilantro,* and, occasionally, tomatoes or *salsa.* It is typically mild in spices and tastes great on chips or bread. *Guacamole* is served as an accompaniment to many dishes for topping or dipping. Some of the food stands serve a version of *guacamole* that is pale green and has been pureed to a very thin and sometimes spicy sauce.

Ceviche can be made from a variety of seafood. Raw fish, scallops, squid, shrimp, and octopus—or combinations of them—are chopped with onions and *cilantro.* The mixture is then marinated in lime juice to "cook" it. *Ceviche* is served on a small, flat, crunchy *tortilla* or in a bowl for dipping with chips (*totopos*).

Aguacate relleno is a half avocado that has been stuffed with cooked shrimp or other seafood, then topped with mayonnaise, thousand island, or "Louis" type dressing.

If you are a soup lover, then you are in for a real treat. Fresh daily prepared soups (*sopas*) are delightful. Vegetable (*verduras*), bean (*frijole*), chicken, and French onion soup (*sopa de cebolla*) topped with mounds of melted cheese, are the obvious recognizable ones. Menus often offer other choices under the soup section such as spaghetti or rice soup. This is not actually soup. It will most likely be a plate of simple rice or spaghetti with butter, oil, or dry cheese mixed throughout. These are called *sopa seca* or dry soups.

Sopa de tortilla is prepared from a rich broth with a light chicken broth and tomato base. It may contain pieces of chicken, chunks of cheese, and avocado. The origin for the name comes from the crunchy strips of *tortilla* chips you will find floating throughout. *Sopa Azteca* is a variation on this soup made with different spices.

Sopa de limón (lime soup) has a clear, chicken-based broth with a bit of chicken and some vegetables. It too may contain strips of crunchy *tortillas*. The primary taste and the name is derived from the addition of enough fresh lime juice to give it a crisp, unusual flavor. Different variations are available in some regions such as *consomme de pollo* and *caldo Tlalpeño*.

A soup made from blended raw vegetables is called *Gazpacho*. This is then served cold.

Crema sopas (cream soups) are prepared from such vegetables as *chiles*, asparagus, carrots, mushrooms, or broccoli combined with cream. Served normally hot, but occasionally cold, they are a special treat if you are a vegetable lover fond of cream soups.

Pozole is offered either as the soup course or as a main dish. It consists of a base broth—goat (*cabrito*), pork (*puerco*), or chicken (*pollo*)—and contains hominy plus some or all of the following: radishes, onions, chickpeas, tomato, sausage.

A stew (*caldo*) called *Menudo* is prized throughout Mexico. It is composed of a rich dark broth with hominy, cow's feet, and tripe (stomach). In some cases, cow's intestine is used. Aficionados believe it can cure hangovers!

Birria is a rich stew with a meat base, usually goat. It is served mainly in northern and central Mexico, although you will find it in other areas. The city of Cocula near Guadalajara has been touted as having the best *birria*. We personally believe this claim could be true. Throughout the state of Mexico a similar stew is made using sheep (*borrego*) meat.

A popular sandwich offered at restaurants, as well as roadside stands, is the *torta*. This is served on a round bread roll resembling a hamburger bun. Made with a wide variety of meats, a *torta* could also include refried beans as a spread, plus onions, tomatoes, and cheese. Often these sandwiches are grilled and contain a combination of several different meats. This type of *torta* is called a *Cubana* in certain areas, particularly Oaxaca, Cuernavaca, and Veracruz. When in doubt, you can order a hamburger or cheeseburger and fries (*papas fritas*) at many restaurants.

Throughout a large portion of the country, pinto beans (*frijoles*) are a part of the daily diet. In the more southern regions, like the Yucatan, black beans are served most often. Beans may be either boiled and served like a soup or mashed into a paste and refried in lard or oil. They accompany most meals, including breakfast.

Rice (*arroz*) is also a staple. It is usually cooked either with a meat broth or a tomato-based broth, which gives it a slightly rosy tone. Bits of onions, tomato, *chile* pepper, and meat sometimes are added, depending on the particular region.

Cheese will likely be served in, on, under, or next to most any item you order. It is another staple of the Mexican diet. The country produces a variety of regional white cheeses. Many restaurants and families make a popular type of cheese called *panela*. If you are not a cheese lover, don't forget to use the following phrase when ordering any meal, "*sin queso*."

 Mexican restaurants also serve cactus. Don't worry—it's just an exotic vegetable. One form is *chayote,* cactus fruit, which you can find in markets in the United States. *Chayote* is peeled and cut into thick chunks or strips. When steamed, it resembles a cucumber but has a flavor similar to a firm zucchini squash. A second type is called *nopales*. These are actually the spiny leaves of a cactus variety of the same name. When peeled, sliced thin, julienne-style, and steamed, *nopales* resemble green beans and you may be surprised to find you have been eating cactus leaves. These are often mixed with scrambled eggs for breakfast. *Nopales* are also a popular ingredient for salads and *salsa*. Both varieties are quite tasty.

Mexican combination plates frequently contain at least two or more of the following items, along with rice and beans.

Tacos should be a familiar name to everyone. *Tacos* are fresh soft corn tortillas folded and filled with beef, pork, seafood, or chicken. Flour tortillas are occasionally used. A deep fried version is called *taco dorado.* *Tacos* will sometimes contain shredded lettuce or cabbage, and possibly cheese. Normally *tacos* are not spicy and you add *salsa* and other condiments to taste. At the local stands, you will be served the *tortillas* with the desired meat or seafood filling and you add the condiments— lettuce, cabbage, radishes, onions, *salsa*, *chile*, or *guacamole*. Some *taquerías* and other establishments have *taco* fillings of batter-fried fish, shrimp, scallops, or lobster. All are wonderful!

If you are adventurous, try the exotic fillings like *tripa* (stomach) or *cabeza*, which is the sweet, fatty meat from the head of either a goat or cow. In some regions, a *taco* is a *tortilla* containing meat or fish that has been rolled and fried crispy. These are called *flautas* or *taquitos*.

Enchiladas are corn *tortillas* that have been filled with either cheese, beef, chicken, or pork then rolled, covered with a mild red sauce and baked. These are served topped with more sauce and cheese or thick, sweet cream. In some regions, you can find *mole enchiladas* prepared with a sauce containing unsweetened chocolate, *chile,* and spices. *Enchiladas Suiza* and *enchiladas verde* are also quite popular. A green sauce is used in these recipes that may be spicy, but tasty.

Tamales consist of a corn or meat filling that has been covered by a corn-meal dough and wrapped in either corn husks or banana leaves. These are then steamed and served still in the casing. Some places change the filling to pineapple or other fruits and serve *tamales* as desserts.

Chile Relleno is a mild *poblano* pepper that has been stuffed with cheese and sometimes meat or seafood, then dipped in egg batter and fried. Occasionally served with a *chile*-based sauce, it can be mild to slightly spicy.

Quesadillas are flour *tortillas* topped with cheese and, frequently, with beef, chicken or seafood. Folded in half, they are cooked on a hot surface until the cheese melts. They are generally served with *salsa, guacamole,* and sour cream on top or on the side for dipping.

Sopes or *Pelliscadas* are small fat *tortillas* cooked in hot oil. The sides are slightly rolled up to form a shallow bowl that is filled with different ingredients such as refried beans, meat, lettuce, tomatoes, onions, and cheese. In the Yucatan these are called *salbutes*.

Gorditas are similar to *sopes*. Instead of topping it, however, the cooked *tortilla* is slit to form a pocket and served stuffed with similar items as those used to top the *sope*. Some regions fill *gorditas* with fried potatoes and mild, sweet peppers. Other areas use ground beef fried with onions, peppers and onions and called *picadillo*.

Tostados are corn *tortillas* baked or fried crisp and flat then topped with meat and assorted toppings including refried beans, lettuce, tomatoes, onions and cheese. These are similar to *sopes,* but thinner and crispier and in some areas are known as *panuchos*.

Burritos are flour *tortillas* that are wrapped around meat, poultry, or seafood. Scrambled eggs, meat, and potatoes are often used when *burritos* are served for breakfast. These are usually served without a sauce over top. Condiments for topping and filling are offered on the side. The deep-fried variety is called a *chimichanga*.

MEATS

The typical Mexican diet contains a protein source from meat, poultry, or fish. Domestic cooks use nearly every portion of the animal in some sort of recipe. Little is wasted.

Carne de res (beef) is popular. If you love tender steaks, you may be disappointed with the Mexican beef. Cooks tend to use tougher cuts of meat, filleted very thin, and often they overcook according to most standards. While grilled with a variety of spices and very flavorful, beef tends to be slightly tough. If the menu says "filet," be sure to ask whether "filet" means "filet mignon" if that's what you expect. We have found that other cuts such as New York, Rib-eye, and T-bone are often not as tender as anticipated.

Pollo (chicken) is a standard menu item. It is prepared in a wide variety of ways and is the base ingredient for many main dishes. You should be satisfied with any method of preparation since all tend to be tender, juicy, and quite tasty. If you prefer white meat only, always order the breast (*pechuga)* portions.

 Pavo (turkey) is not available in all states, but you will see it offered from time to time on menus especially in the southwestern states like Oaxaca and Chiapas. Less frequently offered items include duck (*pato*), quail (*codorniz*), and rabbit (*conejo*).

Puerco or *cerdo* (pork) is traditional in many regions. You will find it in many prepared dishes or simply served as *carnitas,* which is pig, braised in it's own fat or pit- roasted, chopped, and served with *tortillas*, cilantro, onions & lime. "*Chicharrón*" is the most prized portion. It is taken from the tender white rib meat area with some of the fat attached. The meat is juicy, tender, and delicious and is usually sold by the kilo or portions thereof. The state of Michoacán is well known for this excellent dish. It is a dangerous choice, however, if you are watching fat or caloric intake.

 Cabrito (kid goat) is common in northern Mexico and in some central regions as well. It is frequently prepared *al horno*, *asada*, *barbacoa,* or used in *birria*. Goat is also commonly called *chivo*.

Borrego (sheep) is less commonly found but offered predominantly in central and northern Mexico. It is usually prepared by the same methods as goat. Rack of lamb is a common menu item in these regions, as is *mixiote*. This dish is prepared from mutton in a spicy sauce and steam cooked in corn husks, *maguey,* or banana leaves.

Fajitas may be prepared with meat, chicken, seafood, or vegetables. These items are cut into small pieces or strips and grilled along with sliced sweet peppers, tomatoes, and onions. Combinations are also available. Served sizzling hot, fajitas are meant to be eaten wrapped in fresh hot *tortillas* and accompanied by a variety of condiments such as *guacamole*, *salsa*, onions, beans, rice, and sour cream.

Meats are commonly prepared in one of the following ways:
"Adobo or Adobado"—stewed in a *chile* sauce with spices and vinegar.
"Al Carbón"—grilled over an open wood or charcoal fire.
"Al Horno"—roasted in a very hot oven.
"Al Pastor"—thinly sliced (most often pork), marinated, and roasted slowly on a vertical spit. Usually served on *tacos* with a small piece of cooked pineapple. (Resembles a Greek-style Gyro on a *tortilla.*)
"Arrachera"—thin sliced beef skirt steak that has been tenderized, marinated, and grilled. Normally very tender and tasty.
"Asada"—grilled.
"Barbacoa"—in most regions this means pit roasted.
"La Parilla"—broiled.
"Machaca"—beef that has been cooked and shredded.
"Milanesa"—usually beef, sometimes veal or chicken, that has been filleted, then tenderized, breaded, and pan fried. (Similar to chicken-fried steak)
"Mole"—in a dark sauce made with *chile* and unsweetened chocolate. Most often served over chicken or enchiladas.
"Pipián"—a green sauce similar to *mole* and made from crushed pumpkin seeds.
"Rostizada"—usually chicken, either whole or quartered, cooked BBQ-style on a spit or an open charcoal-style grill.
"Tampiqueña"—thin sliced or filleted beef steak (*bistek*), well-seasoned and grilled.

FISH AND OTHER SEAFOOD (*PESCADO Y MARISCOS*)

In coastal regions saltwater seafood is a staple of the diet. Some interior states offer fresh-water fishes such as trout (*trucha*) and bass (*lobina*). Ocean fishes include grouper (*mero*), tuna (*atún*), red snapper (*huachinango*), yellowtail (*jurel*), mahi mahi (*dorado*), sea bass (*robalo*), and Jack crevalle (*toro*). Menus sometimes offer a generic white fish (*pescado blanco*). Commonly served either filleted or whole (*entero*), fish is cooked however you like it.

And how would you like it? Choices include:
Al mojo de ajo—pan sautéed in butter and garlic.
Al vapor—steamed.
Diablo—pan sautéed in a spicy sauce.
Empanizada—breaded and fried.
Frito—either battered or simply seasoned and pan fried in hot oil.
La Plancha—cooked on a hot iron or surface.
Veracruzana—baked and topped with a sauce made from onions, tomatoes, sweet peppers, olives and local spices.
Zarandeado—baked in foil with a slightly spicy red sauce.

Camarones (shrimp) are a prevalent seafood choice on most menus. They can be prepared in many ways, including those listed above. The choice is yours. If you want shrimp peeled before they are served, be sure to request "*sin cascara.*"

Other common seafood choices include oysters (*ostiones*), clams (*almejas*), octopus (*pulpo*), squid (*calamar*), crab (*jaiba* or *cangrejo*), scallops (*callos*), lobster (*langosta*), and fresh water lobster (*langostino*).

Small stands on many beaches grill various seafood on skewers over open wood fires. The vendors will deliver delicious shrimp or fish kebobs right to your chair. Whole fish are also prepared using this method. You flake off the tender, juicy meat and eat it on a *tortilla*. Fresh oysters on the half shell are also available at these establishments.

Seafood is a popular item served at *taco*-stands throughout Mexico. Be sure to try one along your journey. Fish or shrimp is batter fried for the *taco* filling and is especially tasty.

DESSERTS (POSTRES)

Mexico's most recognized dessert is *flan*, an egg custard served with caramelized sugar or liqueur on top. *Pasteles* are freshly prepared cakes and pies, including varieties of cheesecake. Cakes and candies called *tres leches* (three milks) and ice creams (*helados*) of various varieties are popular. Ice-cream is often home-made and sold at numerous locations. We've even tasted such unusual flavors as avocado, shrimp, corn, and cheese. Frozen fruit juice bars called *paletas* are another favorite dessert. They come in dozens of flavors and many contain chunks of fresh fruit.

Nuts and chocolate are used to top many desserts. You may also encounter small shops or street carts offering a variety of dessert crepes. Cooks will custom-make these for you using ingredients such as liqueurs, fruit, caramel, chocolate, and cream.

Candies or sweets are called *dulce*. They come in many forms. Fruits, and sometimes vegetables, are a common base for candies. Guava (*guayaba*), papaya, pineapple (*piña*), bananas (*plátanos*), sweet potato (*batata*), peach (*durazno*), and pumpkin or squash (*calabaza*) are often candied. *Tamarinda* is a native fruit that is often used. Some are pureéd, cooked, and jellied, then sold in rolls called "*en rollo*."

BEVERAGES

Bottled water, either plain or mineral (*agua mineral*) varieties, carbonated sodas (*refrescos*), and beer (*cerveza*) are the usual offerings. The beer selection, as described in the Grocery section of this guide, is quite extensive. Coca-Cola and Pepsi have the corner on the soda market in Mexico with Coke as the No. 1 seller. You will readily find all varieties of Coca-Cola, except the caffeine-free variety, which is scarce. Mexican-produced sodas are usually fruit-based, strawberry (*fresa*), apple (*manzana*), cherry (*cereza*), orange (*naranja*), or lime (*límon*). All are quite refreshing. You'll also find great fresh lemonade readily available.

Liquado is a fruit-based milk shake similar to the Orange Julius drink that used to be found in the United States. It is available at many restaurants and specialty drink shops. Many stores and roadside stands offer fresh squeezed orange juice (*jugo de naranja*). The Mexican juice orange may look unripe because it is slightly green, but you will become addicted once you taste its sweet juice, especially after it has been freshly squeezed in front of you.

Many restaurants and walkup stands offer a drink called *agua fresca*. These cool drinks are prepared from fruits, vegetables, and flowers, leaves, or seeds of native plants. The juice is mixed with water to create a lemonade-style drink. There are numerous variations on the recipe. Most establishments will cheerfully give you a small sample to taste. Try them and you'll discover a refreshing change from sodas.

Horchata de arroz, a popular drink made with this recipe, has a milky white appearance and is prepared from rice. *Jamaica* is grape-colored and the flavor is unique and delicious. It is made from dried hibiscus flowers. Another fruit based beverage is *Tepache*, a cider-like drink made from the rinds of pineapple with brown sugar and cloves. *Tejuno* is sold at many carts along the streets. It is made from a corn base with salt and lime and served cold. *Tuba*, is created from heart of palm juice. You will see vendors on the streets serving this from large gourds.

Hot chocolate can be a special treat if this is one of your favorite beverages. Most places prepare it from fresh chocolate that has been ground by hand. Hot milk is then added for a delicious steaming drink.

Another popular drink, especially in northern Mexico, is *Atole*. It is made from a corn base with milk, vanilla, and cinnamon, with other flavors sometimes added. Thick and served hot, it is great in the morning for breakfast from one of the many sidewalk stands.

Specialty coffee houses are quite common throughout Mexico today, especially in the cities. They offer espresso, mocha, latte, and regular coffee along with pastries or light foods. Veracruz has a famous restaurant called the *Parroquia* that serves hot espresso in a cup. Waiters later pour the hot steaming milk into it when you beckon them by clinking a spoon on the side of your cup.

Mixed alcohol drinks are commonly offered, even in small establishments. Mexico is the birthplace of *tequila* made from the blue agave plant. Promoters of *tequila* are spreading the word throughout the world that this liquor deserves a place as a quality bottle on the connoisseur's shelf.

The varieties of *tequila* are as endless as the flavors. Pure *tequila* will be made from 100 percent agave sugar. It can be clear (*blanco*), freshly distilled and not aged; *reposado,* which is aged in oak barrels or vats for at least 30 days; or *añejo,* which is aged a minimum of a year. Premium *tequila* varieties are aged 3 years and more. These are the most expensive and are simply sipped straight as you would a fine brandy or cognac.

To learn more about this popular, legendary drink, you can visit and taste test at one of the many *tequila* specialty stores found in larger cities. You might also consider a visit to the town of Tequila near Guadalajara. There you can be treated to a fun and educational tour of one of the many factories (*fábricas*). Contrary to popular belief, *tequila* does not contain a worm in the bottle. The worm is only found in some varieties of *Mezcal,* which is made from an entirely different variety of agave plant, the *maguey*. The worm is used as a marketing ploy and there are many good varieties of *Mezcal* available.

Another alcohol drink similar to tequila is called *Raicilla*. It is produced in Jalisco from the *lechugilla* variety of agave. The state of Chihuahua has its own specialty liquor called *Sotol* which is made from another member of the agave family, the *sotol*.

CHAPTER 16: ENTERTAINMENT

MOVIES

If you are a movie buff, bring a supply of videotapes or DVDs along on the trip. This will give you occasional evening diversion from the traveling routine. Some people find that they need a "fix" of life back home from time to time.

Larger cities have Blockbuster Video rental stores that stock new movies in English with Spanish subtitles. Even small towns have some sort of video rental outlet. Most of their movies for rent are in English with Spanish subtitles. This is a great way to learn or practice your Spanish. You may have to leave a signed credit card receipt (voucher), which you get back on return of the movies. If remaining in the same area for a while, you may also apply for a membership card. Most local movie theaters offer first-run movies in English with Spanish subtitles. Movies made for children will be in Spanish. If the poster at the box office does not state the language, ask the ticket agent if it is in *Inglés*.

REGULAR TELEVISION RECEPTION

The larger population areas have at least one or more television stations in Spanish. Usually the programming amounts to rebroadcast material from Mexico City stations. If you don't speak Spanish, this a wonderful way to practice the language. It's fun to try and figure it out—and rewarding when you begin to understand.

In parks that have long term seasonal residents, you might find cable television service with English language stations. Others have satellite service for the park and rebroadcast it locally for their customers. These are exceptions, so don't expect to find such service in many RV parks.

SATELLITE TELEVISION

You can obtain satellite television while in Mexico through either DirectTV or STAR System. Both companies offer plans at economical prices with a variety of English language channels available. Visit the offices located in most Mexican cities to learn about these service plans.

It is possible to receive the U.S.-based DirectTV or Dish networks service in many areas by using a 40-inch dish connected to your system. We have spoken to people who claim to receive programming as far south as the Puerto Vallarta with this larger dish. The 18-inch dish only receives signal 100 miles south of the border.

The Canadian company, Star Choice uses an 18-inch dish which receives signal throughout Canada, the United States, and Mexico. They offer programming with Canadian and U.S. based network stations. We have seen it in use throughout the country. Check their service options out online at http://www.starchoice.com.

LOCAL CONCERTS AND DANCE PRESENTATIONS

When you are staying in or near a larger city, you will likely have access to wonderful, and often free, evening entertainment. Many cities and villages with a *Zócalo* (town square) have regular presentations, especially on the weekends. The Mexican custom is to gather in this area in the evenings; Sundays are family day at the *Zócalo*. You will be treated to some extraordinary dance and song presentations if you venture out to see them. You will be amazed at how lively the cities are at night. Joining in the local culture is one of the enriching benefits of traveling in Mexico.

Check with the local tourist bureau or your campground manager for details and event schedules. Look for handouts and the free local papers that offer tourist tips. You'll find these at hotels and information booths. Fellow RV travelers are also a great source of information about the local events and sites to see.

CHAPTER 17: MISCELLANEOUS ITEMS AND TIPS

LAUNDRY

The coin-operated, self-service laundromat almost doesn't exist in much of Mexico. However, you should have no trouble locating a full service *lavendería*. Attendants will wash, dry, and fold your clothes for just a few cents more than you can do it yourself in the United States. Ironing is also available on request for a nominal charge. Price is usually assessed by weight—either a set rate per kilogram or a flat rate by the load. Same day or at least overnight service is usually available and a few RV parks have on-site laundries or offer contacts to local services who pick up and deliver. Some services are better than others, but in all the years using them we have only once had an item damaged by the use of bleach. We get so spoiled that it is hard to readjust to self service when returning home.

TIPS FOR USING THE LAVENDERÍA:

1) Choose one where you can see the machines or know that they have proper operating washers and dryers.

2) Always sort your clothing (*ropa*). Separate light, dark, and delicate items, and request that they be washed separately (*separado*).

3) Keep a list of items sent.

4) Put your name and RV park name in each bag. To sort and carry our laundry, we purchased inexpensive, bright-colored, woven market bags with handles and zipper closings.

5) State specific instructions in writing with each bag such as whether or not to use bleach (no *blanqueador*), ironing (*plancha*), or line dry (*seca línea*) requested.

PUBLIC RESTROOM FACILITIES
This delicate subject is rarely covered in the travel books that we have read. Most people, women in particular, are not prepared for what they may find in Mexico's public facilities. Except in major tourist areas and in more upscale dining restaurants, the restrooms (*baños*) will not likely meet your standards. Many do not have toilet seats (we jokingly call these hovercraft), and it is rare to find toilet paper available.

In Mexico most older sewer systems cannot handle paper products being flushed through them. You will find waste baskets in the bathrooms for deposit of the paper. It is not just a custom to do so, but a necessity to avoid severe plumbing problems.

Many public areas will charge a *peso* or so for the use of their facilities. A few even include tissue paper with that fee. We suggest that you always carry paper with you when you are going out shopping, exploring, and eating out. Small, travel-size packages of facial tissues are just right for such occasions. When restroom attendants are present, it is customary to tip them a few *pesos*.

HAIRCUTTING AND BEAUTY SERVICES
We have had good experiences with these services in Mexico. Men seeking a simple hair cut (*corte de pelo*) should look for a *Peluquería*. Women's salons are called *Estéticas*. Many of them are unisex and a full range of services can be found, including cuts, styles (*peinar*), permanent waves (*permanente*), hair coloring (*teñir*), and manicure (*manicura*) services. The larger cities will have the best selection; the tourist areas seem to have more operators who have experience with different hair types and current cuts and styles.

Most of the larger malls have product-specific salons like those in the United States, such as Paul Mitchell. Prices will be considerably less than you are probably accustomed to paying. Beauty-supply vendors can also be found in many areas. These are open to the public and stock many professional and familiar brand-name supplies.

PETS

Your dogs or cats should be no problem while in Mexico.
(Note, however, that a health certificate is required. See below.)
Birds and exotic pets such as reptiles require special permits
to enter and exit Mexico. In larger, more affluent cities and
towns, domestic pets are kept and pampered. In the very poor
regions, domestic pets are a rarity. Yours will likely be a source
of much curiosity in those areas. The poor have enough problems feeding
and caring for their families. Dogs and cats are merely part of the general
animal population and considered little more than a nuisance.

You may be appalled at the overall disregard for animals that we consider
prized companions. The stray dog population in many places is large
because of uncontrolled breeding. While numerous, unrestrained, and
often malnourished, few are aggressive.

 Keep your pets restrained, on leash at all times. This
will avoid possible contact with unknown or diseased
animals. Always pick up after your animal, even though
others may not. This also makes a good-neighbor policy
in the RV parks.

Get your pet a health checkup and stock a supply of
necessary items such as shampoos, flea-repellent
products, and medications. Veterinary supply vendors are
pretty common, mostly for livestock, but they also carry
domestic pet items. Grooming services are available in
larger population areas. Most cities also have veterinary
doctors and clinics for domestic pets.

You are required to have an international veterinary health certificate (form
77-043) for transporting any pet into Mexico. This form must signed by a
veterinarian not more than 30 days before entry into Mexico. A rabies
vaccination is required within six months of your re-entry at the U.S. border.
Therefore, if the interval between the last rabies shot and the time you plan to
return will be longer than six months then your pet should be revaccinated
before departure. You probably won't be asked for the health papers within the
country but will need them when returning through the U.S. border points.

PUBLIC TRANSPORTATION

Mexico's public transit system is efficient, inexpensive, and comprehensive. The vast majority of Mexican citizens do not own automobiles. Within cities and towns you will find it simple to use. Buses are all marked with the destinations on the front and frequently run back and forth on specified routes. Fares are normally from one to three *pesos,* depending on the city. We suggest you take at least one ride on a local city bus—just to experience part of Mexican daily life. *Colectivos* are smaller buses or vans, usually Volkswagens, that follow a very loose schedule along a route to pick up anyone waiting for a ride.

Taxis are great way to get around a city. Municipalities have standard, government-regulated, basic taxi rates for their areas. In larger cities, rates are specific to an area. The rate is always a flat rate for the entire car, whether carrying one or four persons. Pooling a cab with someone else going to the same destination is very cost-effective. Drivers must be licensed. An official taxi driver will have an ID card issued by the municipality. Most drivers either wear their license or post it visibly on the dash of their vehicle. One should always err on the side of caution and request to see that license before entering the cab, especially in Mexico City. There, tourists have been victims of fare abuse by illegal and unlicensed taxi drivers who use vehicles marked like other cabs but do not adhere to the rate standards. You could pay exorbitant prices if you unwittingly use an unlicensed taxi. Be safe—ask to see the license.

Using a taxi saves parking headaches as well as the need to navigate traffic in unfamiliar territory. Always ask *¿cuánto cuesta?* (what is the cost?), and agree on the price for your destination before getting in the cab. Fares at night are usually slightly higher than during the day. Tipping drivers is optional even though some will boldly ask for one. We tip if the driver was courteous, conversational, or gave us extra information. Drivers can also be "hired" for special side tours or simply just for daily touring, usually at pretty fair prices. Many speak English, along with other languages, and their knowledge of the city makes them excellent guides.

CHAPTER 18: NATIONAL AND RELIGIOUS HOLIDAYS

JANUARY (*ENERO*)

January 1 ~ *Año Nuevo* (New Year's Day)
Celebrated as in most countries with parties, fireworks and family gatherings. These celebrations tend to be very elaborate, often lasting for twenty-four hours or more.

January 6 ~ *Día de los Santos Reyes* (Day of the King Saints)
This ritual day ends the Christmas festivities in Mexico. It celebrates the arrival of the three wise men and their gifts to the Christ child. Mexican families will gather and exchange Christmas presents on this day. A special cake called *rosca de reyes* is served with a figurine inside. The person who gets this symbol hosts a party, called a *candelaria*, for all present on February 2 to honor the day the Christ child was presented to the people in Jerusalem.

January 17 ~ *Feast Day of San Antonio de Abad*
On this religious holiday, animals are allowed to enter the churches for a special blessing by the Catholic priests. People bring their household pets as well as farm animals to the churches for this event.

FEBRUARY (*FEBRERO*)

February 5 ~ *Día de la Constitución* (Constitution Day)
Official government holiday to commemorate the signing of the Mexican constitution.

February 24 ~ Flag Day

The official national holiday to honor the Mexican flag. Schools host parades and many towns have small celebrations in their zocalo on this day.

February/March ~ *Carnavál* (Carnival)

This actual date each year coincides with the beginning of the Catholic observation of Lent. This five-day festival starts the weekend before Lent. The word is derived from the Italian phrase *"carne vale,"* which means "flesh taken away," denoting the last celebration of carnal pleasures before the forty-day Lent period preceding Easter. Huge festivals and parades with floats, dancing, music, and elaborate costumes are held in the streets, reminiscent of Mardi Gras in New Orleans. Port cities like Acapulco, Vera Cruz, Mazatlán, Campeche, Tampico, Ensenada, and La Paz are the traditional hosts of these *Carnavál* Festivals. One Mexican custom is to break colored confetti-filled eggs over the heads of friends and family members.

MARCH (*MARZO*)

March 21 ~ Birthday of Benito Juárez

An official holiday to celebrate the birth of one of Mexico's most beloved presidents. Benito Juárez, a *Zapotecan* Indian lawyer and the first indigenous president, was known as the president of the people. He was elected in 1861 and was known for his substantial educational and economic reforms.

MARCH (*MARZO*) OR APRIL (*ABRIL*)

Semana Santa (Holy Week)

Easter is the most widely celebrated and important holiday of the year, second only to Christmas. Nearly everyone in Mexico receives time off work and school during the week before and the week after Easter Sunday (*Domingo de Gloria*). Mexican families traditionally vacation during this week, with many flocking to the beach areas. Several cities celebrate with re-enactments of the Passion, including the procession of the Penitents and the crucifixion.

MAY (*MAYO*)

May 1 ~ *Primero de Mayo*

A national holiday much like the Labor Day holiday that is observed in the United States. It is also known as International Worker's Day.

May 5 ~ *Cinco de Mayo*

The French invaded Mexico's gulf coast port city of Puebla de los Angeles in 1862. This celebration honors of the defeat of the French by the Mexicans. It has somehow become more important in the United States, and observance of this date is more prevalent there than in Mexico itself. Traditions include festive parties with dance, music, food, and pageants.

May 10 ~ *Día de las Madres* (Mother's Day)

In the Mexican culture, mothers are considered extremely important. Mother's Day celebrations are traditionally very elaborate. Families gather for meals, and many towns host dances with live music.

JUNE (*JUNIO*)

June 1 ~ Navy Day

An official national holiday celebrated in honor of Mexico's Navy.

SEPTEMBER (*SEPTIEMBRE*)

September 8 ~ *Día de Nuestra Señora*

Local to the Baja peninsula, this holiday is in honor of the first mission established 1697 in Loreto, Baja California, by the Spanish Jesuit, Padre Juan Maria Salvatierra.

September 16 ~ *Fiesta Patria de la Independencia* (Mexican Independence Day)

This holiday celebrates the independence of Mexico from the Spanish. In 1810, Father Miguel Hidalgo declared the beginning of the revolt against Spanish domination in the town of Dolores, located in the state of Guanajuato. His speech was known as *El Grito de Dolores* and was the signal that began a fierce, bloody eleven-year war for independence from the Spanish rule that ended in 1821.

OCTOBER (*OCTUBRE*)

October 12 ~ *Día de la Raza*

Commemorates the arrival of Columbus in the Americas. It is considered the historical founding of the Mexican people in the late fifteenth century.

NOVEMBER (*NOVIEMBRE*)

November 1 & 2 ~ *Día de los Muertos* (Day of the Dead)

These days are a celebration of the dead. The first is in correspondence to Europe's All Saint's Day. The second revolves around the Aztec worship of the dead. Families honor their dead relatives with parades and visits to cemeteries, which they decorate. They bring offerings and spend time eating and drinking. It is the third most important Mexican holiday. Some towns have extensive festivals and celebrations.

November 20 ~ *Día de la Revolución* (Mexican Revolution Day)

A celebration of the anniversary of the start of the Mexican revolutionary war, which began in 1810. Although Father Hidalgo issued his cry to war, *Grito de Dolores,* in mid-September, fighting did not actually start until November 20, the official day of this observance.

DECEMBER (*DECIEMBRE*)

December 12 ~ *Día de Nuestra Señora de Guadalupe*

Mexico's patron saint is the *Virgin of Guadalupe*. The holiday is observed with a feast. Festival activities and Mariachi masses are held on the Sunday closest to December 12. Any town with a church named for this saint will see large crowds who travel from surrounding areas.

December 16 ~ *Las Posadas*

This marks the beginning of the long season of Christmas celebrations. Candlelight processions (*posadas*) are held for nine consecutive nights ending at nativity scenes. This marks Joseph and Mary's search for lodging before the birth of the Christ child. *Las Posadas* ends with *Día de los Santos Reyes* celebrations on January 6.

December 25 ~ *Navidad* (Christmas Day)

Celebration of the Christian holiday to honor the birth of Christ. Beginning at midnight on this day, Catholic churches hold masses continually for the next twenty-four hours.

Expect government offices to be closed for all national holidays. Most are also closed for the major religious holidays. Other businesses do not follow a specific pattern for holiday closures. Retail stores are traditionally closed on Sundays with a few exceptions. Large grocery markets are often open seven days a week. In major tourist areas, you will find many types of stores that remain open on holidays and even on Sundays. For one day prior to and on voting day for national public officials, it is illegal to sell or serve alcohol in Mexico. However, a few hotels and restaurants in towns frequented by tourists may serve alcohol to non-residents in specified lounge areas or with meals.

Holiday travel during Semana Santa is extremely heavy. Highways are crowded, especially those leading to and from the beach cities. Hotels in those cities will be filled to capacity. Beaches will be exceptionally busy and campgrounds filled with large Mexican families camping in tents and vans, along with the occasional small RV. Plan your travel and activities during that time period accordingly.

CHAPTER 19: GENERAL INFORMATION

The following chapter contains important addresses, telephone numbers & websites that should be helpful both before and during your travels to Mexico. Before you depart, you may want more specific information on the country or on the individual states you plan to visit. Contact information for Foreign Embassies & Tourism offices is provided. The Internet has become very useful in obtaining information. Be advised however that some sites do not contain updated information so do your homework diligently.

Many RV manufacturers have special clubs and organize tours for their members. Check with the specific manufacturer of your rig. FMCA and Escapees also have chapters which specialize in Mexico travel and organize group tours.

RV tour companies who provide organized and guided tour services to Mexico destinations are listed below.

Fantasy RV Tours
(800) 952-8496
http://www:fantasyrvtours.com

Tracks to Adventure
(800) 351-6053
http://www.trackstoadventure.com

Adventure Caravans
(800) 872-7897
http://www.adventurecaravans.com

Copper Canyon Tours
1-800-213 8098
http://www.coppercanyonrvtours.com/

Other contacts you might require are as follows:

CANADIAN CUSTOMS SERVICE
Website: http://www.cbsa-asfc.gc.ca/travel/canadians-e.html
Info on Canadian customs requirements and restrictions.

FERROMEX CHEPE (RAILROAD OFFICE)
Information on passenger railroad travel, ticketing and schedules to the Copper Canyon and throughout Mexico.
(from the U.S. or Canada)
Tel: 011-52 (521) 439-7212 From US or Canada
Toll free from within Mexico: 01 (800) 122-4373
http://www.chepe.com.mx/ing_html/index.html
Other great Copper Canyon websites:
http://www.mexicoscoppercanyon.com/chepe.htm
http://www.canyontravel.com/

GREEN ANGELS (EMERGENCY HIGHWAY ASSISTANCE)
The drivers are bilingual and provide mechanical help, first aid, radio-telephone communication, basic supplies and small parts, towing, tourist information, and protection. Services are free, and spare parts, fuel, and lubricants are provided at cost. Service is available 24 hours a day, seven days a week. In the event of a highway breakdown or emergency you can call the toll-free number: 01 (800) 903-9200.

GUÍA ROJI (ATLAS DE CARRETERAS)
Treaty Oak
P. O. Box 50295
Austin, TX 78763 Tel: U.S: (512) 326-4141
World Wide Books & Maps at:
www.worldwidebooksandmaps.com
Also available online from Amazon.com.
http://www.amazon.com/Guia-Roji-Mexico-Tourist-Atlas/dp/9706211764

DEPARTMENT OF FISHERIES
For full details on importing your boat into Mexico you can check one of the following websites.
http://www.mexonline.com/boatmex.htm or

SECTUR **TRAVEL HOTLINE** (MINISTRY OF TOURISM)
Toll-free from the interior of Mexico: 01 (800) 987-8224
Toll-free from the United States: 1 (888) 401-3880
Av. Presidente Masaryk No. 172, Col. Chapultepec Morales,
C.P. 11587, Mexico, D.F. Email: correspondencia@sectur.gob.mx
Website: http://www.sectur.gob.mx/wb2/securing/sect_2_home
This agency has personnel available twenty-four hours a day to answer
questions or provide emergency travel assistance .

SEA OF CORTEZ FERRY

The ferry service offers both passenger and vehicle crossings between
several points on the mainland and Baja. For specific contact information
regarding crossing the Sea of Cortez by Ferry you can access the
following websites:
http://www.mexconnect.com/mex_/mexicoferryw.html
http://www.sanbornsinsurance.com/ferry.html

UNITED STATES CUSTOMS SERVICE

Department of the Treasury
Washington, DC 20229
Telephone number from the U.S: (202) 927-6724
Website: http://www.cbp.gov/xp/cgov/toolbox/publications/travel/
For pamphlets that explain all customs requirements and restrictions for
returning from Mexico. Ask for the publication *Know Before You Go—
Customs Hints for Returning U.S. Residents,* as well as any others they
suggest and provide. We suggest obtaining and reading these free guides
before you depart.

U.S. STATE DEPARTMENT

2201 C Street NW
Washington, DC 20520
Overseas citizen services Hotline for American Travelers:
(202) 501-4444
Website: http://travel.state.gov

AMERICAN EMBASSIES &
AMERICAN CONSULAR SERVICES IN MEXICO

NOTE:
If calling from outside Mexico, add 011-52 before these telephone numbers when you dial. If calling from another city within Mexico dial 01 before number.

OFFICIAL U.S. EMBASSY
DISTRITO FEDERAL - MEXICO CITY
Paseo de la Reforma 305
Col. Cuauhtémoc
CP 06500 Mexico, D.F
Tel: (55) 5-080-2000
Fax: (55) 5-511-9980
http://mexico.usembassy.gov/index.html

BAJA CALIFORNIA - TIJUANA
CONSULAR SERVICES FOR ALL OF
BAJA CALIFORNIA
Avenida Tapachula 96
Colonia Hipodrómo
CP 22420 Tijuana, Baja Ca. Norte
Tel: (664) 622-7400
Fax: (664) 686-1168
Hours: 8 a.m. to 5 p.m., Monday though Friday. After business hours, call the San Diego answering service by dialing (from Mexico) 001-619-692-2154.
http://www.traveltobaja.net/

BAJA CALIFORNIA - CABO
Blvd. Marina Local C-4
Plaza Nautica Col. Centro
CP 23410 Cabo San Lucas, B.C.S.
Tel.: (624) 143-3566
Fax: (624) 143-6750
Email: usconsulcabo@hotmail.com

CHIHUAHUA - CIUDAD JUÁREZ
Av. Lopez Mateos 924 Nte.
CP 32668 Ciudad Juarez, Chihuahua
Tel: (656) 613-1655
After hours: (656) 265-8484
Fax: (656) 616-9056
http://ciudadjuarez.usconsulate.gov/wwwhmain.html

COAHUILA - CD. ACUÑA/DEL RIO
Lerdo 450 Sur, Colonia Centro
CP 26200 Ciudad Acuña, Coahuila
Tel: (877) 772-8179
After hours: (877) 788-5083
Email: usacuna@yahoo.com

COAHUILA - PIEDRAS NEGRAS
Abasolo 211, Local #3, Colonial Centro
CP 26700 Piedras Negras, Coah.
Tel: (878) 782-5586, 8664
After hours: (878) 788-0343
Fax: (878) 782-8707
usconsularagencypn@hotmail.com

AMERICAN CONSULAR SERVICES IN MEXICO

GUANAJUATO - SAN MIGUEL DE ALLENDE
Dr. Hernandez Macias 72,
S. Miguel de Allende, Guanajuato
Tel: (415) 152-2357
Fax: (415) 152-1588
After hours: (415) 152-0068
Email: coromar@unisono.net.mx

GUERRERO - ACAPULCO
Hotel Cont. Emporio Costera
M. Aleman 121-Local 14
CP 39670 Acapulco, Guerrero
Tel: (744) 469-0556
Fax: (744) 484-0300
Email: consular@prodigy.net.mx

GUERRERO - IXTAPA/ZIHUATANEJO
Hotel Fontan, Blvd. Ixtapa
Ixtapa, Zihuatanejo
Tel: (755) 553-2100
Fax: (755) 554-6276
CP 40880 Zihuatanejo, Guerrero
Email:
consularixtapa@prodigy.net.mx

JALISCO - GUADALAJARA
Progreso 175
CP 44100 Guadalajara, Jalisco
Tel: (33) 3-825-2700, 2998
After hours: (33) 3-826-5553
Fax: (33) 3-826-6549
http://www.usembassy-mexico.gov
/guadalajara/guadalajara-eng.htm

JALISCO - PUERTO VALLARTA
Paradise Village Plaza, Paseo de los
Cocoteros #1, Local #4, Interior
#17, Nuevo Vallarta
Tel: (322) 222-0069, 3301
After hours: (33) 3-268-2145
Fax: (322) 223-0074
http://www.usembassy-mexico.
gov/guadalajara/Vallarta.htm

NUEVO LEÓN - MONTERREY
Avenida Constitucion 411 Poniente
CP 64000 Monterrey, Nuevo León
Tel: (818) 345-2120
Fax: (818) 342-0177
http://monterrey.usconsulate.gov/m
emty.htm

OAXACA - OAXACA
Macedonio Alcala No. 407,
Interior 20
CP 68000 Oaxaca, Oaxaca
Tel: (951) 514-3054, 2853
Fax: (951) 516-2701
Email:
conagent@prodigy.net.mx

QUINTANA ROO - COZUMEL
Plaza Villa Mar en El Centro,
Plaza Principal, Parque Juárez
entre Melgar y 5a. Ave., 2nd floor,
CP 77600 Cozumel, QR.
Tel: (987) 872-4574, 872-4485
Fax: (987) 872-2339
Email: usgov@cozumel.net

AMERICAN CONSULAR SERVICES IN MEXICO

QUINTANA ROO - CANCUN
Plaza Caracol Dos, Segundo Nivel
No. 320-323, Blvd. Kukulkan, Km.
8.5, Zona Hotelera
CP 77500 Cancun, Q.R.
Tel: (998) 883-0272
Fax: (998) 883-1373
After hoursl: (998) 845-4364
From other cities in Mexico:
045 (998) 845-4364
Email: uscons@prodigy.net.mx

SAN LUIS POTOSÍ - S. LUIS POTOSÍ
Edificio "Las Terrazas"
Ave. Venustiano Carranza
2076-41 Col. Polanco
CP 78220 San Luis Potosí, S.L.P.
Tel: (444) 811-7802
Fax: (444) 811-7803
Email: usconsulslp@yahoo.com

SINALOA - MAZATLÁN
Hotel Playa Mazatlán, Playa
Gaviotas No. 202, Zona Dorada
CP 82110 Mazatlán, Sinaloa
Tel./Fax: (669) 916-5889,
Email: mazagent@prodigy.net.mx

SONORA - HERMOSILLO
Calle Monterrey #141 Poniente,
Col. Esqueda,
CP 83260 Hermosillo, Sonora
Tel: (662) 289-3500
http://usembassy.state.gov/
hermosillo/

TAMALUIPAS - NUEVO LAREDO
Calle Allende 3330, Col. Jardin
Nuevo Laredo, Tamaulipas
Tel: (867) 714-3954
After hours: From within Nuevo
Laredo: 044 (867) 727-2797
From other cities in Mexico:
045 (867) 727-2797
http://nuevolaredo.usconsulate
.gov/

TAMAULIPAS - MATAMOROS
Avenida Primera #2002 y Azaleas,
CP 87330 Matamoros, Tamps.
Tel: (868) 812-4402
After hours: 044 (868) 818-1507
From other cities in Mexico:
045 (868) 818-1507
http://matamoros.usconsulate.gov/

TAMAULIPAS - REYNOSA
Calle Monterrey #390
esq. Sinaloa Col. Rodriguez,
CP 88630 Reynosa, Tamps.
Tel: (899) 923-9331, 923-8878
Fax: (899) 923-9245,
Email:
usconsulreynosa@hotmail.com

YUCATÁN - MÉRIDA
Calle 60 No. 338 K x 29 y 31,
Colonial Alcala Martin
CP 97000 Mérida, Yucatán
Tel: (999) 942-5700
http://merida.usconsulate.gov/

CANADIAN EMBASSY & CONSULATES IN MEXICO

EMBASSY OFFICE - MEXICO CITY
Calle Schiller No. 529
Col. Bosques de Chapultepec
Del. Miguel Hidalgo
CP 11580 Mexico, D.F.
Tel: (55) 5-724-7900
Fax: (55) 5-724-7980
Email: enqserv@dfait-maeci.gc.ca

CANADIAN CONSULAR SERVICES:
Website:
http://www.canada.org.mx

JURISDICTION:
ACAPULCO, GUERRERO STATE
Centro Comercial Marbella,
Local 23, Prolongación Farallon
s/n, esq. Miguel Alemán
CP 39670 Acapulco, Guerrero
Tel: (744) 484-1305 / 481-1349
Fax: (744) 484-1306
Email: acapulco@canada.org.mx

JURISDICTION: CANCUN, QUNTANA ROO STATE
Plaza Caracol II, 3rd floor,
Local 330, Blvd. Kukulkán km.8.5
Zona Hotelera
CP 77500 Cancún, Quintana Roo
Tel: (998) 883-3360 / 3361
Fax: (998) 883-3232
Email: cancun@canada.org.mx

JURISDICTION: COAHUILA, NUEVO LEÓN & TAMAULIPAS STATES
Edif. Kalos, Piso C-1, Local 108-A
Zaragoza 1300 Sur y Constitución
CP 06400 Monterrey, Nuevo León
Tel: (81) 8-344-2753, 8-344-3200
Fax: (81) 8-344-3048
Email:
monterrey@international.gc.ca

JURISDICTION: JALISCO STATE (EXCEPT THE COAST)
World Trade Center, Av. Mariano
Otero # 1249, Piso 8, Torre Pacífico
Col. Rinconada del Bosque
C.P. 44530 Guadalajara, Jalisco
Tel: (33) 3-671- 4740
Fax: (33) 3-671- 4750
Email: guadalajara@canada.org.mx

JURISDICTION: JALISCO STATE PUERTO VALLARTA AREA
Edificio Obelisco Local 108
Avenida Francisco Medina
Ascencio # 1951
Zona Hotelera Las Glorias
CP 48300 Puerto Vallarta, Jalisco
Tel: (322) 293-0098 / 293-0099
Fax: (322) 293-2894
Email: vallarta@canada.org.mx

JURISDICTION: MAZATLAN, SINALOA STATE
Avenida Playa Gaviotas # 202,
Local 9, Zona Dorada
CP 82110 Mazatlán, Sinaloa
Tel: (669) 913-7320
Fax: (669) 914-6655
Email: mazatlan@canada.org.mx

JURISDICTION: OAXACA, CHIAPAS STATES
Pino Suarez 700, Local 11 B
Multiplaza Brena, Col. Centro
CP 68000 Oaxaca, Oaxaca
Tel: (951) 513-3777
Fax: (951) 515-2147
Email: oaxaca@canada.org.mx

JURISDICTION: BAJA CALIFORNIA SUR (NORTH)
Germán Gedovius # 10411-101
Condominio del Parque, Zona Rió
CP 22320 Tijuana, B.C.N
Tel: (664) 684-0461
Fax: (664) 684-0301
Email: tijuana@canada.org.mx

JURISDICTION: BAJA CALIFORNIA SUR (SOUTH)
Plaza José Green, Local 9
Blvd Mijares s/n, Col. Centro
CP23400 San José del Cabo, B.C.S.
Tel: (624) 142-4333
Fax: (624) 142-4262
Email: loscabos@canada.org.mx

GERMAN EMBASSY IN MEXICO

EMBASSY OFFICE - MEXICO CITY
Horacio 1506, Col. Los Morales,
Seccion Alameda
CP 11530 Mexico, D.F.
Tel: (55) 5-283 2200
http://www.mexiko.diplo.de/Vertret
ung/mexiko/de/Startseite.html

UK EMBASSY IN MEXICO

EMBASSY OFFICE - MEXICO CITY
Río Usumacinta 26,
Col Cuauhtémoc
CP 06500 México DF
Tel: (55) 5-242-8500
Fax:(55) 5-242-8517
http://www.britishembassy.gov.uk/

SPANISH EMBASSY IN MEXICO

EMBASSY OFFICE - MEXICO CITY
Galileo, 114 Colonia Polanco
CP 11560 Mexico, D.F.
Tel: (55) 5-282-2974, 2271
Fax: (55) 5-282-1302, 1520

NOTE:
If calling from outside Mexico, add 011-52 before these telephone numbers when you dial. If calling from another city within Mexico dial 01 before number.

MEXICAN GOVERNMENT TOURISM OFFICES

You may request specific or detailed travel information from one of the Mexican Secretariat of Tourism office (*SECTUR*) before you travel. A list follows with locations of these offices in the United States, Canada and individual state offices within the country of Mexico.

 USA

CALIFORNIA
1880 Century Park East Ste. 511,
Los Angeles, CA 90067
Tel: (310) 282-9112
Toll Free: 1 (800) 446-3942
Fax: (310) 282-9116
http://www.visitmexico.com

FLORIDA
5975 Sunset Drive #305,
South Miami, FL 33143
Tel: 786-621-2909
Toll Free: 1 (800) 446-3942
Fax: (305) 718-4098
http://www.visitmexico.com

ILLINOIS
300 N. Michigan, 4th Floor
Chicago, IL 60601
Toll Free: 1 (800) 446-3942
Fax: (312) 606-9012
http://www.visitmexico.com

NEW YORK
400 Madison Avenue #11c
New York, NY 10017
Toll Free: 1 (800) 446-3942
http://www.visitmexico.com

TEXAS
4507 San Jacinto, Suite 308
Houston, TX 77004
Toll Free: 1 (800) 446-3942
Fax: (713) 772-6058
http://www.visitmexico.com

 CANADA

BRITISH COLUMBIA
999 West Haisting, Ste. 1610
Vancouver, British Columbia
V6C 2W2
Tel: (604) 669-2845
Fax: (604) 669-3498
http://www.visitmexico.com

ONTARIO
2 Bloor St. West, Ste. 1502
Toronto, Ontario M4W 3E2
Tel: (416) 925-0704, Ext 22 or 23
Toll Free: 1 (800) 446-3942
Fax: (416) 925-6061
http://www.visitmexico.com

QUEBEC
One Place Ville Marie, Suite 1931
Montreal, Quebec H3B 2C3
Toll Free: 1 (800) 446-3942
Fax: (514) 871-3825
http://www.visitmexico.com

 MEXICO STATE TOURISM OFFICES

NOTE:
If calling from outside Mexico, add 011-52 before these telephone numbers when you dial. If calling from another city within Mexico dial 01 before number.

Most of the Tourism websites are in Spanish but several have English versions.

AGUASCALIENTES
Palacio de Gobierno, Plaza
Principal s/n Centro Historico
CP 20000 Aguascalientes, AGS.
Tel: (449) 910-2000 and
From Mexico: (800) 900-2002
http://www.aguascalientes.gob.mx

BAJA CALIFORNIA NORTH
Blvd. Agua Caliente # 4558 Piso 11
Oficina 1108, Torres de Agua
Caliente, Col. Aviación,
CP 22420 Tijuana, B.C.
Tel: (664) 686-1103 or 1345
http://www.discoverbajacalifornia.
com/

BAJA CALIFORNIA SOUTH
Palacio de Gobierno, Isabel la
Católica y Allende,
CP 23090 La Paz, B.C.S.
Tel: (612) 123-9400 ext. 02268
http://www.bcs.gob.mx

CAMPECHE
Av. Ruiz Cortines s/n
Plaza Moch-Couoh, Centro
CP 24000 Campeche, Campeche
Tel: (981) 811-9229 or 9225
http://www.campechetravel.com/in
dex-ingles.htm

CHIAPAS
Boulevard Belisario Domínguez,
Edif Plaza de las Instituciones #950
CP29060 Tuxtla Gutiérrez, Chiapas
Tel: (961) 617-0550
http://www.turismochiapas.gob.mx
/lang.php?lang=en

CHIHUAHUA
Palacio de Gobierno, Planta Baja,
Calles Aldama y Venustiano
Carranza, Col. Centro
CP 31000 Chihuahua, Chihuahua
Tel: (614) 429-3300
http://www.chihuahua.gob.mx/turis
moweb//

COAHUILA
Tel: (866) 457-3750 from U.S.
From Mexico: (800) 718-4220
http://www.secturcoahuila.gob.mx/
principal.html

COLIMA
Tel: (312) 316-2021
http://www.visitacolima.com.mx/e
nglish/index1.htm

 MEXICO STATE TOURISM OFFICES

DURANGO
Calle Florida No. 1106, 2do. Piso,
Barrio el Calvario Zona Centro
CP 34000 Durango, Durango
Tel: (618) 811-2139, 1107, 9677
http://www.durango.gob.mx/site/pr
incipal.html

GUANAJUATO
From Mexico (800) 714-1086
http://www.guanajuato-travel.
com/v1/

GUERRERO
Palacio de Gobierno, Blvd. René
Juárez #62, Col. de los Servicios,
Chilpancingo, Guerrero
Tel: (747) 471-9700
http://www.guerrero.gob.mx

HIDALGO
Av. Francisco I.Madero Num. 702
Esq. Pino Suárez, Col. Real de
Minas C.P. 42090
Pachuca de Soto, Hidalgo, México.
Tel: (771) 718-3937, 718-4454
From Mexico: 800-718-2600
http://turismo.hidalgo.gob.mx

JALISCO
Morelos No. 102, Plaza Tapatia
CP 44100 Guadalajara, Jalisco
From Mexico (800) 363-2200
http://www.visita.jalisco.gob.mx

MEXICO (STATE)
Includes info on Mexico City.
http://turismo.edomex.gob.mx/esp/
ing/index.html#edomex

MICHOACÁN
Av. Tata Vasco # 80
(esq. Hospitales)
Col. Vasco de Quiroga
CP 58280 Morelia, Michoacán.
Tel: (443) 317-8032, 8052. 8054,
8057, 8059
From Mexico: (800) 450 2300
http://www.turismomichoacan.gob.
mx/

MORELOS
Av. Morelos Sur No. 187,
Col. Las Palmas
CP 62050 Cuernavaca, Morelos
Tel: (777) 314-1880, 3872, 3790,
6747
http://www.morelostravel.com/pub
lica/index.php

NAYARIT
Av. México y Abasolo s/n Centro.
CP 63000 Tepic, Nayarit
Tel: (311) 215-2000
http://www.nayarit.gob.mx/

NUEVO LEÓN
Zaragoza y 5 de Mayo, Centro
CP 64000 Monterrey, Nuevo León
http://www.nl.gob.mx

 MEXICO STATE TOURISM OFFICES

OAXACA
Murguía 206 Centro Histórico
CP 68000 Oaxaca, Oaxaca
Tel: (951) 516-0123, 514-9341
http://www.aoaxaca.com/oaini.php

PUEBLA
5 Oriente No. 3
Centro Histórico
CP 72000 Puebla, Puebla
Tel: (222) 777-1519, 1520
In Mexico: (800) 326-8656
http://www.puebla.gob.mx/puebla/t
urismo.jsp

QUERÉTARO
Tel: (442) 238-5067
From Mexico: (800) 715-1742
http://www.venaqueretaro.com/eng
_index.html

QUINTANA ROO
Av. Calzada del Centenario #622
Col. Bosque, Edificio Hotel Ejidal
CP 77019 Chetumal, Quintana Roo
Tel: (983) 835-0860
http://sedetur.qroo.gob.mx/index.p
hp

SAN LUIS POTOSÍ
Allende No. 120, Centro Histórico
CP 78000 San Luis Potosí, S.L.P.
Tel: (444) 814-1416
From Mexico: (800) 343-3887
http://www.descubresanluispotosi.c
om/web//ing/index.html

SINALOA
Calle Carnaval y Mariano
Escobedo 1317, Col. Centro
CP 82000. Mazatlan, Sinaloa
Tel: (669) 981-8883 to 8887 &
8889
http://www.sinaloa-
travel.com/eng/start.html

SONORA
Tel: (662) 289-5800
http://www.gotosonora.com/

TABASCO
Av. Los Ríos s/n esq. Calle 13
Tabasco 2000 Center
CP 86035 Villahermosa, Tabasco
Tel: (993) 316-3633

TAMAULIPAS
Hernán Cortes No. 136, Col. Pedro
Sosa Edificio "El Peñon"
Rel 01 (834) 31 5 61 36, 31 5 61 37
CP 87000 Cd. Victoria, Tamaulipas
Tel: (834) 315-6136, 6137
From USA (888) 580-5968
http://www.tamaulipas.gob.mx/gob
ierno/secretarias/sec_turismo/

 MEXICO STATE TOURISM OFFICES

VERACRUZ
Blvd. Cristóbal Colón No. 5
CP 91190 Xalapa, Veracruz
From Mexico: (800) 837-2887
http://portal.veracruz.gob.mx/porta
l/page?_pageid=313,1&_dad=porta
l&_schema=PORTAL

YUCATÁN
Centro de Convenciones Yucatán
Siglo XXI, Calle 60 Norte Interior
s/n, Planta Alta, Ex Cordemex, Col.
Revolución
CP 97118 Mérida, Yucatán
Tel: (999) 930-3762
http://mayayucatan.com.mx/

ZACATECAS
Av. Hidalgo No. 403 Segundo Piso
Centro Histórico
CP 98000 Zacatecas, Zacatecas
Tel: (492) 924-6751, 3426, 9331
From Mexico: (800) 712-4078
http://www.turismozacatecas.gob.
mx/

READING LIST

SUGGESTED PUBLICATIONS

Don't forget to purchase a good English/Spanish dictionary. There are numerous ones on the market. We like the one published by Larousse as it seems to be very comprehensive. It is also small and easy to carry.

1) *Mexico Handbook* By Joe Cummings and Chicki Mallan
 Published by Moon Publications, Inc
 Available at bookstores & Online
 Second Edition
 ISBN-10: 1-56691-123-0
 ISBN-13: 978-1-56691-123-8
Several other area-specific books are available from these same authors with more extensive detail on such areas as the Yucatan, Colonial Mexico, Northern Mexico, Archaeological Mexico, and Baja.

2) *Traveler's Guide to Mexican Camping* By Mike and Terri Church
 Published by Rolling Homes Press
 Third Edition
 ISBN-10: 0-97494-712-1
 ISBN-13: 978-0-97494-712-9
 Website: http://www.rollinghomes.com
Good clear, concise directions, GPS coordinates, and maps to each of the known campgrounds and camping areas. Well researched! Their website offers updates and current information on changes since the book was printed.

3) *Lonely Planet Mexico*
By John Noble, Andrew Dean Nystrom, & Ben Greensfelder
Published by Lonely Planet Publications Pty. Ltd.
Eighth Edition
ISBN-10: 1-74059-744-3
ISBN-13: 978-1-74059-744-9

4) *Mexico: The Rough Guide* By John Fisher
Published by Rough Guides Ltd.
Seventh Edition
ISBN-10: 1-84353-843-1
ISBN-13: 978-1-84353-843-1

5) *Archaeological Mexico-A Guide to Ancient Cities and Sacred Sites*
By Andrew Coe
Published by Avalon Travel Publishing
Second Edition
ISBN-10: 1-56691-321-7
ISBN-13: 978-1-56691-321-8

6) *Route of the Mayas* By Alfred A. Knopf
Published by Random House
ISBN-10: 0-67975-569-1
ISBN-13: 978-0-67975-569-2

ONLINE INFORMATION SOURCES

They following list of websites is provided to assist you in your travel planning and during your trip through Mexico.

CAMPGROUNDS:
http://www.rollinghomes.com —*Travelers Guide to Mexican Camping*
http://www.ontheroadin.com —RV Parks in Mexico
http://www:acamayareef.com —Acamaya Reef RV Park

GENERAL AND PRE-PLANNING INFO:
http://www.mexconnect.com —General travel and planning info
http://www.mexonline.com —General travel and planning info
http://www.sanbornsinsurance.com —General travel and planning info
http://usembassy.state.gov/ —Embassy and Consulate info worldwide
http://mexico.usembassy.gov/index.html —U.S. Embassy website
http://www.canada.org.mx —Canadian Consular Services
http://www.customs.ustreas.gov —United States Customs Service
http://www.ccra-adrc.gc.ca —Canadian Customs Service
http://www.sectur.gob.mx/wb2/securing/sect_2_home —Mexico Dept. of Tourism (SECTUR) English Site
http://www.banjercito.com.mx/site/imagenes/iitv/instruccionesIITV_ing.html —Online vehicle importation permit application, Banjercito
http://www.mexonline.com/boatmex.htm —Boat importation info
http://www.walmartmexico.com.mx —Walmart locations in Mexico
http://www.worldwidebooksandmaps.com —World Wide Books & Maps

TRAVEL DESTINATION INFO:
http://www.travelguidemexico.com —Online travel magazine
http://www.visitmexico.com —General
http://www.mexicofile.com —Baja specific info
http://www.mexweb.com —Guadalajara area specific info
http://mexicoscoppercanyon.com/ —Copper Canyon travel info

COMMUNICATIONS:
http://www.telmex.com —Area codes and dialing info for Mexico
http://www.cellularabroad.com —Cellular service in Mexico
http://www.skype.com —Internet based International calling service
http://www.minutepass.com —Long Distance calling card service
http://www.starchoice.com —Canadian Star Choice Satellite TV

HEALTH INSURANCE & MEDICAL INFORMATION:
http://www.iamat.org —Medical information for foreign travelers
ttp://www.mexbound.com —Mexbound.com
http://www.mexpro.com —Mexpro Mexican Insurance Professionals
http://www.skymed.com —Skymed Emergency Medical Insurance

VEHICLE INSURANCE:
http://www.mexicoinsurance.com —Ada Vis Global Insurance
http://www.mexadventure.com —Adventure Mexican Insurance
http://www.aaa.com —American Automobile Insurance Company
http://www.aonrecreation.com —Aon Recreation Insurance
http://www.caa.ca —Canadian Automobile Insurance Company
http://www.drivemex.com —DriveMex.com
http://www.mexbound.com —Mexbound.com
http://www.mexpro.com —Mexpro Mexican Insurance Professionals
http://www.rvinsurancepro.com —RV Insurance Associates
http://www.sanbornsinsuance.com —Sanborns

ONLINE NEWSPAPERS:
U.S. Based NewsWebsites:
http://www.chron.com
http://www.latimes.com
http://www.nytimes.com
http://www.washingtonpost.com

Canadian Based News Websites:
http://www.canada.com/calgaryherald
http://www.canada.com/montrealgazette
http://www.canada.com/vancouversun
http://www.globeandmail.com
http://www.thestar.com
http://www.thetelegram.com

GLOSSARY

abarrotes	groceries
abrazadera/tornillo	clamp (for vehicle)
acelerador	accelerator (for vehicle)
aceite	oil
adelante	go forward/go ahead
Aduana	Customs
aeropuerto	airport
agave	cactus variety
agua	water
agua mineral	mineral water
agua purificada	purified water
aguacate	avocado
aire	air (for tires)
ajustar	adjust
alineanacion	wheel alignment
almejas	clams
almuerzo	large breakfast meal
alta	high
alto	stop
alto próximo	stop ahead
altura libre	vertical clearance
anchura libre	horizontal clearance
Angeles Verdes	Green Angels
año	year
antojito	appetizer
apretar	tighten
aquí	here
arrancar	to start
arranquedora	starter (for vehicle)
arreglar	to repair
arroz	rice
artesanías	artisans/handcrafts
atún	tuna, type of fish
Auxilio Turístico	tourist assistance
baleros	bearings (for vehicle)
balneario	swimming area
Banco del Ejército	Bank of the Army

banda/cinta	fan belt (for vehicle)
baños	bathroom
basura	trash
batería or acumulador	battery
blanco	white
blanqueador	bleach
bobina de encendido	coil (electric for vehicle)
bolillos	bread rolls
botella	bottle
bomba de agua	water pump (for vehicle)
bomba de gasolina	fuel pump (for vehicle)
borrego	sheep
botana or tapa	snack
bujía	spark plug (for vehicle)
caballero	gentlemen
cabeza	head
cable	cable
cabrilla	black sea bass, type of fish
cabrito or *chivo*	goat
café con leche	coffee with milk
calabaza	squash or pumpkin
calamar	squid
caldo	stew
caliente	hot (to touch)
callos	scallops
camarones	shrimp
cambio	exchange
camino	road
camioneta	truck
campamento	campground
cangrejo	crab
carburador	carburetor (for vehicle)
caro	expensive
carretera	road/highway
carril	lane
cascada	waterfall
caseta	booth

cebolla	onion
cena	dinner or evening meal
centro	central
cerdo	pork
cereza	cherry
cervecería	beer manufacturer
cerveza	beer
chalana	car ferry
chayote	edible variety of cactus
chorizo	spicy sausage
chuleta de puerco	pork chops
ciclista	bicyclist
cinturón de seguridad	seat belt
cobre/cobro	toll
codorniz	quail
cojinete de la rueda	wheel bearing (for vehicle)
colectivos	small passenger transport vehicles
comida	food; usually noontime meal
con	with
conceda	to grant or award
condensador	condenser (for vehicle)
conejo	rabbit
Correo	post office
corte de pelo	haircut
crema	cream
crema ácida	sour cream
crema dental	toothpaste
cruce	crossing
Cruce de Escolares	school crossing
Cruce de Ferrocarril	railroad crossing
cuadra	block
cuchara	spoon
cuchillo	knife
cuenta	check or bill
cumpleaños	birthday
cuota	toll
cruceta	universal joint (for vehicle)

curva	curve
dejar	leave
dentista	dentist
deposito	deposit
derecha	right
derecho	straight
desayuno	breakfast
desde	since/from
despacio	slow
desviación	detour
día	day
diferencial	differential (for vehicle)
direccionales	turn signals (for vehicle)
disminuya	decrease or diminish
distribuidor	distributor (for vehicle)
divido	divided
doble	double
dónde	where
dorado	dolphin fish (mahi mahi)
drenaje	RV dump station or connection
dulce	candies or sweets
durazno	peach
eje	axle
pavimento	pavement
eléctrico	electrical
embrague	clutch (for vehicle)
empaque	gasket
en rollo	rolled
engranajes	gear (for vehicle)
engrasar	lubricate
entero	whole
entrada	entrance
entronque	intersection
envase	bottle
estación	station or stop (i.e., bus stop)
Estación de Ferrocarril	train station
estacionamiento	parking
estética	hair salon

estrechamiento asimétrico	roadway narrows/right lane ends
estrechamiento simétrico	roadway narrows to one lane
fábrica	factory
farmacia	pharmacy
faros	headlights (for vehicle)
fiesta	party
filtro	filter (for vehicle)
frenos	brakes (for vehicle)
fresa	strawberry
frijoles	beans
frío	cold
frito	fried
fruta	fruit
fumar	to smoke
ganado	livestock
garrafón	water container (20 liters)
gas	propane
gasolinera	fuel station
gato	car jack (for vehicle)
gato	cat
generador	generator
glorieta	traffic circle
gracias	thank you
grande	large
grasa	grease, fat
gratis	free, complimentary
grava suelta	loose gravel
gringos	common term for North Americans
grito	shout
grúa	tow truck
gruta	cave
guayaba	guava
hablar	speak
harina	flour
helados	ice cream
herramientas	tools
hielo	ice

hombre	men
hombres trabajando	men working
huachinango	red snapper, type of fish
huevos	eggs
información	information
Inglés	English
izquierdo	left
jabón	soap
jaiba	crab
jamón	ham
jitomate	tomato
jugo	juice
jurel	yellowtail, type of fish
kilo	unit of measure/approx. 2.2 pounds
lago	lake
laguna	lagoon
langosta	lobster
langostino	freshwater lobster
larga distancia	long distance
lavandería	laundry
leche	milk
lechuga	lettuce
libre	free (no cost)
ligera	light
limón	lime
línea seca	line dry
liquido de frenos	brake fluid
llantas	tire
llantera	tire shop
lleno	full
lobina	bass, type of fish
luces	lights
madre	mother
Magna Sin	regular unleaded gasoline
maguey	cactus type used for making Mezcal
maquinaria agrícola	farm machinery
maíz	corn

maltrate	to deface
manejar	drive
mañana	tomorrow/later
manguera	hose (for vehicle)
manicura	manicure
mantequilla	butter
manzana	apple
margarina	margarine
mariscos	seafood
más	more
mecánico	mechanic
media	half
médico	medical
mercado	market
mero	grouper, type of fish
mesa	table
MexPost	Mexican post office
migración	Immigration
mofle	muffler (for vehicle)
monumento	monument
mordida	pay-off or bribe
mostaza	mustard
muelle	boat dock
muelles	springs (for vehicle)
muertos	dead
mujeres	women
múltiple	manifold (for vehicle)
música	music
naranja	orange
Navidad	nativity
niebla	fog
nopales	edible variety of cactus
nuestra	our
nuevo	new
obedezca	obey
ostiones	oysters
padre	father

palanca de cambios	gear shift (for vehicle)
pan dulce	sweet pastries
pan tostado	toast
panadería	bakery
papas	potatoes
papel de baño	toilet paper
parabrisas	windshield (for vehicle)
parada de autobús	bus stop
Parque Nacional	National Park
pasteles	baked goods
pato	duck
pavo	turkey
peatones	pedestrians
pechuga	breast
peinar	hairstyle
peligroso	dangerous
peluquería	barber
Pemex	brand name of fuel station
Pemex Premium	premium unleaded gasoline
pendiente peligrosa	dangerous downgrade
pequeño	small
periférico	bypass road
permanente	permanent
perro	dog
pescado	fish, general classification
pescado blanco	whitefish
pesos	Mexican currency
PGF	Procuraduría General de Federal
PGR	Procuraduría General de República
picante	spicy hot
piedras	rocks
pimiento	pepper
plancha	iron
plátanos	bananas
playa	beach
poblado	population area
pollo	chicken

por favor	please
postre	dessert
primario/primero	main
principia	initiate or begin
propina	tip, gratuity
protéjalos	protect, take care of
próximo	nearby, near
puente	bridge
puerco	pork
pulpo	octopus
queso	cheese
queso crema	cream cheese
raya continua	solid line
rebase	pass
recibos	receipts
rediadora	radiator (for vehicle)
refacciones	auto parts
refrescos	refreshments/sodas
regadera	shower
regulador del voltaje	voltage regulator (for vehicle)
relleno	filled
reparación	under repair
requesón	cottage cheese
restaurante	restaurant
retorno	turnaround area on roadway
revisar	to check
revueltos	scrambled
robalo	sea bass, type of fish
ropa	clothing
rueda	wheel (for vehicle)
ruido	noise
sal	salt
salida	exit
sanitario	restroom
santo	saint
seca	dry
seguridad	security

semáforo	traffic light
semana	week
señales	signs
separado	separate
servicio	service
servilleta	napkin
silla	chair
sin	without
sin cascara	without shells
sin queso	without cheese
sinuoso	winding
soldadura	weld or solder
solo	only
sopa	soup
super mercado	supermarket
superficie derrapante	slippery roadway or surface
suspensión	suspension (for vehicle)
taller	garage/workshop
tanque	tank
taza	cup
teléfono	telephone
Telmex	Mexican telephone company
tenedor	fork
teñir	to color or to dye
termina	end/terminate
termostato	thermostat
tienda	store
tirando	leak (as in radiator or oil leak)
tirar	to throw
tocino	bacon
tope	speed bump
tornillo	bolt
toro	jack crevalle, type of fish
tortilla	flat, round, unleavened bread made from flour or corn meal
tramo	section or part of roadway
transbordador	auto ferry/oceangoing

tránsito lento	slow traffic
tránsito pesado	cargo or heavy vehicles
tres leches	three milk
tripa	cow stomach
trucha	trout, type of fish
tubo de escape	exhaust pipe (for vehicle)
turista	tourist
utilice	utilize/use
válvula	valve (for vehicle)
vaso	drinking glass
velocidad	speed
venta	sell
ventilador	fan
verduras	vegetables
vibradores	type of speed bump with ridges
yogur	yogurt
zapatas de frenos	brake shoes (for vehicle)
Zócalo	town center/park
zona	zone
Zona Arqueológica	Archaeology Zone
zona de derrumbes	falling rock zone

Día de la Semana

Day of the Week

Lunes	Monday
Martes	Tuesday
Miércoles	Wednesday
Jueves	Thursday
Viernes	Friday
Sábado	Saturday
Domingo	Sunday

Mes	**Month**	
Enero	January	
Febrero	February	
Marzo	March	
Abril	April	
Mayo	May	
Junio	June	
Julio	July	
Agosto	August	
septiembre	September	
Octubre	October	
Noviembre	November	
Diciembre	December	

Numeros	**Numbers**	
Cero	Zero	(0)
Uno	One	(1)
Dos	Two	(2)
Tres	Three	(3)
Cuatro	Four	(4)
Cinco	Five	(5)
Seis	Six	(6)
Siete	Seven	(7)
Ocho	Eight	(8)
Nueve	Nine	(9)
Diez	Ten	(10)
Once	Eleven	(11)
Doce	Twelve	(12)
Trece	Thirteen	(13)
Catorce	Fourteen	(14)
Quince	Fifteen	(15)
Dieciséis	Sixteen	(16)
Diecisiete	Seventeen	(17)
Dieciocho	Eighteen	(18)
Diecinueve	Nineteen	(19)

Numeros	Numbers	
Viente	Twenty	(20)
Treinta	Thirty	(30)
Cuarenta	Forty	(40)
Cincuenta	Fifty	(50)
Sesenta	Sixty	(60)
Setenta	Seventy	(70)
Ochenta	Eighty	(80)
Noventa	Ninety	(90)

For intervening numbers add (*y*) plus number from one to nine (for example: *veinte y dos* is twenty-two—22).

Cien	One Hundred	(100)
Doscientos	Two Hundred	(200)
Trescientos	Three Hundred	(300)
Cuatrocientos	Four Hundred	(400)
Quinientos	Five Hundred	(500)
Seiscientos	Six Hundred	(600)
Setecientos	Seven Hundred	(700)
Ochocientos	Eight Hundred	(800)
Novecientos	Nine Hundred	(900)
Mil	Thousand	(1000)
Millón	Million	(1,000,000)

For intervening numbers add combinations of numbers (for example: *doscientos ochenta y dos* is two-hundred eighty-two—282).

Preguntas	**Questions**
¿Quién?	Who?
¿Quién es ese hombre?	Who is that man?
¿Cuál?	Which?
¿Cuál te gusta?	Which one do you like?
¿Qué?	What?
¿Qué es esto?	What is this?
¿Mande?	What? (polite term for "I didn't hear you, repeat please.")
Eso, cuál	That, which
Es importante que usted me hable or (*hable conmigo.*)	It is important that you talk to me.
¿Cuándo?	When?
¿Cuándo llegará usted?	When will you arrive?
¿Dónde?	Where?
¿Dónde esta la gasolinera¿	Where is the fuel station?
¿Dónde esta el baño?	Where is the bathroom?
¿De dónde viene?	Where are you coming (or traveling) from?
¿A dónde va usted?	Where are you going (or traveling) to?
Como	Like, as
¿Cómo?	How?
¿Cómo está usted?	How are you? (formal)
¿Cómo estás?	How are you? (informal)
¿Cuánto/cuántos?	How much/how many?
¿Cuánto cuesta?	How much does it cost?
¿Cuántos quiere?	How many do you want?
¿Me puedo estacionar aquí?	May I park here?
¿Por qué?	Why?
¿Por qué no?	Why not?

INDEX